# MINIATURES AND SILHOUETTES OF EARLY AMERICAN JEWS

# Miniatures and Silhouettes of Early American Jews

BY

HANNAH R. LONDON

combining the two volumes

MINIATURES OF EARLY AMERICAN JEWS

and

SHADES OF MY FOREFATHERS

CHARLES E. TUTTLE COMPANY: PUBLISHERS
RUTLAND, VERMONT

*Representatives*

*Continental Europe:* BOXERBOOKS, INC., *Zurich*

*British Isles:* PRENTICE-HALL INTERNATIONAL, INC., *London*

*Australasia:* PAUL FLESCH & CO., PTY. LTD., *Melbourne*

*Canada:* M. G. HURTIG LTD., *Edmonton*

*Published by the Charles E. Tuttle Company, Inc.
of Rutland, Vermont & Tokyo, Japan
with editorial offices at Suido 1-chome, 2-6
Bunkyo-ku, Tokyo, Japan*

*Copyright in Japan, 1970 by Charles E. Tuttle Co., Inc.*

*Library of Congress Catalog Card No. 78-87797*

*Standard Book No. 8048 0657-8*

*First Tuttle edition published 1970*

PRINTED IN JAPAN

# PUBLISHER'S FOREWORD

This welcome one-volume reprint of Miss London's second and third books on the general subject of pictures of early American Jews is of great significance not only to American Jewry but to historians and to those who love to delve into rich and legitimate Americana.

In her second book, *Shades of My Forefathers,* Miss London assembled 59 excellent early American silhouettes which she described with the keen social and historical perception of the connoisseur and the expert. And her comments are as apt as her descriptions, as when she remarks that "The silhouettists had a way of following the socialites to further their business interests. At England's delightful spa, Bath, which was visited by the beau monde, they would ply their trade, in the shadow of the famous portraitists, among them Gainsborough and Reynolds."

*Miniatures of Early American Jews,* Miss London's third book, continued her pictorial representation of Jews in early American life. Her goal here was to bring to light miniatures of American Jews and relate them to the artists who painted them. This she has done with admirable acumen.

These two volumes, here combined under the title *Miniatures and Silhouettes of Early American Jews,* indeed perpetuate the Jewish group, for as the author says, "Since we in this country descend from many stocks, the existence of the Jewish group, for one, must not be lost or overlooked."

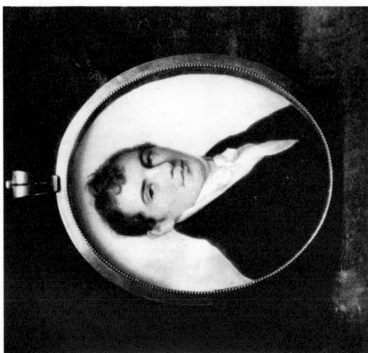

JOSEPH MARX
*By* EDWARD GREENE MALBONE
*Owned by Pennsylvania Academy of the*
*Fine Arts, Philadelphia*

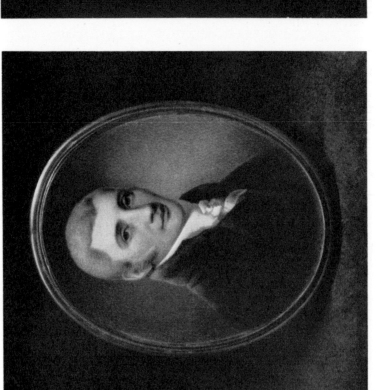

ASHER MARX
*By* EDWARD GREENE MALBONE
*Owned by Pennsylvania Academy of the*
*Fine Arts, Philadelphia*

# Miniatures of
# Early American Jews

BY
HANNAH R. LONDON

TO THE MEMORY OF MY SON
PFC. ROBERT E. SIEGEL
BORN JUNE 5, 1925; KILLED IN ACTION,
WORLD WAR II, IN FRANCE, SEPTEMBER 16, 1944

# CONTENTS

# LIST OF ILLUSTRATIONS

# PREFACE

SOME years ago when I read a paper on portraits of Jews painted during the Colonial period and in the early days of our Republic, at a meeting of the American Jewish Historical Society in Philadelphia, I had little reason to believe that I should later find enough material to warrant further research in this field.

However, I was soon at ease in that respect, for in the audience were many descendants of early American Jews, who owned a considerable number of ancestral oil portraits, silhouettes and miniatures. They invited me to view these treasures at their homes, and from them, as well as by correspondence with others, and research in museums and historical societies, I was enabled to find enough material to write *Portraits of Jews by Gilbert Stuart and Other Early American Artists,* which was published by William Edwin Rudge, of New York, in 1927. Subsequently, I wrote a book on silhouettes of early American Jews entitled, *Shades of My Forefathers.* Published by The Pond-Ekberg Company, of Springfield, Massachusetts; this work came out in 1941.

The following work on miniatures presents my latest research on the pictorial representation of early American Jews. I trust this research will be further pursued, and I think it will, as long as scholars are interested in the artistic endeavor of our early painters, and in the character and accomplishments of the Jewish men and women who were painted by these artists. I hope that in the course of time correspondence between artists and their sitters will be brought to light as this phase of the research has been difficult to discover.

Since we in this country descend from many stocks, the existence of the Jewish group, for one, must not be lost or overlooked. As documentary evidence, most assuredly, the pictorial representation of Jews in early American life plays an important role.

In the preparation of this work, I gratefully acknowledge the kind assistance and cooperation given me by Mr. Harry B. Wehle of the Metropolitan Museum of Art; Mrs. Ralph Catterall of the Valentine Museum; Mr. Ruel P. Tolman, former acting director of the National Collection of Fine Arts; Mr. Isidore S. Meyer of the American Jewish Historical Society; and Mr. Theodore Bolton, author of *Early American Portrait*

*Painters in Miniature.* I am also indebted to my late sister, Blanche London Margules, and my husband, Benjamin M. Siegel.

The personnel of the Carolina Art Association, the Frick Art Reference Library, the Maryland Historical Society and the Pennsylvania Academy of the Fine Arts were also helpful to me. My thanks extends to the many individuals who supplied valuable biographical comment together with their permission to reproduce the precious miniatures in this book. Finally, I wish to express my sincere appreciation to Mr. Harry Fromkes of New York for his deep interest in my work.

HANNAH R. LONDON

BROOKLINE, MASSACHUSETTS
1953

# I
## BRIEF HISTORY OF THE MINIATURE PORTRAIT

THE painting of miniature portraits as a special art-form evolved historically from the art of ancient illuminated manuscripts. Linear decorations in red, gold, silver and other colorings within the borders and on initial letters of these manuscripts, are known as rubrications. As manuscript writing developed, rubricating was followed throughout the text by pictorial scenes and small portraits of living persons — the summation of which is known as miniature painting.

Old manuscripts were generally in book form and handwritten, chiefly on vellum, parchment, leather and paper. Vermilion, the yellowish-red hue used in their embellishment, is but another name for minium, from which we have the word "miniature."

The art of illustrating manuscripts flourished throughout the ages of antiquity and even beyond the time of the invention of printing in the 1400's. Showing at first Chinese influence, the most noted work in this form of literary production was achieved by Persian artists in the Thirteenth and Sixteenth Centuries. In this latter period, India, too, attained great heights in the art. Less distinguished than the work of the Mohammedan painters in either Persia or India are the illustrated manuscripts which were written in Turkey in the Fifteenth Century.

From the Orient and Egypt, and other sections of the Near East, the custom of decorating manuscripts spread to Europe and was developed by Greek and Roman artists of the Classical and Medieval Ages. Small portraits as well as the usual rubrications illustrate their work.

With the Classical revival of the arts in the Renaissance, in the Fourteenth Century, illuminated manuscripts emerge as an artistic expression in Italy, Spain, France, Germany and Russia. In Italy, Giulio Clovio, in the Sixteenth Century, was among the first of the continental artists to paint the separate portrait in miniature, apart from those he made for book illustration.

In France, Jean Clouet, 1485-1545, painted small portraits on vellum and paper in books. Upon his death, his son François, as court painter to Henri II, was noted for his delicate work in the execution of the detached

miniature portrait. Of the French artists who followed and painted the small separate portrait, among the most celebrated were Dumont, Sicardi, Isabey, Augustin, Fragonard and Boucher. Their work is distinguished for its elegance, exquisite coloring, and devoted attention to detail.

At the opening of the Sixteenth Century, the painting of portraits on a small scale, as apart from the occasional portrait which appeared in illustrated manuscripts, was now an established art-form on the continent. In France, the small portrait came to be known as a "mignature" and its equivalent, miniature, now applies to anything of small size.

More accurately, "painting in little," as the English term it, describes the small portrait, which first appeared on illuminated manuscripts and documents in England about the beginning of the Sixteenth Century. Then separate small portraits were painted, with the artist often referred to as a "limner," a term derived from the Latin, *illuminare*. Some of the finest miniatures painted in England were done by the German, Hans Holbein, the younger, 1497-1543, who had a strong influence on native English talent. His first visit to England, bearing letters to Sir Thomas More, was in 1526, when he painted a number of portraits. He again visited London in 1532 and subsequently entered the service of Henry VIII, for whom he painted dainty miniatures on vellum, paper and copper. He died in London in 1543.

The earliest known native miniature painter in England was Nicholas Hilliard (1547-1619). His work resembles the miniature painting in illuminated manuscripts, with its flat forms and elimination of shadows. Succeeding Hilliard were Isaac and Peter Oliver, who gave a rounded expression to faces. These artists were followed by two painters, John Hoskins, and his son, John Hoskins, Jr.

The most accomplished of English miniaturists was Samuel Cooper (1609-1672), who spent a part of his early life in France and Holland. His portraits were painted on the reverse side of playing cards, with chicken skin sometimes stretched across them, and he experimented upon mutton bone.

Ivory, as a suitable material on which to paint a miniature, was not used until the Eighteenth Century. The brilliant work of Richard Cosway (1741-1821) is considered foremost in the mastery of painting on ivory.

Cosway was succeeded by Andrew Plimer and his brother Nathaniel. George Engleheart (1750-1829) painted four thousand miniatures, all of which he listed. Other noted miniaturists were the skillful John Smart and Ozias Humphrey. Then followed Nathaniel Hone, Horace Hone, Peter

Paillou and William Wood. Henry Bone was the greatest English expo-
nent of the miniature portrait in enamel. The last of the famous English
miniature painters was Sir William Ross (1794-1860), who lived to see
his art replaced by photography.

## II
## AMERICAN MINIATURES

AMERICAN miniature painters, though influenced chiefly by English artists, reveal in their work qualities which naturally are in keeping with the indigenous traditions of our own painting. This individuality also extends to the conventional, very simple gold frames of our miniatures which differ from the frames of English and continental miniatures, generally ornate, and often studded with precious and semi-precious stones.

Miniatures in America were made to be set in brooches, watch fobs, wrist bracelets and snuff boxes, but most frequently they were used as lockets or attached to pendants and hung on the walls. In some cases to prevent their delicate colors from fading, they were merely kept in cabinet drawers and taken out from time to time to be carefully pondered over while held in the hand. These tender mementos were commissioned for keepsakes or gifts to family members, friends and lovers.

The medium used in painting a miniature was primarily water color with ivory as the most suitable base. But miniatures were also painted in water color on paper and in oil on ivory or wood, and in either medium on metal. Under the microscope we discern several types of technique; stippling, hatching, wash, and brush strokes in oil and water color.

The little portraits usually range from two and one-half inches to three inches in height, and from two inches to two and one-half inches in width.

To pass judgment on a miniature, it should be held in one's own hand in a good light and examined under a magnifying glass. Thorough knowledge of drawing is required so that over-painting will not becloud the ivory which should show through as much as possible. A good miniature has a very lifelike appearance. Miniatures are generally signed on the face side; some on the reverse, over a bit of paper, and many remain without identification of any kind.

Among the early miniature portrait painters in America was John Watson, who came from Scotland and settled in 1715 in the town of Perth Amboy, in East Jersey. Here he made small portraits in India ink and pencil. An early known miniature painted on ivory about 1740-1760 is that of Mrs. Jacob Motte, who lived in Charleston, South Carolina. The

style of the miniature at once suggests the work of Jeremiah Theus, who was painting in Charleston at that time. For several decades after 1750 John Wollaston and John Hesselius were actively engaged in painting miniatures in the mid-Atlantic colonies; often their work is identified by an "almond-eyed" mannerism.

Also working along the coast of the mid-Atlantic area, very successfully, as miniature painters, were a number of other early Eighteenth Century artists, including Mathew Pratt, Charles Willson Peale, James Peale, Robert Fulton and Henry Benbridge.

Distinguished work in New England during this early period was done by John Singleton Copley of Boston, who as a Tory left America in 1774 never to return, and by his half-brother, Henry Pelham, who also embarked for England. Joseph Dunkerley worked in Boston; his miniatures are sometimes with ulterior commercial motive incorrectly attributed to Copley.

Other native-born New England miniaturists of the Eighteenth Century were Henry Savage, of Princeton, Massachusetts, and John Trumbull, of Connecticut. The latter's father, Jonathan Trumbull, was Governor of Connecticut from 1789 to 1809. Though Trumbull is remembered chiefly for his heroic full canvases, depicting historical scenes, he still may be included among the best of our miniature painters. His little portraits were generally painted in oil on wood panels.

At the end of the Eighteenth Century a number of excellent miniaturists came here from Europe. Among them were the Irishmen, Walter Robertson and John Ramage. Archibald Robertson came from Scotland in 1791 and Robert Field and William Birch came from England a few years later. Field set up a studio in Philadelphia and later moved to Halifax, Nova Scotia. William Birch is known for his extremely competent portraits in enamel, much prized by collectors nowadays. Edward Miles also came here from England and settled in Philadelphia where he died. He was an excellent miniature painter and taught the art, as well. Another foreign competitor was Henri Elouis, who came from France, where he returned in 1807.

The early Nineteenth Century was the age of greatest productivity among our miniature painters. The work of Rembrandt Peale and Raphael Peale, sons of Charles Willson Peale, and of Anna Claypoole Peale, daughter of James Peale, falls within this period. They resided in Philadelphia, as did George Freeman and George L. Saunders, who were also painting miniatures at this time. Another Philadelphian was Thomas Sully, who

painted some sixty miniatures of distinction. His brother, Lawrence, also had a reputation as a miniature painter.

Artists of the period who were painting miniatures in New England include Henry Williams, who advertised himself as a miniature painter in Boston in 1824; Sarah Goodridge and Gilbert Stuart. Other New Englanders of native talent were the self-taught Alvan Clark, who was working in Boston in 1836, and Richard Morrell Staigg, whose productions are chiefly associated with Newport.

Anson Dickinson came from Connecticut to New York where he was painting miniatures in the early Nineteenth Century. His contemporary, William Dunlap, also painted in miniature, though he will always remain best known for his valuable *History of the Rise and Progress of the Arts of Design in the United States*. New York in the early Nineteenth Century was the mecca for other miniaturists of note including John Wesley Jarvis, Joseph Wood, Henry Inman and his partner, T. S. Cummings.

The outstanding native artists of the early Nineteenth Century were Edward Greene Malbone, Benjamin Trott and Charles Fraser. The career of Fraser extended beyond this period as he lived until 1860.

Inevitably commercialization raised its head; after 1850 the craze for the quick, easy, and inexpensive daguerreotype forced the abandonment of miniature painting. However, a few miniaturists continued to paint in the late Nineteenth Century, especially in New York, where they were doing interesting work. Among them were George Catlin, John Wood Dodge, who lived until 1893; Nathaniel Rogers, John Alexander MacDougall and Ann Hall, whose art is spirited and original.

The preceding pages of this chapter do not mention all of our miniature artists. Over three hundred painters are listed in *Early American Portrait Painters in Miniature,* by Theodore Bolton. From the point of view of draughtsmanship and color, their work as a whole is extremely satisfying. They showed a good feeling for balance and rhythm within the constrictions of their medium. The features of beautiful women and handsome men received most delicate treatment in delineation. The coiffures of the ladies are somewhat like those of today, brushed smoothly back from the ears and in curls atop the head. Youthful male faces are framed by unruly locks, while the older men with gray hair or powdered wigs display a pioneer seriousness.

The styles of the fashionable costume designers were also high lighted in harmoniously blended colors.

Our miniature artists were endowed with a talent for true depiction of

detail and could employ this gift most dexterously. The keepsakes they have left us are convincing examples of a fine art, and a continuous source of aesthetic pleasure.

# III

## EIGHTEENTH CENTURY MINIATURES

Ramage — Lawrence Sully — Charles Willson Peale —
Polk — Philippe A. Peticolas — James Peale

IT IS NOT within the purview of this book to outline the history of
miniature painting in its entirety. That has been accomplished in the
work of Mr. Harry B. Wehle, Curator of Paintings in the Metro-
politan Museum of Art in his *American Miniatures*. The history of this
art can also be gleaned by studying the works listed in the Bibliography
of this book. My purpose is but to bring to light miniatures of American
Jews and relate them to the artists who painted them. Some of these minia-
tures have already been listed; a few have been reproduced, and the remain-
der have been held in obscurity. It will be seen that miniatures of American
Jews represent the work of a whole galaxy of miniature painters practicing
their art here from 1730-1850.

This chapter will include a discussion of the earliest attributed minia-
tures, herein illustrated.

Among them is the miniature of Joseph Simson by John Ramage. The
miniature was owned in 1920 by a great-granddaughter of the sitter, Mrs.
Ansel Leo, of Yonkers, New York.

Born in Germany in 1686, Joseph Simson came to these shores in 1718,
with his uncle Nathan Simson who had sisters residing at Bonn, Germany.
Joseph Simson's wife was Rebecca Isaacks; their sons were Sampson and
Solomon.

Joseph Simson's name was on the roster of Captain Ellison's Company,
the Orange County Regiment of New York Volunteers, organized about
1738. A scholarly gentleman, he had corresponded with Dr. Kennicott of
Oxford, and Dr. Cooper, President of King's (now Columbia) College.
It appears, also that he was interested in Chinese Jews with whom he
corresponded in Hebrew. He died in 1787.

His son, Solomon, married Sarah Mears. Their son, Sampson Simson,
was a graduate of Columbia College in 1800, and founder of Mount Sinai
Hospital, New York. Sampson Simson's sister, Rebecca, married Abraham
Isaacks; they had two children, Moses and Jochebed; the latter married
Rev. Ansel Leo. Sampson Simson survived his sister and her children, and

his estate was inherited by a grandnephew, Sampson Simson Leo, who received an LL.B. degree from Columbia College in 1872. He died November 5, 1923.

The miniature of Joseph Simson is reproduced in the *Lyons Collection,* Volume 27, of the Publications of the American Jewish Historical Society, and the illustration in this book is by kind permission of the Society.

There is a note in the *Lyons Collection* that the miniature was done by Ramage who, attracted by the patriarchal Simson — gazing from a window — entered the house and begged for the privilege of painting Simson's miniature. We read that after much persuasion, the latter finally consented. Simson was then about one hundred years of age.

John Ramage, the artist, was noted for his excellent miniatures. He was born before 1763, in Ireland, and practiced as an artist and goldsmith in Boston in 1775. During the Revolution he served with the British troops in New York, and after their departure he resumed his profession. He is listed in the New York directories as a painter from 1786-1795. He went to Canada in 1794, and died October 24, 1802, in Montreal, at the home of a family by the name of des Rivières.

Ramage is described by Dunlap as being always beauishly attired, wearing a scarlet coat, white silk waistcoat, black satin breeches, white silk stockings, and silver buckles on his shoes. His powdered locks were covered by a small cocked hat, and he carried a gold-headed cane and snuff box.

Miniatures by Ramage were in the line style, as opposed to the dotted. This linear technique, most apparent in his delineation of hair, appears as if drawn by pen. His ivories were frequently of the narrow type, and approximate more closely in size those of Copley and C. W. Peale, measuring, generally, one and one-half by one and one-eighth inches, or two by one and one-half inches. Characteristic of his portraits is the placing of the head which covers about half of the ivory; the face is generally placed three quarters to the front, with the eyes to the spectator, and the nose is always delineated by a sharp thin line.

Ramage indulged in rich color, and his sitters are always most fashionably dressed. His backgrounds were often dark, shading to robin's-egg blue. Miniatures by Ramage are generally in lockets, in fluted or otherwise chased gold frames, of his own design, and, as far as known, were never signed.

A miniature of Jacob De Leon by John Ramage is in the possession of Miss Emma L. Samuel, of Philadelphia. De Leon was born in 1764. In

1790 he was living with his wife, née Hannah Hendricks, in Kingston, Jamaica. From the few known facts of his life, we have been able to gather that as a captain in the Revolution, on General Pulaski's staff, he fought at the Battle of Camden, South Carolina, in 1780, and with Jacob De La Motta and Major Benjamin Nones, carried the mortally wounded General De Kalb from the field. De Leon died in 1828.

Almeria, his daughter, married Hayman Levy, Mayor of Camden, South Carolina. One of their sons was killed in the Civil War; another died from the hardships endured during that war. Hayman Levy died in 1865.

Jacob De Leon's son, Abraham, married Isabella Nones. The late Perry De Leon, great-grandson of Jacob, resided in Richmond, Virginia. He wrote that he owned a portrait in oil from De Leon's miniature.

The little portrait, in a gold locket, represents Jacob De Leon wearing a claret-colored coat with gilt buttons and ruffled shirt or jabot. His deli-cate and refined features are framed by powdered gray hair or wig and he has brown eyes. The background is a bluish gray.

The miniature was lent by Mr. Bunford Samuel to a loan collection of old miniatures in the Tenth Annual Exhibition of Miniatures at the Pennsylvania Academy in 1911.

Jacob De Leon's miniature is reproduced in my *Portraits of Jews*, pub-lished in 1927, as unattributed, and it illustrates F. F. Sherman's *John Ramage*, published in 1929, as by Ramage.

Contributed to the Museum of the City of New York by Miss Florence Dreyfous is a miniature of a Miss Gomez, a member of Miss Dreyfous' mother's family. Mr. Wehle and I believe this to be by John Ramage.

The miniature in a locket is mounted as a pin. Against a background of robin's-egg blue, the sitter is represented in a simple white ruffled bodice. Her parted hair, black and coarse, falls over the shoulders. Her eyes are brown.

The pose, the linear technique of the hair, the size and color of the miniature, and the hand-wrought frame all suggest the work of Ramage.

Solomon Marache's miniature, too, is in character with the mannerism of Ramage's work. Marache was living in Philadelphia in 1760. He was of the firm of Marache and Spencer, importing merchants. Marache's family came from Trinidad, West Indies.

Mrs. Sarah P. Bent, of Philadelphia, whose husband, Rev. Rufus H. Bent, is Mr. Marache's direct descendant, told me that Solomon Marache was excommunicated from Synagogue Mikveh Israel, because of his marriage to a Gentile.

Solomon Marache's daughter, Hannah, married Mr. Bent's grandfather, Judge Armstrong of the Court of Philadelphia. I also learned that there were large portraits of Mr. and Mrs. Solomon Marache which were owned by Mrs. George Knox M. McIlwain, of Philadelphia.

The miniature of Solomon Marache in a locket represents him in a dark blue coat with gilt buttons. He wears a white satin vest, frilled jabot and collar. His wig is white; his eyes are blue, and complexion fair. The hand-made frame is the type associated with the work of Ramage.

At the home of Mrs. Edith Lowenstein, in New Orleans, I held in my hand the very small miniature of her ancestor, Major Benjamin Nones. This miniature belongs to Mrs. Lowenstein's sister, Miss Miriam Gold-baum.

Major Benjamin Nones, born in Bordeaux, France, March 9, 1757, emigrated to Philadelphia about 1777. In 1782, he married Miriam Marks, daughter of Levy and Rachel Marks. He died in Philadelphia, February 8, 1826.

As an aide on the personal staff of General Washington, Benjamin Nones served with the title of Major and received special mention by Congress for bravery in action. After the War he engaged in business with Haym Salomon. Papers in the possession of Mrs. Lowenstein say that Major Nones was well acquainted with Alexander Hamilton as well as George Washington. It is a tradition in her family that Joseph Nones, son of Benjamin, sat on George Washington's knee!

I have attributed the miniature of Major Benjamin Nones to John Ramage. He is represented against a brown background with head turned to right and eyes facing the spectator. Nones has light brown hair, brown eyes and pinkish cheeks, and red lips. He wears a dark blue coat, white vest, embroidered in fleurs-de-lis, and white flowing bow tie.

Painted by Lawrence Sully is the miniature of Abraham Alexander, Sr. The latter was born in London in 1743, the son of Joseph Raphael Alexander. After his arrival in this country, he became lay reader in the Congregation Beth Elohim, Charleston, and a lieutenant in the South Carolina Revolutionary forces from 1781-1782. Abraham Alexander was also auditor of the United States Custom House in Charleston, and one of the eight founders in 1801 of the Mother Lodge of Scottish Rite Masonry and its first Secretary-General. He died in Charleston, February 21, 1816, where he is buried in the old Coming Street Cemetery.

Abraham Alexander, Sr., was the great-great-grandfather of Mr. Henry A. Alexander of Atlanta, Georgia, who sent me a photographic copy of

the miniature. The sitter is depicted wearing a dark coat, buttoned vest, a high collar and lace jabot. His wig is blue. Mr. Alexander informs me that the miniature is signed by Sully. It was exhibited at the Carolina Art Association in 1936, and is listed in their catalogue, *Exhibition of Miniatures owned in South Carolina and Miniatures of South Carolinians owned Elsewhere, Painted Before the Year 1860.* Mrs. Thomas J. Tobias, Sr., of Charleston, now owns the miniature.

Lawrence Sully, the artist, was born in 1769. He painted miniatures in Charleston, Norfolk and Richmond. He was the elder brother of Thomas Sully. Lawrence Sully died in 1804.

Charles Willson Peale painted the miniature of Colonel David Salisbury Franks. Franks, who resided in Montreal previous to 1775, took an active part in the affairs of the Spanish and Portuguese Synagogue there, and held office as president of its junto. He and his father carried on an extensive trade with the French-Canadian colonists.

Business affairs first attracted Colonel David Salisbury Franks to the New England colonies, and to Philadelphia where he eventually settled. Then, when the Revolutionary War broke out, he became active in public affairs, joined the Army, and became major of a regiment. In May 1778, he was appointed aide-de-camp to General Benedict Arnold, and was entrusted with the military correspondence to General Washington.

When Arnold was tried for treason, Franks was implicated, but the military tribunal completely acquitted him from all suspicion in the case. Major Franks continued to serve in the Army with distinction and was raised to the rank of Colonel.

He was then sent on several important diplomatic missions to Europe, and in 1784, was appointed American Consul at Marseilles. In 1785, he accompanied the American agent in France to Morocco to negotiate a treaty of peace and commerce with the Emperor on behalf of our government. The treaty was concluded early in 1787 and brought to America by Colonel Franks. He died about 1794.

The miniature of Colonel Franks, owned by Mrs. Clarence I. De Sola, was painted by Peale at Valley Forge for seventy-five dollars. This is authenticated by Horace W. Seller's list of Peale portraits from the artist's own Memorandum Book, 1778-1798, of which there is a transcription in the *Pennsylvania Magazine of History and Biography,* April, 1904.

Colonel Franks' miniature, still in its original frame, is encased in glass on both sides. In bright contrast to his powdered hair is his coat of military blue. Colonel Franks presented his miniature to his sister Rebekah of

Montreal. She was the great-grandmother of Mr. Clarence I. De Sola.

Attributed to Charles Willson Peale is the miniature of Samuel Myers, now owned by Mr. William C. Preston, son of the late Mr. Edmund M. Preston.

Samuel Myers was born in New York City in 1754. His patriotic father, Myer Myers (1723-?), a banker and famed New York silversmith, was forced to flee to Connecticut upon the occupation of New York by the British. Samuel Myers' mother was Elkaleh Cohen, the first wife of Myer Myers.

The elder Myers had banking interests in Holland, and his son Samuel went there in 1790 to engage in the family business. He was devoted to his sister Judith, and kept up a lively correspondence with her while he was abroad.

Upon Samuel's return from Holland, he married Judith's intimate friend Sarah Judah, whose initial "S" on some of the family silver is the only record preserved. She died in 1795, childless, about a year after her marriage.

In 1796, Samuel Myers married Judith Hays of Boston, daughter of Moses Michael Hays. They settled in Richmond. Samuel Myers was one of the early directors of the First National Bank in Virginia. He was a member of the Richmond Amicable Association, a social organization, which also engaged in much charitable work. Among its members were John Marshall (afterwards Chief Justice) and the famous "Parson" Buchanan.

Samuel Myers died in Richmond in 1836. His children were Samuel Hays and Gustavus Adolphus, lawyers; Henry, who became a physician; Rachel, who married Commander Joseph Myers, an invalid; and Ella and Rebecca Hays Myers, who remained unmarried and made their home with Rachel.

Samuel Hays Myers married Eliza Kennon Mordecai, daughter of Jacob Mordecai, at one time president of Beth Shalome Congregation. Their son, Edmund T. D. Myers, was not a member of the Congregation. Caroline, daughter of Edmund T. D. Myers, married Edward Cohen, of Baltimore, afterwards of Richmond. For many years he served on the Board of Beth Shalome; he was secretary of the Congregation, and a member of the Cemetery Committee.

Henry, son of Samuel Myers, died unmarried, and Gustavus married Mrs. Anne Augusta Conway, a widowed daughter of Governor Giles. Their son was William Barksdale Myers, an artist, who married Mattie

Paul. Mrs. Richard Frothingham O'Neil of Boston, and Mrs. John Hill Morgan, of New York, are daughters of that union.

The tiny miniature of Samuel Myers, originally in a jewelled ring, is now set in a modern watchfob. It shows Myers as a young man in pow-dered hair or wig, with a rolled curl over one ear. He has large eyes and a prominent nose, a strong chin, and a small and firm mouth. He wears a stock collar with jabot and little rosettes.

The artist, Charles Willson Peale, was born in Queen Anne's County, Maryland, April 15, 1741. He consulted Copley early in his career, and went to London in 1768 where he studied with Benjamin West. On his return he resided in Philadelphia, joined the Continental Army and par-ticipated as an officer in the Battles of Trenton and Germantown. He painted fourteen portraits of Washington from life. Peale died in Phila-delphia, February 22, 1827.

The miniature of Barnard Gratz was sent to me for examination by Dr. Jacob R. Marcus of Hebrew Union College, Cincinnati. Barnard Gratz was born in Germany in 1738. He came to Philadelphia when he was about seventeen years of age, and entered later into a business partner-ship with his brother Michael. Together they engaged in many financial enterprises including the exploitation and development of western Pennsyl-vania, Virginia, Illinois and Kentucky. Barnard married Richea, daughter of Samuel Myers Cohen. Their daughter Rachel, born in 1764, became the second wife of Solomon Etting of Baltimore; another daughter, Fanny, died at an early age.

From the beginning of hostilities between the Colonies and England, the Jews took an active part in the patriotic cause. Gratz was one of the merchants of Philadelphia to sign the Non-Importation Resolutions in 1765. After the outbreak of the Revolutionary War, he took the oath of alle-giance to the Commonwealth of Pennsylvania. Mr. Gratz became a trustee of Mikveh Israel Congregation, Philadelphia. He died in Baltimore, April 20, 1801.

The unframed miniature of Barnard Gratz is a tiny piece of work. An inscription on a bit of paper on the back of the miniature indicates the name of the sitter, and the artist as Charles Peale Polk. It came from the estate of the late Albert Rosenthal, a well-known artist of Philadelphia, and was bought at auction in New York from Mr. Benjamin Rosenzweig.

The sitter is shown wearing a plum-colored coat, with white stock and frill. He has gray hair and blue eyes and the background is in blue-gray.

Charles Peale Polk, 1767-1822, also painted a large portrait of Barnard

Gratz which is reproduced in *Portraits of Jews*. Polk, nephew of the noted artist, Charles Willson Peale, is celebrated for having painted some fifty portraits of Washington from memory.

The miniature of Joseph Solomon by Philippe A. Peticolas is in the Maryland Historical Society. Joseph Solomon was born in London in 1700. He married Bilah Cohen. They resided in Lancaster, Pennsylvania, where Mr. Solomon was a merchant. Shinah, their eldest daughter, married Elijah Etting. Joseph Solomon died in 1780.

His miniature represents him wearing a brown suit and gray wig. He is of fair complexion and has blue eyes.

The artist, Philippe A. Peticolas, was born in 1760 in France. He emigrated to Santo Domingo before 1789. He then sailed for Philadelphia, resided there and in Lancaster, and removed in 1805 to Richmond, where he died in 1843. Most of his miniatures were painted in or near Richmond and they are generally signed.

The miniature of Joseph Solomon is listed in the *Handlist of Miniatures in the Collection of the Maryland Historical Society,* as by Peticolas. In the *Art Quarterly,* Autumn 1944, R. P. Tolman also says that it was by Peticolas. If Peticolas painted this miniature in 1780, the year of Solomon's death, the artist was then only twenty years old. But the miniature shows Solomon to be considerably younger than eighty!

The miniature of Elihu or Elijah Etting by Philippe A. Peticolas is owned by the Pennsylvania Academy of the Fine Arts. Elijah Etting was born in Frankfort-on-the-Main, Germany, in 1724. He came to America in 1758. The following year he married Shinah, daughter of Joseph and Bilah Solomon, of Lancaster, Pennsylvania. Their children were Reuben, Solomon, Fanny, Kitty, Hetty, Betsy, Sally and Joseph. The family resided in York, Pennsylvania, where Elijah engaged in extensive trade with Indians. He died in York in 1778.

Elijah Etting's miniature was in the Loan Exhibition of Historical Portraits at the Pennsylvania Academy of the Fine Arts in 1887, and was also exhibited there in December 1911, in the Tenth Annual Exhibition of Miniatures. It was presented to the Academy by Mr. Frank Marx Etting.

In this miniature, set within a plain gold frame, Etting is portrayed wearing a gray-brown coat and neckcloth tied with a full white bow. The curls of his powdered hair or wig cluster at the nape of the neck, where they are tied with a narrow ribbon. His eyes are blue, and a lock of his own brown hair, bound with seed pearls, is under glass at the back of the miniature. The face of the miniature is signed and dated by the

artist. It is interesting to note that the miniature bears the signature of the artist and the year 1799. However, Elijah Etting allegedly died in 1778. This disparity still needs definitely to be resolved.

Painted by James Peale are the lovely miniatures of Mr. and Mrs. Reuben Etting. Both of these miniatures are owned by the Pennsylvania Academy of the Fine Arts, presented by Mr. Frank Marx Etting in 1886.

The Etting name was prominently associated in national and civic affairs in Maryland, Pennsylvania, New York and Connecticut.

Reuben Etting was born in York, Pennsylvania, in 1762, the son of Elijah and Shinah (Solomon) Etting. A well-known brother was Solomon Etting. In 1798, Reuben was commissioned Captain of the "Baltimore Independent Blues." In 1801, Thomas Jefferson appointed him United States Marshal for Maryland. He died June 3, 1848.

The Reuben Ettings were the parents of Elijah Gratz Etting, who became District Attorney of Cecil County, Maryland. Benjamin, another son, was engaged in the sale of iron products. Henry was Commodore in the United States Navy; Horatio was a real estate operator; Edward Johnson was an iron manufacturer and merchant and father of Captain Charles Etting and Lieutenant Theodore Etting, officers in the Civil War.

The miniatures of Mr. and Mrs. Reuben Etting were exhibited in the Loan Exhibition of Historical Portraits at the Pennsylvania Academy of the Fine Arts in 1887. The introductory note of the catalogue of this exhibition is worthy of mention. It was written by Charles Henry Hart, an art critic of Jewish faith, and among the first literary men in the States to grasp the historical significance of American portraiture.

He wrote: "Collections of this kind are not only entertaining but instructive. They are historically valuable in making us acquainted with the appearance and personal influence of the men and women of past generations, and they are artistically valuable in showing to students in the broadest sense of the word the method of pose, composition, and technique of our foremost portrait painters."

The Etting miniatures were also included in the Tenth Annual Exhibition of Miniatures, in 1911, at the Pennsylvania Academy.

Reuben Etting's miniature in a small oval represents him with gray hair, possibly a wig. He has a most pleasing face; especially noticeable are the large orbits of his gray eyes, his well-shaped nose, mouth and chin. He wears a plum-colored coat, a white ruff and vest. The miniature set in a thin gold frame is signed and dated by the artist.

James Peale was born in 1749 in Chestertown, Maryland. He was a

Captain in the Continental Army and a member of the Maryland Society of the Cincinnati. After the War he pursued his profession, chiefly as a miniature painter, in which he had been instructed by his brother, Charles Willson Peale. James Peale's work is characterized by a delicacy of color which he used very successfully on luminous backgrounds. Nearly all of his miniatures are signed I P or J P. Peale had six children. A daughter, Anna Claypoole, was also a miniature painter. He died May 24, 1831, in Philadelphia.

Mrs. Reuben Etting, whose maiden name was Frances Gratz, was born in 1771, the daughter of Michael and Miriam (Simon) Gratz. She died in 1852.

Her miniature, set in a thin gold frame, is signed and dated by the artist. Mrs. Etting was not as conventionally beautiful as her sisters, Rebecca and Rachel, but her small face, with its dark eyes and aquiline nose, reflects an interesting personality. Her dark brown hair, entwined by a string of pearls, falls in a lock over the shoulder down to her low-cut purple bodice, ruffled in sheer white.

Most exquisite is the miniature by James Peale of Mrs. Moses Sheftall, wife of Dr. Sheftall. Her maiden name was Nellie Bush. The miniature is signed and dated. In 1927 it was included in an exhibition of miniatures at the Metropolitan Museum of Art, where it is now on loan.

This miniature reproduced in *American Miniatures,* by Harry B. Wehle, was incorrectly labeled as a portrait of Mrs. Mordecai Sheftall. It was similarly labeled when reproduced in an article on James Peale in *Art in America,* August 1931, by Frederic F. Sherman.

Of predominating interest in Mrs. Sheftall's miniature is the gray-powdered coiffure in pompadour, falling on the ears, with a curl over each shoulder. She has hazel eyes and smooth complexion. Her blue dress is pictured with a white ruffle. The background is gray. The miniature, formerly owned by a descendant of the sitter, the late Mrs. Walter M. Brickner of New York, is now the property of her sister-in-law, Mrs. Edmund H. Abrahams of Savannah, Georgia.

Mrs. Walter M. Brickner, born Perla Solomons Abrahams, was a direct lineal descendant of Abraham Isaacks, first recorded in New York in 1697; of Moses Michaels, a resident of New York in 1711, and of Judah Mears, who lived in New York in 1723.

Mrs. Edmund H. Abrahams also owns the miniatures of Mr. and Mrs. Mordecai Sheftall, née Frances Hart. Mordecai Sheftall was Commissary

General of Issues in the Revolutionary War. Their unattributed minia-tures were painted from large portraits which were destroyed.

Mrs. Perla Sheftall Solomons, grandmother of Mr. Edmund H. Abra-hams and granddaughter of Mordecai Sheftall, owned a number of oil paintings of various members of the family. She directed that these por-traits be interred with her at the time of her death, which was accordingly done.

# IV

## SOME UNATTRIBUTED MINIATURES

AMONG the miniatures of American Jews, there are many which, unfortunately, remain unattributed. Most of these were painted with meticulous care and are none the less interesting and valuable. According to Mr. Harry B. Wehle, the circular little portrait of Joseph Andrews was probably painted by one of the French miniaturists working in New York or Philadelphia.

Mr. Andrews was born in New York City in 1750. He married Sally Salomon, daughter of Haym Salomon, who rendered important financial assistance to the cause of the Revolution. Mr. and Mrs. Joseph Andrews were the parents of seventeen children. Joseph I. Andrews, a son, married Miriam Nones of New York, daughter of Major Benjamin Nones of Revolutionary fame. The daughter of that union was Mrs. E. L. Gold-baum of Memphis, Tennessee. Joseph Andrews was engaged in banking business. He died in Philadelphia in 1824.

The miniature of Joseph Andrews is painted against a blue-gray back-ground. He wears a medium-blue coat, a white blue-sprigged waistcoat, and ruffled shirt. His eyes are brown, the hair and eyebrows are gray, possibly powdered.

Miss Florence Dreyfous, who presented the miniature to the Museum of the City of New York, is a great-granddaughter of Joseph Andrews. She inherited the miniature from her grandparents, Simeon and Esther Andrews Dreyfous.

The miniature of Mrs. Joseph Andrews is also unattributed. She was born in 1779 in Philadelphia, where she died in 1854. Her miniature, too, was presented to the Museum of the City of New York by Miss Florence Dreyfous. It is a tiny oval, mounted as a pin. She wears a white head-dress, a pearl necklace and pendant earrings. Her eyes are hazel, her hair black, and she is high complexioned. The background is grayish brown.

Unidentified miniatures of a lady and gentleman, members of the Andrews-Dreyfous family, are in the possession of Miss Florence Dreyfous. They were inherited from her grandparents. As these miniatures from their technique, costume and framing, appear to have been painted later than other miniatures of Miss Dreyfous' family, I am inclined to think

they depict her grandparents, Simeon and Esther Andrews Dreyfous.

The gentleman wears a dark-colored suit and dark neckcloth relieved by a light waistcoat. He has blue eyes and light brown hair. The background is a purple-gray.

The lady is represented in a black bodice, cut low in the form of a wide spreading vee. Her eyes are light brown as is her hair, which is worn high and in curls at the sides. Her earrings are long and coral-colored. The background is a pinkish gray. Both miniatures are framed alike, encircled in elaborately chased gilt in black ribbed-wood frames.

Also unattributed is the miniature of Isaac De Lyon, owned by Mr. Thomas J. Tobias of Charleston, South Carolina. According to family papers, Isaac De Lyon emigrated from Portugal to Savannah, Georgia, where in 1764 he was a trustee of Mikve Israel Congregation. He married Rinah Tobias, daughter of Joseph and Leah de Oliverah Tobias, of Charleston. They had three children: Abraham, Esther and Judith. About 1779, Isaac De Lyon removed to Charleston, where he was a saddler. After the Revolution, his property was amerced, as he was a known Tory. His name appears on the records of K. K. Beth Elohim Synagogue in Charleston in 1802.

The miniature of Isaac De Lyon, now on loan at the Gibbes Art Gallery in Charleston, depicts him in a three-quarters view, wearing a powdered wig, cut *en brosse* on top with curls over each ear. His heavy lidded brown eyes are turned to the spectator. His nose and chin are long and he has smiling lips and ruddy complexion, with a bluish shadow around the cheeks. He wears a white waistcoat and stock with his Prussian blue coat. The background is greenish-gray. Engraved on the back of the narrow gold frame are his initials I.D.

The miniature of Judith De Lyon, daughter of Isaac De Lyon is also unattributed. Judith was born, probably in Savannah, Georgia, in 1748. She married Moses Cohen, who came to Charleston from London, England, in 1772. They had two children, Rhina and Bella. Judith De Lyon died in Charleston in 1816, and is buried there in the Coming Street Cemetery.

Mr. Thomas J. Tobias owns the miniature of Judith De Lyon, now on loan at the Gibbes Art Gallery in Charleston. Painted when she was about sixty years of age, the miniature depicts her in a three-quarters view wearing a white cap, flat on top and tied at the left. She has brown eyes and heavy brows; a fleshy nose, thin up-curved lips, rosy complexion, and gray-black curly hair. The background is a bluish-green.

Owned by the Newport Historical Society is the miniature of Abraham

Touro. He was born in Newport, Rhode Island, in 1774, the son of Reverend Isaac Touro and Reyna Hays of Boston.

Abraham Touro's father, the first minister of the historic Touro Synagogue of Newport, was of Portuguese origin. He settled in Jamaica, but came to Newport about 1760 to serve the Jewish congregation. During his residence there he became a close friend of Ezra Stiles. About 1780, after the British left Newport, Reverend Isaac Touro and his family moved to Kingston, Jamaica, where he died shortly afterwards. Mrs. Touro then returned with her children — Judah, Abraham, and a daughter, Rebecca; another son, Nathan, had passed away. They made their home in Boston with Moses Michael Hays, Mrs. Touro's brother. When Mrs. Touro passed on in 1787, the children were reared by their uncle.

Rebecca Touro subsequently married Joshua Lopez, son of the merchant-prince, Aaron Lopez, of Newport. Abraham Touro and his brother, Judah, remained bachelors.

Abraham Touro lived for some time in Medford, Massachusetts, where he entertained with lavish hospitality many distinguished persons, including his neighbor, Governor John Brooks. Touro's mansion was conveniently situated close to the canals, on a site near the present Touro Avenue, with approach to the open sea, where he could easily pursue his shipping interests. His vessels were known in many a port plying between Boston and the West Indies. A relic of his home — an iron fireback — was taken from the chimney and given to the Royall House Association in Medford.

On October 3, 1822, Abraham Touro met with a tragic accident while viewing a military parade in Boston. When his horse suddenly became frightened and unmanageable, Mr. Touro leaped from his chaise and fractured his leg. This accident was responsible for his death on the 22nd of October. He is interred in the old Jewish Cemetery in Newport, made immortal by the words of Longfellow in his poem, *Jewish Cemetery at Newport.*

> "Gone are the living; but the dead remain,
> And not neglected; for a hand unseen,
> Scattering the bounty, like a summer rain,
> Still keeps their graves, and their remembrance green."

Touro Synagogue in Newport, built by Peter Harrison, Colonial architect, is maintained in its original simplicity, in splendid condition, by a fund which Touro left for its support. Among his other numerous be-

quests were funds for repairing and preserving the street, known as Touro Street, leading from the Jewish Burying Ground to Main Street. One of the institutions to benefit by his will was the Massachusetts General Hospital, which was bequeathed ten thousand dollars. There Touro's large portrait by Gilbert Stuart may be seen.

Abraham Touro's miniature, simply framed in gold with an O hook, was presented to the Newport Historical Society by twenty-six unnamed donors. It represents Touro in his youth. Large expressive brown eyes, with strongly marked eyebrows, are set far apart. His nose and mouth are well-defined; the cheekbones are high, and his broad face tapers to a pointed chin. His hair is brown and long to the nape, and over his forehead are string-like bangs. He wears a dark blue coat with a brown dotted white vest and white stock with long bow-tie. The background is in gray-blue.

Unattributed is the miniature of Rabbi Gershom Mendes Seixas owned by his great-granddaughter, Mrs. Annie Nathan Meyer, of New York City.

Rabbi Seixas was born in New York City, January 14, 1745. He was the son of Isaac Mendes Seixas and Rachel Levy, daughter of Moses Levy. The first wife of Rabbi Seixas was Elkalah Cohen, whom he married in 1775; his second wife was Hannah Manuel whom he married in 1789.

As an ardent patriot during the Revolutionary War, he protested taxation without representation. When the British were about to enter New York, he closed Synagogue Shearith Israel, of which he was minister, rather than fly the British flag. In 1789, after the Revolution, George Washington invited him, together with thirteen other clergymen, to his inaugural in New York. At this ceremony Rabbi Seixas offered a prayer invoking God's blessing upon the First President and the new nation. Rabbi Seixas was a trustee of Columbia College. He died in New York in 1816.

The late Mrs. Annie Nathan Meyer was a trustee of Barnard College. Another distinguished great-granddaughter was Mrs. Maud Nathan. The late Associate Justice Benjamin Nathan Cardozo of the Supreme Court of the United States was a great-great-nephew of Rabbi Seixas.

Rabbi Seixas' miniature depicts him in clerical robes with slate pencillings on buttons, closure and collar. He has dark brown eyes and natural complexion. The background is in robin's-egg blue. The miniature still in its original frame was set to be worn as a brooch or to be hung from a chain.

The miniature of Uriah Hendricks was bequeathed by Mrs. Lucian Florance to her niece, Mrs. Beatrice M. Phillips, great-granddaughter of the sitter. It is now owned by Mrs. Laurence Frank, of New York. It is reproduced here by courtesy of the Frick Art Reference Library.

Uriah Hendricks was born in Holland in 1737. He emigrated from London to New York about 1755 and became a prosperous merchant. His first wife was Eve Esther, daughter of Mordecai Gomez, whom he married in 1765. After thirteen years of marriage, during which time they had eight children, Mrs. Hendricks passed away. He later married Rebecca Lopez, daughter of Aaron Lopez. Uriah Hendricks died in 1798.

His miniature represents him against a brown background. He wears a black coat; his hair and eyes are dark brown.

The miniature of Joshua Isaacs is owned by Mrs. Benedict Bruml, of Long Island City, New York. The illustration is by courtesy of the Frick Art Reference Library.

Bible records in an article in *The Saint Charles Magazine*, January 1935, show there were two Joshua Isaacses living in the American Colonies in the Eighteenth Century. The second Joshua was a posthumous child of the first.

Joshua the First was the son of Joseph Isaacs, 1659-1737. Bible entries confirm the marriage of Joshua the First to Hannah, daughter of Moses Levy of New York.

Joshua Isaacs the Second was born in 1745. In 1781 he married Brandly Lazarus, daughter of Sampson Lazarus, a shopkeeper in Lancaster, Pennsylvania. A daughter, Frances, was born in 1783; Solomon was born in 1786. Joshua Isaacs the Second was a prominent member of Shearith Israel Congregation, New York. He died in 1810.

It becomes evident from the Bible inscriptions, as well as from the resemblance to a portrait which illustrates the same article in *The Saint Charles Magazine,* that the miniature of Isaacs presented here is of Joshua Isaacs the Second.

He is depicted against a brown background. He wears a bright blue coat and has grayish hair, hazel eyes and very pink spotty cheeks.

From Mrs. August Kohn, of Columbia, South Carolina, I received the photograph of the miniature of her great-great-grandfather, Abraham Moise. Mrs. Kohn wrote that the miniature formerly belonged to Penina Moise, the poetess, who was Abraham's daughter.

Mr. Moise, born in Alsace, was the first member of his well-known family to settle in this country. He emigrated to Santo Domingo, West

Indies, where he married a Jewess, Sarah. In 1791, when a native insur-
rection occurred in Santo Domingo, Mr. and Mrs. Moise escaped in the
dead of night from the Island and set sail for these shores, arriving in
Charleston, South Carolina. Their sons Aaron, Benjamin, Cherie, and
Hyam were with them. Three other sons and two daughters were born to
them in Charleston. Abraham Moise died in Charleston in 1809, and his
wife died there on April 15, 1842.

Their gifted daughter, Penina, was only twelve years old when her
father passed away, and because of the family's financial straits, she was
obliged to give up her schooling. She became a regular contributor to
various publications, and was called upon to celebrate in verse many local
important events.

Aaron Moise, the eldest son, became cashier of the Bank of the State
of South Carolina. Benjamin died unmarried. Abraham, the first of the
Moise family born in America, married Caroline, granddaughter of Meyer
Moses. Cherie Moise married Hetty Cohen of Charleston; Hyam Moise
married Cecilia Wolfe of the same city. I have no record of the remaining
children.

The miniature of Abraham Moise shows him wearing a richly colored
dark blue velvet coat with white waistcoat and a ruffled jabot. He has blue
eyes and gray hair, and two little wens, one under the other on his right
cheek.

Unattributed are the miniatures of Mr. and Mrs. Daniel Hart. Mr.
Hart's miniature is owned by Mrs. David Hart of Denmark, South Caro-
lina. It was included in an exhibition of miniatures painted before the
year, 1860, held at the Carolina Art Association in 1935.

Daniel Hart resided in Charleston in 1782 where he was a leader in the
Congregation Beth Elohim. He was appointed Consul for Holland in
Charleston. He died in 1810.

In his miniature, Daniel Hart appears to be in middle life. His white
hair is parted in the middle and falls loosely to his narrow sloping shoul-
ders. His dark buttoned coat is open, revealing a double-breasted white
waistcoat. Dark, shaggy eyebrows frame the glowing eyes of his small face
with its dimpled chin.

At one time the miniatures of Mr. and Mrs. Daniel Hart were in posses-
sion of Miss Isabel Cohen of New York. She wrote me that the miniatures
were buried during the Civil War. Mr. Hart's miniature remained in a
good state of preservation, but Mrs. Hart's was nearly obliterated. I do
not know who now owns Mrs. Hart's miniature.

The miniature of Naphtali Phillips is now owned by his grandson, Captain N. Taylor Phillips of New York. The sitter, son of Jonas and Rebecca Mendes (Machado) Phillips, was born in New York City, October 19, 1773. His maternal grandfather was Rev. David Mendes Machado, who was minister of the Spanish and Portuguese Synagogue on Mill Street, now South William Street, from 1737 to 1747.

When Naphtali was but three years old his parents fled with him from New York to Philadelphia, after the Battle of Washington Heights, November 1776, when New York was occupied by the British. His father, Jonas Phillips, an ardent patriot served as a soldier in the Revolutionary Army. The family continued to reside in Philadelphia until after the War, where the elder Phillips was president of Mikveh Israel Synagogue.

When George Washington was inaugurated, Naphtali Phillips was sixteen years old and was among the cavalcade escorting Washington from Philadelphia to New York for the ceremony.

Naphtali Phillips married Rachel Hannah Mendes Seixas in Newport, Rhode Island, in 1797. She was the daughter of the prominent merchant and banker Moses Mendes Seixas. The house in which they were married is still standing. It became the residence of Commodore Oliver Hazard Perry, of the United States Navy, hero of the Battle of Lake Erie in the War of 1812. Later the house was occupied by August Belmont, Sr., New York banker, and American correspondent of the Rothschilds, who married a daughter of Commodore Perry. The house is now occupied by the Salvation Army.

Mr. and Mrs. Phillips took up their residence in New York about 1801 where he became the proprietor of the *National Advocate,* the leading New York newspaper.

After the death of his wife in 1822, Naphtali Phillips married in the following year, his late wife's cousin, Esther Seixas. She was the daughter of Lieutenant Benjamin Mendes Seixas, one of the founders of the New York Stock Exchange.

Besides being President of the Spanish Synagogue, Shearith Israel, for fourteen terms, Naphtali Phillips participated in local communal affairs. He was an active member of the Democratic Party in New York City and served as a member of the Tammany Society for nearly three-quarters of a century.

Mr. Phillips died November 1st, 1870. As a mark of respect to his profound piety and long and loyal service to his people, his funeral was held in the vestibule of Shearith Israel Synagogue. For over two and one-

half centuries no one else except the ministers of the Congregation was thus honored.

His miniature is one of extraordinary beauty and excellent workmanship. Deep set and wide apart are his small blue eyes. The hair is short cropped and gray. He wears a dull-red coat with gray-blue velvet collar. The revers of his waistcoat are embroidered. His stock collar is tied with a gracious bow. The background of the miniature is gray. His hair under glass is in back of the miniature which is framed with an ornate gold rim.

The miniature of Mr. Phillips' first wife, Rachel Hannah Mendes Seixas, is also owned by Captain N. Taylor Phillips. She was born in Newport, Rhode Island, August 9, 1773. Her father, Moses Mendes Seixas, was a brother of Reverend Gershom Mendes Seixas. Her mother was Jochebed Levy, daughter of Benjamin and Judith Levy.

In 1790, Rachel's father, Moses Mendes Seixas, as Warden of the Hebrew Congregation in Newport, delivered a famous formal address to George Washington on his visit to the city, August 17. The stirring address read in part:

> Deprived as we heretofore have been of the invaluable rights of free citizens, we now (with a deep sense of gratitude to the Almighty Dispenser of all Events) behold a Government erected by the Majesty of the People — a Government, which to bigotry gives no sanction, to persecution no assistance — but generously affording to All liberty of conscience, and immunities of citizenship; — deeming everyone, of whatever nation, tongue, or language, equal parts of the great Government machine.

George Washington's reply to this address contained one of Mr. Seixas' very phrases as he said:

> For happily the Government of the United States which gives to bigotry no sanction, to persecution no assistance, requires only that they who live under its protection should demean themselves as good citizens, in giving it on all occasions their effectual support.

Mrs. Phillips is represented in miniature painted during her middle years. Posed in a three-quarters view she wears a blue dress with red scarf and a dainty lace cap, of simple circular design, from which tight curls emerge over her forehead and ears. Her lace fichu is delicately rendered.

[ 30 ]

Unattributed is the handsome miniature of John Solomons. When I examined it the miniature belonged to Miss Aline Solomons of Washington, D. C., the granddaughter of the sitter. It is now owned by Captain N. Taylor Phillips of New York.

John Solomons was born in England, December 17, 1788. He married Julia, daughter of Simeon and Hetty Levy in 1818, after emigrating to the United States in 1810. They were the parents of the Honorable Adolphus Simeon Solomons of New York and Washington. John Solomons died September 19, 1858, in his home at 44 Bank Street, New York.

His miniature represents him wearing a slate black coat; his winged collar has a small bow tied in captivating fashion. His eyes are brown as is also his hair which is exquisitely brushed over the temples. The background is a blue-gray. The miniature is set in a simple beaded gold frame. On the reverse are his initials, J S, and a bit of hair under glass.

The miniature of Adolphus Simeon Solomons, done when he was nineteen months old, is also unattributed. It is now owned by Captain N. Taylor Phillips, New York, whose wife was a daughter of Mr. Solomons.

Adolphus S. Solomons was born in New York City, October 26, 1826, the son of John and Julia (Levy) Solomons. When he was fourteen years old he enlisted as a color-guide in the New York State National Guard and five years later he became a sergeant. Solomons received his education at the University of the City of New York.

In 1851, he married Mrs. Rachel Seixas Phillips of New York. Daniel Webster was then Secretary of State and appointed Solomons "Special Bearer of Despatches to Berlin." On his return from Germany, Solomons became active in charitable institutions. He was one of the founders of the present Mt. Sinai Hospital, and advocated the establishment of the Montefiore Home for Chronic Invalids. He became general agent of the Baron de Hirsh Fund, was a member of the central committee of the Alliance Israélite Universelle and later its treasurer for the United States.

Solomons was also identified with communal affairs in Washington, and at his home there, the National Association of the Red Cross was incorporated. For seventeen years he served the Red Cross as an active member, and in 1881 President Chester Arthur appointed him and Clara Barton to represent the United States Government at the International Congress, which was held in Geneva, Switzerland. Solomons was elected vice-president of that congress. He was still on the executive board during the Spanish-American War when the Red Cross ministered the needs of our soldiers. He died in Washington, March 18, 1910.

In his miniature he wears a white dress, with dropped shoulder lace ruffles and coral-colored bows, a high sash, and crinkled double-strand coral necklace. From a light blue background emerges the heart-shaped face of the child with eyes set wide apart and reddish brown hair. The miniature is ornately framed.

Another unattributed miniature is that of Mrs. Zalegman Phillips. Her maiden name was Arabella Solomon. She was born in 1786, the daughter of Myer S. and Catherine (Bush) Solomon of Baltimore. In 1805, Arabella married Zalegman Phillips, son of Jonas and Rebecca Mendes (Machado) Phillips.

Zalegman Phillips was graduated from the University of Pennsylvania in 1795, and became one of the leading criminal lawyers of Philadelphia. Mr. and Mrs. Zalegman Phillips were the parents of nine children, two of whom, Henry Mayer Phillips and Jonas Altamont Phillips, became prominent lawyers. Mrs. Phillips died in 1826.

The miniature of Arabella Phillips is owned by a great-granddaughter, Mrs. William Moran of Sumter, South Carolina. She is depicted as rather a young woman of fair complexion with black curly hair. Her black dress is draped about her right shoulder with a red scarf. The miniature has a soft feminine quality such as we associate with the work of Sully, Inman or the later Peales. It is encased in red leather, lined with white satin, mellowed by time. Before the miniature came into possession of Mrs. Moran, it was owned by her aunt, Arabella Phillips Moses.

The miniature of Solomon Etting in the Eleanor S. Cohen Collection of the Maryland Historical Society is in water color on paper. He is described as wearing a blue suit. His grayish-brown hair is puffed at the top of his head, and he has a ruddy complexion. The neckcloth, bow, and pleated ruffle, as well as the frame, are almost identical with the miniature of Solomon Etting by Benjamin Trott, which is in the Pennsylvania Academy of Fine Arts. The miniature in the Academy has a more pleasing expression.

There is another miniature of Solomon Etting in the Maryland Historical Society which is in profile. In a letter I received from Miss Eleanor S. Cohen when I was working on *Portraits of Jews,* Miss Cohen wrote that this miniature was considered to be by Trott. It is now recorded in the *Handlist of Miniatures* of the Maryland Historical Society as unattributed. In this miniature Etting wears a blue suit; he has a ruddy complexion, blue eyes, and gray hair.

In the Maryland Historical Society is a miniature of Rachel Gratz. She was the daughter of Barnard and Richea Gratz, of Philadelphia. Rachel, born in 1764, became the second wife of Solomon Etting. She died in Baltimore in 1831.

She is represented wearing a white dress, loosely frilled along the collar line. Noticeable are her large blue eyes, set far apart, and arched brows. She has a fair complexion, a well-shaped long nose, small mouth and long full chin. Her light-brown hair, curling to the shoulders, is fluffed over the middle of her forehead.

In the American Jewish Historical Society is a miniature of Judah Eleazer Lyons, son of Eleazer and Hannah (Levy) Lyons. Judah Lyons was born in Philadelphia in 1779. His wife was Mary, daughter of Samuel Asher Levy of Surinam, South America. The couple had nine children, four of whom died at an early age. The surviving children were Asher, Henry, Samuel, Reverend Ellis Lyons of Richmond and New York, and Reverend Jacques J. Lyons of Shearith Israel Synagogue, New York. Judah Lyons died in New York City, August 29, 1849.

His miniature represents him as a determined looking individual, in early manhood, wearing a dark coat and waistcoat with stock collar and bow tie. His curly close-cropped hair is worn with sideburns.

Also unattributed is an exquisitely painted miniature of Benjamin Etting owned by the Pennsylvania Academy of Fine Arts. Benjamin, born in 1798, was the son of Reuben and Frances (Gratz) Etting. He married Harriet Marx, daughter of Joseph and Richea (Myers) Marx, of Richmond, Virginia. He was engaged in the sale of iron products. Benjamin Etting died in 1875.

The Benjamin Ettings were the parents of Lieutenant-Colonel Frank Etting, United States Army. Another son, Frank Marx Etting, 1833-1890, practised law for some time, then entered the Army and was appointed paymaster with the rank of major. He continued in office throughout the Civil War. At the opening of the Centennial Exposition in 1876, he was elected its chief historian. Frank Marx Etting was also the author of *History of Independence Hall*.

Benjamin Etting's miniature exhibited at the Pennsylvania Academy of Fine Arts in 1887-1888, was on loan there, again, at the Tenth Annual Exhibition of Miniatures in 1911. Presented by Frank Marx Etting to the Academy, it is recorded as painted from life in Canton, China, by an unknown Chinese artist, in 1826. The miniature, set in a plain gold frame, shows Etting wearing a dark bluish-purple coat with four gold buttons,

a white neckcloth and yellow scarf. He has dark brown hair, dark eyes and a pale complexion.

The miniature of Isaac Lopez Brandon, contributed by Miss Blanche Moses of New York, is in the American Jewish Historical Society. He was the son of Abraham Rodriguez Brandon of the Barbados. His wife was Lavinia Brandon.

Isaac Lopez Brandon is depicted in miniature as a young man, wearing a blue-black coat and white waistcoat with fancy bow and stock collar. He has dark eyes and dark brown curly hair and sideburns. His handsome youthful face is enhanced by the pale-pink background, and the gold studded inner rim of the frame. The miniature was exhibited at the Museum of the City of New York in the Spring of 1935, when it was loaned by Miss Blanche Moses.

Isaac Brandon's sister, Sarah Brandon, was also painted in miniature. Presented by Miss Blanche Moses, it is in the American Jewish Historical Society. Sarah Brandon was born in the Barbados and educated in London, where Miss Moses says the miniature was probably painted. She married Joshua Moses, son of Isaac and Reyna (Levy) Moses. Miss Blanche Moses is a descendant of Isaac Moses.

The miniature of Miss Brandon was exhibited in the Spring of 1935, at the Museum of the City of New York. Her dark-brown hair is worn high with curls at either side of the forehead. Her eyes are brown. Her white bodice elaborately portrayed is tied with a sash. The background is painted a very delicate pinkish-blue. It is not unlikely that brother and sister were painted by the same artist.

The unattributed miniature of Jacob De Sola is owned by Dr. S. De Sola of New York. Jacob De Sola was born in 1800 in Curacao, Dutch West Indies, where he died in 1867. His wife was Leah C. Henriquez. He was descended from the De Sola family of Cordova, Spain, whose coat of arms bears the motto THE LORD IS MY SHEPHERD in Hebrew.

In this miniature Jacob De Sola wears a dark green velvet coat. He has jet black hair and dark brown eyes and slightly flushed cheeks. His collar is tied with a bow and an oblong-shaped scarfpin set with ruby stones adorns his pleated jabot. It is thought by the owner that the miniature may have been painted in Paris, France, when De Sola was about forty years old.

Just before the untimely passing of the late Mr. Edmund M. Preston of Richmond, Virginia, he had photographed for me two miniatures of his ancestor, Samuel Myers, which had been handed down in the family.

I have referred to one of these — the tiny miniature of Mr. Myers painted by C. W. Peale. The other miniature, Mr. Preston wrote, was thought to be painted by Gilbert Stuart. However, in an exhibition of Richmond Portraits, held in 1949, at the Valentine Museum, it was listed as unattributed.

After his marriage to Judith Hays of Boston in 1796, Samuel Myers settled in Richmond, where he built a home on Broad and Governor Streets, facing the Governor's Mansion and Capitol Square.

The gardens of his home, in the rear, ran down-hill to Shockoe Valley. Nearby was Edmund Randolph's house and the old Beth Shalome Synagogue, and a few blocks away the Wickham house. Mr. Myers' residence was of brick construction, large and square with lofty piazzas. The interior was noted for its carved and white painted woodwork, and gray marble fireplaces, with graceful fluted columns. Arched recessed book-shelves were on either side of the fireplace in the drawing room. Judge William Crump later purchased the place. Part of the garden was then sold, and on this ground several houses were erected — among them that of Commander Joseph Myers on Broad Street, and Mr. Gustavus A. Myers' home on Governor Street.

In *Records of the Myers, Hays and Mordecai Families from 1707 to 1913*, privately printed by Mrs. Edward (Caroline) Cohen, Samuel Myers is thus described:

> "His cold and dignified demeanor created an impression of severity which has become a tradition amongst his descendants. In appearance he was handsome, blue-eyed and fair, and very refined and elegant-looking, judging from his miniatures and his portrait by Gilbert Stuart, which show him both in youth and age."

The Stuart portrait is represented in *Portraits of Jews*. His miniature depicts him with his own gray hair — a man of advanced years with a very strong chin and glowing eyes. He wears a dark blue coat and white stock collar with dotted flowing tie. The background is brown. There is a bit of plaited hair under glass in the back of the miniature, which is set in a gold oval case with attached pendant. The miniature is now owned by Mrs. Edmund M. Preston.

Also unattributed is the miniature of Moses Mears Myers, now owned by Mrs. Brooke Mordecai of Madera, California. Mrs. Mordecai is a sister of the late Mr. Edmund M. Preston.

Moses Mears Myers, son of Myer Myers and his second wife, Joyce Mears, was born in 1771. He married Sally Hays, daughter of Moses

Michael Hays of Boston, September 21st, 1796. At the same time, Samuel Myers, a half-brother, married Judith, sister of Sally Hays. Both families settled in Richmond where they became well integrated in the community.

Three daughters, Catherine, Harriet and Julia were born to Mr. and Mrs. Moses Mears Myers. A nephew, Commander Joseph Myers, U.S.N., son of Samson Myers, was also brought up in their home. Joyce Mears Myers, mother of Moses Mears Myers, lived in her widowhood with her son. She died in Richmond, July 19, 1824.

Unfortunate investments depreciated Mr. Myers' fortune, as well as his wife's. His daughters inherited portions of their grandfather Hays' estate through their unmarried aunts, Catherine and Slowey Hays. Moses Mears Myers died in Richmond, in 1860 where he is buried in the old Hebrew Cemetery.

The miniature of Moses Mears Myers is set in a gold locket initialed M.M.M. His gray hair, bushy eyebrows, and well-shaped features, tender and refined are clearly delineated. He wears a closed coat, waistcoat, stock collar and frill.

# V
## EDWARD GREENE MALBONE

GREATEST of all American miniature painters was the genius Edward Greene Malbone, born in Newport, Rhode Island, August, 1777. He was the son of General John Malbone and a Mrs. Greene. Four other children were born to this alliance and the family lived in seclusion in Newport. Malbone's early life is revealed in a letter written by his sister, Mrs. H. Whitehorne to William Dunlap. This was published in Dunlap's *History*.

During Malbone's early years he kept much to himself, copying pictures and prints and drawing from nature. In the fall of 1794, he left home, went to Providence and began the practice of his art. The following year he attended his father's funeral in Newport and on his return to Providence, kept busy at his work until 1796 when he moved to Boston. The next few years were spent in New York and Philadelphia in profitable employment, and in the summer of 1800 Malbone returned to Newport, to be with Washington Allston, his boyhood friend. Allston in a letter says: "As a man his disposition was amiable and generous and wholly free from any taint of professional jealousy."

In the autumn of 1800 Malbone went to Charleston, South Carolina, where he met with great success as a miniature painter. His sitters were well-known, wealthy and aristocratic. The following year he went to London with Washington Allston. There he met Benjamin West, the dean of American artists and president of the Royal Academy. West regarded Malbone's work very highly and urged him to remain in England. For a short time Malbone studied at the Royal Academy and returned to America in December, 1801. Dunlap says that the improvement he made during his short visit was very evident, and after fulfilling his engagements in Charleston, he visited and painted in all our principal cities on the seaboard. His company and portraits were sought by all who could appreciate his conversation or his skill.

He again visited Charleston in December 1805, planning later to make a second trip to London. However, he contracted a cold which settled on his lungs and he returned to his home. As he continued in delicate health, upon the advice of his physician he sailed for Jamaica. He did not

improve there and started to return to Newport in May, 1807, but was not able to go further than Savannah, Georgia, where he died at the home of a cousin, Robert MacKaye.

The following inscription is on his tombstone in the Colonial Cemetery at Savannah:

Sacred to the Memory
Mr. Edward G. Malbone
The Celebrated Painter

Son of the late Gen. John Malbone of
Newport, R. I. He was cut off in the
meridian of his Life and Reputation
while traveling for the benefit of his
health. Seldom do the records of Mortality
boast the name of a victim more pre-eminently excellent:
His death has deprived his country of an ornament
which Age may not replace, and left a blank in the
catalogue of American Genius which nothing has a tendency
to supply. He closed his valuable life May 7, 1807, in the
29th year of his age.

Malbone's work was not surpassed by any other American miniaturist and it compared favorably with that of the English miniaturists — Samuel Cooper, Hans Holbein, John Smart and Richard Cosway, and with Isabey of France.

His early miniatures were generally signed in black in small block or script, as Malbone; E. G. Malbone; Edw. G. Malbone; Edward G. Malbone; or E. G. M. His later miniatures, generally larger than the early ones, were not signed.

Information about the Malbone miniatures of Solomon and Rachel (Gratz) Moses, David Moses and Rebecca Gratz was furnished by Miss Kathleen M. Moore, of Westmount, Province of Quebec. Miss Moore's great-grandmother was Rachel Gratz.

Rachel, born in 1783, was the daughter of Michael and Miriam (Simon) Gratz of Philadelphia. She married Solomon Moses of New York in 1806, and they became the parents of eight children. Three daughters and four sons reached maturity; one child died young. When Rachel passed away in 1823, her eldest child was but sixteen years of age.

One of her sons, Dr. Simon Gratz Moses, became a leading physician in St. Louis. He was professor of obstetrics in Missouri Medical College and president of the St. Louis Obstetrical Society.

Sarah Gratz Moses, a daughter of Rachel, and grandmother of Miss Kathleen M. Moore, married Jacob Henry Joseph of Montreal. Their son, Henry Joseph, took particular pride in the many Stuart and Sully portraits of his ancestors.

The miniature of Rachel Gratz, signed and dated by Malbone, is almost in complete profile. She has a high-bridge retroussé nose, beautifully shaped lips, and a small dimpled chin. Loose curls of her blonde hair, over the top of her head, fall gently to the nape of her neck, which is long and graceful. The background is painted in pale blue. Rachel's hair is woven in at the back of the miniature.

I was very fortunate when motoring through Savannah to have seen this exquisite example of Malbone's work, which is owned by Mrs. John Heard Hunter. She is a great-granddaughter of Rachel Gratz and inherited the miniature from her grandmother, Mrs. Cohen, née Miriam Gratz Moses, a daughter of Rachel Gratz Moses.

Mrs. Wharton writes in *Heirlooms in Miniatures* that a miniature of Rachel Gratz by Malbone was presented as a gift from him to Mrs. J. Ogden Hoffman. The miniature of Rachel Gratz by Malbone, owned by Miss Mordecai of Philadelphia was a copy painted in 1805. It was lent in 1911 by Miss Mordecai to the Pennsylvania Academy of Fine Arts for their Tenth Annual Exhibition of Miniatures. I have not been able to establish the present ownership of either of these miniatures.

The miniature of Solomon Moses, 1774-1857, painted by Malbone in 1806, is owned by Miss Kathleen M. Moore. She inherited it from her cousin, the late Miss Rachel Gratz Nathan of New York, whose mother, Rebecca Moses, was a daughter of Solomon and Rachel (Gratz) Moses.

This miniature was lent by Miss Nathan for an exhibition at the Metropolitan Museum of Art, in the Spring of 1927. It was also in an exhibition of Malbone's work at the National Gallery of Art, Washington, in 1929.

Mr. Moses is represented wearing a black coat, white waistcoat, stock and tie. He has black hair and pale blue eyes. The background is white, with gray at top and touches of blue, green and purple at lower left and right. It is reproduced by courtesy of the Metropolitan Museum of Art.

In both of above mentioned exhibitions was the miniature of David Moses (1776-1858), brother of Solomon Moses. David, a bachelor, resided in New York. He was the great-uncle of Rachel Gratz Nathan. The miniature is now owned by Miss Miriam Dent, of Hofwyl Plantation, Brunswick, Georgia, who inherited it from her cousin, the late Miss Rachel Gratz Nathan.

David Moses is painted against a background of blue sky with clouds; there are touches of purple at lower right and left. He wears a dark blue coat with gilt buttons; a white shirt and stock and waistcoat, revealing a light-blue fold. His hair is black and he has gray eyes. The miniature is reproduced by courtesy of the Metropolitan Museum of Fine Arts.

An unattributed miniature in profile of Isaac C. Moses, father of Solomon and David Moses is owned by Mrs. Carrie M. Serra. Isaac C. Moses was the maternal great-grandfather of Eleanor S. Cohen of Baltimore.

Malbone's miniature of Rebecca Gratz also was exhibited at the Metropolitan Museum in the Spring of 1927, and in the National Gallery of Art in 1929, lent by the late Miss Rachel Gratz Nathan. The catalogue of the latter exhibition lists another miniature of Rebecca* by Malbone, lent by Mrs. Thomas B. Gannet, now Mrs. Paul Hamlen, of Milton, Massachusetts. However, I do not consider this miniature to be a likeness of Rebecca Gratz. The same miniature is also incorrectly noted in *American Portraits Found in Massachusetts, Volume I,* published by the Historical Records Survey.

After Miss Kathleen M. Moore examined the photograph of the above miniature, she wrote to me that she did not think it represented a portrait of Rebecca Gratz.

A negative of this presumptive miniature of Rebecca is in the National Collection of Fine Arts, Washington, number 6220B, and Mr. Ruel P. Tolman, acting director there, shares my opinion. A letter from him says that it is very similar in coloring to that of Mrs. James Fleming and Mrs. Langdon Cheves, but not a miniature of Rebecca Gratz.

Mr. Mark Bortman of Newton, Massachusetts, now owns this miniature which he recently purchased, together with a number of other miniatures from Mrs. Paul Hamlen, at the Parke-Bernet Galleries, New York.

As the life of Rebecca Gratz has been most interestingly narrated by Rollin G. Osterweis in his book, *Rebecca Gratz,* I shall write only in brief about her.

She was born in Philadelphia March 4, 1781. Her father, Michael Gratz, 1740-1811, was a prominent merchant and patriot. Her mother, Miriam, was the daughter of Joseph and Rosa (Bunn) Simon of Lancaster, Pennsylvania.

Rebecca was one of a large family including seven brothers and four sisters. Two of the boys died in childhood; the surviving brothers were

---

* This miniature was recently exhibited as that of Rachel Gratz. It does not resemble her known miniature and, therefore, is not a convincing likeness.

Simon, Hyman, Joseph, Jacob and Benjamin. Her sisters were Frances, Richea, Sarah and Rachel.

Rachel and Rebecca Gratz were frequent visitors at the home of the Jeremiah Ogden Hoffmans of New York, where they became acquainted with a brilliant literary circle. Among the visitors they met, there, were William Cullen Bryant, James Fenimore Cooper, John Inman, brother of Henry Inman, the artist; Henry Tuckerman and Washington Irving. Irving was engaged to Mr. Hoffman's daughter, Matilda, to whom Rebecca was devotedly attached and whom she nursed during a fatal illness. From then on, a beautiful friendship existed between Irving and Miss Gratz, and when he spoke of her in England to Sir Walter Scott, the latter was so impressed by the beauty of her character, he immortalized her as Rebecca in *Ivanhoe.*

Rebecca devoted her life to rearing the children of her departed sister, Rachel; to philanthropy and educational pursuits. She was deeply religious and her interest in Hebrew Sunday Schools and in the Jewish Foster Home in Philadelphia, sprang from a passion for her religion which motivated ennobling deeds. She passed away in Philadelphia in 1869.

It was from the Hoffmans that Malbone received letters of introduction to Rebecca Gratz. This in turn led to Malbone's commissions to paint miniatures of her and her sister and to other commissions which Rebecca was able to secure for him.

The miniature of Rebecca Gratz is owned by Mrs. Carrie M. Serra, who inherited it from the late Miss Rachel Gratz Nathan. Prior to World War II, Mrs. Serra's home was in Rome, Italy. At present, she resides with Miss Moore, her niece, in Westmount, Province of Quebec.

Rebecca, rendered with beauty and grace by Malbone, wears a white dress with brown dots; her hair is black and she has dark brown eyes. The miniature is painted against a brown hatched background. I assume it was done in 1804 when Malbone painted the miniature of her sister Rachel. In 1805 Malbone made a copy of this miniature of Rebecca, which was lent in 1911 by Miss Mordecai of Philadelphia to the Pennsylvania Academy of Fine Arts for their Tenth Annual Exhibition of Miniatures.

Two handsome miniatures by Malbone of the brothers Asher and Joseph Marx are owned by the Pennsylvania Academy of Fine Arts. They were presented by Mr. Frank Marx Etting in 1886.

From an interesting genealogy of the Marx family compiled for Miss Edith Fowler, of Haslemere, Surrey, England, who is a descendant of George Marx, brother of Asher and Joseph Marx, we learn that the father

was Dr. Jacob Marx. The latter was born in Hanover, Germany, in 1743; he died there in 1789. Dr. Marx was court physician to the Elector of Hanover. His wife, Frances, was born in Germany in 1750 and died in Richmond, Virginia, July 8, 1819.

The miniatures of Asher and Joseph Marx were in the Loan Exhibition of Historical Portraits in 1887 at the Pennsylvania Academy, and also on loan there at the Tenth Annual Exhibition of Miniatures in 1911. They were in an exhibition of miniatures at the Metropolitan Museum of Art in 1927, and in an exhibit of Malbone's work at the National Gallery of Art in 1929 in Washington.

There is very little known about Asher Marx. *The History of the Jews of Richmond,* by Ezekiel and Lichtenstein, gives a reference to the sale of land, November 12, 1810, by Asher and Catherine Marx, to Joseph and George Marx. Another reference to Asher is in a pamphlet by Isaac Lyon, giving the history of Beth Shalome Congregation, established in Richmond in 1790, where Asher Marx is listed as one of the founders.

The miniature of Asher Marx represents him wearing a dark gray coat and white stock and tie. He has gray hair and light brown eyes.

Joseph Marx was born in Hanover, Germany in 1773. He emigrated to this country at an early age, and married Richea Myers of New York, daughter of Myer Myers, and sister of Samuel and Moses Mears Myers. They settled in Richmond, where Mr. Marx became a leading merchant and public-spirited citizen. His business, chiefly of a maritime character, was exceedingly profitable. Joseph Marx's name appears as a member of Beth Shalome Congregation in 1791. He died in Richmond on July 12, 1840.

The miniature of Joseph Marx represents him wearing a dark blue coat with gray buttons, a white stock and tie. His hair and eyes are brown.

In *Houses of Old Richmond,* by Mary Wingfield Scott, there is a picture of Mr. Marx's home, said to be designed by Robert Mills. It was a beautiful structure with elaborate woodwork and spacious rooms. Adjacent to it in the year 1816, Joseph Marx built another fine home for his mother which, upon her death in 1819, he gave to his daughter Judith who married Myer Myers of Richmond.

Louisa Marx, another daughter, married Samuel Myers of Norfolk, Virginia; their children were Moses, Joseph M. and Virginia.

Joseph Marx's daughter, Adeline, married Edward Carrington Mayo in 1829. He was the son of Colonel John Mayo and a great-grandson of

Major William Mayo, who with William Byrd, laid out the first plan of Richmond in 1737.

William C. Mayo, son of Adeline and Edward Mayo, married Sarah Wise, a daughter of Governor Henry A. Wise, of Virginia. Their daughter, Sarah, married Dr. William T. Oppenhimer, whose son Henry Wise Oppenhimer married Eleanor Williams, a descendant of Hetty and Solomon Jacobs.

Dr. William T. Oppenhimer's mother owns the Saint-Mémin crayon of Edward Carrington Mayo, and also that of Edward's sister, Maria, who married General Winfield Scott.

Josephine, daughter of Adeline and Edward C. Mayo, married General Archibald Gracie, a descendant of Archibald Gracie, who built Gracie Mansion in Carl Schurz Park, New York City.

Joseph Marx had several other daughters. Harriet Marx married Benjamin Etting. Caroline Marx married Richard W. Barton; their descendants are living in Winchester, Virginia, and in Baltimore. There was also a daughter, Frances, of whom we have no record.

Joseph and Richea Marx had three sons who remained unmarried. Samuel distinguished himself at the University of Pennsylvania, where he obtained a Master of Arts degree. On his return to Richmond, he associated himself in business with his father; later, he entered the Bank of Virginia and eventually became its president. He died in Richmond in 1860.

Charles Marx, born in 1806, was elected to the Richmond Light Infantry Blues in 1826. Upon his death in 1859, the company escorted his remains to the residence of a brother in Richmond.

Dr. Frederick Marx was the most distinguished of the three sons. He joined the militia, becoming a member of the Blues in 1824. He was president of the Medical Society of Virginia in 1843 and in 1854 was one of five leading physicians to open Bellevue Hospital, first private hospital in Richmond. He died in 1877.

# VI

## NINETEENTH CENTURY MINIATURES

ANNA CLAYPOOLE PEALE — INMAN — AMES — BRIDPORT —
COLLAS — RINCK — ANSON DICKINSON

ACCOMPLISHED work in miniature painting continued through-
out the early Nineteenth Century. Among the artists of this
period was Anna Claypoole Peale, who painted a miniature of
Rebecca Gratz. This miniature, formerly owned by Mrs. Joseph Drexel
(Lucy Wharton) of Pennrynn, Pennsylvania, was bequeathed to her grand-
daughter, Mrs. Andrew Van Pelt of Radnor, Pennsylvania.

The miniature is illustrated by courtesy of the Frick Art Reference
Library. Rebecca Gratz is depicted against a very dark gray background,
wearing an orange-colored dress. Her hair is black and her eyes are brown.

Anna Claypoole Peale was the daughter of the artist James Peale. She
was born in Philadelphia in 1791 where she died in 1878. She was mar-
ried twice, and exhibited her work under the name of Mrs. Stoughton
and Mrs. Duncan as well as under her maiden name.

In New Orleans I saw the interesting miniatures of Mr. and Mrs. Elias
Abrams. They are owned by Mrs. Annabel J. Nathans, granddaughter
of the sitters, and have been attributed to Henry Inman.

Elias Abrams, born in England in 1787, was the son of Emanuel Abrams.
The latter was a salt merchant and his warehouse stood on the old Battery
in Charleston. As a soldier in the South Carolina Regiment led by Cap-
tain Richard Lushington in the American Revolution, he was commended
for bravery when the British attacked Charleston.

Many important documents bear the signature of Elias Abrams who
was a clerk of the court in Charleston. His name is listed in a Charleston
directory of 1814. He was the father of ten children, whose many descend-
ants through the fourth generation are scattered over the United States.
Great-great-grandsons were fighting participants in the United States Army
and Navy of World War II. Elias Abrams died August 26, 1851.

Glancing at his miniature, we suspect that Elias Abrams was a witty
gentleman, by the smile of his rather full mouth. He has a florid com-
plexion; his eyes are set in a broad face, and side-locks fall from his curly

brown hair. He wears a buff coat, white vest, ruffled shirt, stock collar and bow-tie. Playfully treated, the miniature shows the artist's brush strokes in water color. The background is a pearl-gray.

Mrs. Abrams, whose maiden name was Catherine Cohen, was born in Germany in 1811 and was brought to this country when a baby. She died in 1864. She is represented wearing a dainty fichu with her dark brown dress and leg-of-mutton sleeves. There is a studded buckle in her belt. Her black curly hair parted in the middle is worn with a large light-brown circular comb. The pendant earrings are gold. The background is dark gray.

Miniatures of Mr. and Mrs. Simon Nathan by Henry Inman are in the possession of the American Jewish Historical Society. These miniatures came from the estate of Sarah Lyons, a member of the Nathan family.

Simon Nathan was born in 1746 in Frome, Somersetshire, England, the son of Judah Nathan. In New York, August 29, 1780, he married Grace, a daughter of Isaac Mendes and Rachel (Levy) Seixas. They had one son, Seixas Nathan, born in 1785.

As a man of wealth, Simon Nathan was enabled to lend financial support to the cause of the Revolution. Risking his life, he supplied the Continental Army with canvas and gunpowder. He provided $300,000 for clothing the soldiers at Fort Pitt, which was repaid in ruinously depreciated currency. He also advanced $320,000 to the State of Virginia for which he received expressions of gratitude from Thomas Jefferson and the Council of Virginia. He died in New York in 1822 and was buried in the old Bowery Cemetery. In 1932, a tablet was erected at the foot of his grave by the Manhattan Chapter, Daughters of the American Revolution, as their tribute to his patriotism. He was the paternal great-grandfather of Mrs. Maude Nathan and Mrs. Annie Nathan Meyer of New York.

In miniature he is portrayed wearing a reddish-brown coat, a white unbuttoned vest with black horizontal stripes, a white shirt and white bow-tie and collar. His gray hair is dishevelled and his arched heavy eyebrows frame large, dreamy brown eyes. The background is in dark tan. It is a wistful, spontaneous type of miniature, romantic in conception.

The miniaturist, Henry Inman, was born October 28, 1801, in Utica, New York. In 1814 he was apprenticed to the painter, John Wesley Jarvis, and in 1822 started his artistic professional life in New York. Simon Nathan died in 1822 and, therefore, must have been among the

first of Inman's sitters. Inman became vice-president of the National Academy of Art in 1838. He died January 17, 1846.

The miniature of Mrs. Simon Nathan represents her wearing a sheer black dress with a large ruffed lace collar, and a light tan bonnet trimmed with black ribbon. She has a natural complexion and brown eyes. The background is dark tan. Her miniature and her husband's are framed alike and are identical in size. Both show the flat strokes of the painter's brush. Inman laid his color on broadly as he was accustomed to working in oils.

Mrs. Nathan was born in 1752. Her father, Isaac Mendes Seixas, was born in Lisbon, Portugal, September 5, 1709, and arrived in New York in 1738. Her mother, Rachel, was the daughter of Moses Levy and Rycha Asher, and her brother was the Rabbi, Gershom Mendes Seixas. Mrs. Simon Nathan died in 1831.

She was a cultivated woman, an interesting letter writer, and somewhat of a poetess. A letter to her niece, Sarah Kursheedt (Mrs. J. B. Kursheedt) of Richmond, Virginia, dated May 16, 1820, speaks of her enthusiasm for Walter Scott's novels. She says, "I must tell you that Sol Moses writes to his family that one of your Sisters I do not know which, is called the beautiful Rebecca of Ivanhoe."

In the same letter she pens a bit of poetry as "proof of my active mind." She was then sixty-eight years old. The poem called *The Falling Leaf,* reads:

> I lately marked a falling Leaf
> From off a withering rose
> And sighing thought how soon my life
> Like this fair Flower will close.
>
> \*   \*   \*
>
> But ah! the Rose again will bloom
> Again its sweets Display
> While I am mouldering in the tomb
> Beneath my parent clay.

In 1895, the miniature of Maurice Levy was presented to the Metropolitan Museum of Art by Miss Ella Levy, niece of the sitter. It has been attributed by Mr. Harry B. Wehle to Ezra Ames. Mr. Levy, also known as Maurice Lewis, was for a time secretary to Aaron Burr. He is represented wearing a black coat with white satin ascot.

Ezra Ames was born in 1768 in Framingham, Massachusetts. As a youngster he lived on the family farm at Staatsburg, New York. By 1790 he was known as a decorative painter of furniture and coaches. His Memorandum Book, owned by the New York Historical Society, records a number of his commissions. In 1795 he resided in Worcester, and later settled in Albany. In 1813 he painted a full-length portrait of Governor Clinton for the State of New York. He died February 23, 1836. One of his children, Julius R. Ames, is listed in the Albany directories as a miniature painter during 1834-1850.

The miniatures of Mr. and Mrs. Arthur Lumley Levy (Louise Barnard) were owned by their granddaughter, the late Miss Florence N. Levy, of New York. Both miniatures were painted in England in 1840, when Mr. Levy went from New York to Southampton, for his wedding. Philip A. Barnard, the artist, was Mrs. Levy's brother. He was a regular exhibitor at the Royal Academy.

The miniature of Commander Joseph Myers, signed by Hugh Bridport, is owned by Mr. Thomas L. Preston of Washington, D. C. The latter is a brother of the late Edmund M. Preston.

Joseph Myers, born in 1797, was the son of Samson Myers, a brother of Moses Mears Myers. On the death of his father, Joseph was brought up by his uncle Moses.

At the age of thirteen, Joseph Myers entered the United States Navy as midshipman, and by successive grades became a Commander. He married his cousin, Rachel Hays Myers. He died in Richmond in 1862.

The following tribute to his memory was written by his niece, Mrs. Edward Cohen.

My first recollection of him was when I was only four years old. I was born in his house, and from that time forth was his greatest delight among the children of his family circle. He was a hopeless invalid even then, but with unbounded energy of mind, always planning and carrying out pleasures and benefits for others, and devising ways that might make his own life more tolerable. He was greatly afflicted by the death of his lovely fiancée, Miss Sarah Ann Ward, of Dinwiddie County, before he was thirty and she only seventeen. A few years after this event he contracted on the African coast the disease to which he was to be a martyr for about thirty-five years. In spite of paralysis then menacing him, his cousin Rachel Hays Myers, who had been devoted to him since her childhood days, and who was some ten years younger than he, married him when he was about thirty-six, and from that time was his cheerful, devoted and adoring nurse, and she survived him only a few months, when she died of pneumonia — but really of a broken heart. All his family loved him, and did what they could to show their desire to meet his slightest wish, and my

brother, Major E. T. D. Myers, and myself were like his children. Such was his spirit that when the war broke out between the States, he resigned from the United States Navy, and though a helpless invalid, actually joined the Confederate Navy and wore its uniform. . . . He was the greatest hero I ever knew, though his field was only his little library, where he lay on his sofa all day long.

The miniature of Commander Joseph Myers represents him wearing a dark blue uniform with black tie. His epaulet and buttons are gold. His black hair is tinged with gray. He has light brown eyes and fair complexion with slight suggestion of pink.

Hugh Bridport, the artist, was born in London in 1794. He came to the United States in 1816, and settled in Philadelphia where he conducted an art school. He died after 1837.

The miniature of Jonas Altamont Phillips by Hugh Bridport is owned by the Pennsylvania Academy of the Fine Arts. Phillips was born in Philadelphia in 1806. He was the son of Zalegman and Arabella (Solomon) Phillips, and grandson of Jonas and Rebecca (Mendes Machado) Phillips. He became a lawyer. In 1847-48 he was the Democratic candidate for the mayoralty of Philadelphia. President Buchanan is said to have offered him the position of Judge of the United States District Court, which he declined. His wife was Frances Cohen of Charleston, South Carolina. He died in Philadelphia in 1862.

Henry M. Phillips, a brother, distinguished himself as a lawyer. Jonas Altamont Phillips' son, Henry Phillips, Jr., was well-known for his studies in folklore, philology and numismatics in the United States and in Europe.

The miniature of Jonas Altamont Phillips was exhibited in the Loan Collection at the Pennsylvania Academy in 1887-88, where it was contributed by J. Marx Etting. It was presented to the Academy in 1913 by Mr. J. Bunford Samuel, at the request of the late Ellen P. Samuel, daughter of Mr. Phillips.

The sitter wears a black opened coat showing a white shirt and vest and high black stock and bow. His light brown hair is waved in a slight pompadour. He has blue eyes and pink complexion. His genial face is slightly bearded.

Joshua Moses, painted in miniature by Louis A. Collas, was the son of Isaac and Reyna (Levy) Moses. He married Sarah Brandon. Little else is known about him. His father, Isaac Moses, 1742-1818, joined with other patriots during the Revolution in the ownership of privateers which preyed on British shipping, and with the authority of Congress, did considerable damage to British commerce. He subscribed $15,000 to the

Colonial forces, assisted in the establishment of the Bank of North America, and was one of the founders of the New York Chamber of Commerce.

Miss Blanche Moses, granddaughter of Joshua Moses presented his minia-ture to the American Jewish Historical Society. It is signed by Collas. The miniature was exhibited at the Museum of the City of New York in the Spring of 1935. Joshua Moses is pictured in a very dark blue coat and white waistcoat and he has dark brown hair and eyes. The back-ground is gray. It is reproduced by courtesy of the Frick Art Reference Library.

Louis Antoine Collas, the artist, was born in 1775 in Bordeaux, France; he died after 1829. He was a pupil of F. A. Vincent and worked in St. Petersburg, Russia; between 1818 and 1829 he was working in New Orleans, Louisiana.

There is a miniature of Judah Touro by A. D. Rinck in the Louisiana State Museum.

Judah Touro was born in Newport, Rhode Island, June 16, 1775. He was the brother of Abraham Touro whose miniature has already been described. After the Revolution his family went to Kingston, Jamaica, and upon the death of the father the family returned to this country, where they made their home with Mrs. Touro's brother, Moses Michael Hays of Boston. Judah Touro was educated by his uncle and employed in his business.

The *Records of the Myers, Hays and Mordecai Families From 1707 to 1913 by Caroline Cohen* contains an excerpt from the *Biography* of the Reverend Samuel May, a close friend of the Hays family which reveals Touro's love for his cousin, Rebecca. It is stated that the home life of the Hays family in Boston was with certain exceptions very agreeable. "There was one great sorrow, the death in August 1802, at the age of thirty-three, of Rebecca Hays, the eldest daughter, whose love affair with her cousin, Judah Touro, disapproved of by her father and home circle, caused no doubt, much painful friction. Her two unmarried sisters, Catha-rine and Sally, were for some reason unknown to me, violently opposed to the match."

After Judah's frustrated love affair and when he was about twenty-six years of age, he left Boston and settled in New Orleans where he became a prosperous merchant.

During the defense of New Orleans by Andrew Jackson, Touro entered the ranks as a common soldier, and was severely wounded on January 1, 1815. He was saved from death by the bravery of his friend Rezin Davis

Shepherd, a young Virginian, who had settled in New Orleans. Their friendship continued throughout their lives, and they both amassed huge fortunes. Touro remained unmarried and died in New Orleans, January 13, 1854.

He was one of the greatest American philanthropists of his era. Both Touro and Amos Lawrence subscribed $10,000 each to complete Bunker Hill Monument. During his entire life Touro contributed generously to charitable institutions and aided many individuals. The provisions of his will disposed of over one-half million dollars. His body was taken to Newport where it now lies in the old Jewish Cemetery.

A. D. Rinck who painted Touro's miniature was working in New Orleans from 1840 to 1860. Mr. Stanley C. Arthur, director of the Louisiana State Museum, and Mr. Benjamin R. Foster, Museum artist, both believe that the miniature was done from life.

There is a large portrait of Judah Touro in the Louisiana State Museum. Another large portrait of Touro is owned by Mr. Monte M. Lemann of New Orleans. It is the belief of Mr. Arthur and Mr. Foster that these portraits were painted by Rinck from the miniature. They consider, too, that the miniature is in water color, although the flat appearance of the hat and clothing give the impression of the use of oil paint. Mr. Touro wears a silk hat, tie and coat of pronounced blue. The vest front and buttons are a reddish-brown. His complexion has the usual flesh tones and the eyes are blue.

Mr. Leon Huhner, who called my attention to this miniature, is the author of the recently published book, *The Life of Judah Touro*.

In *List of Miniatures Painted by Anson Dickinson*, edited by Mary Helen Kidder, of the Connecticut Historical Society, Hartford, 1937, a number of Jewish family names are recorded. They are: Hart, Hays, Isaacs, Jacobs and Noah. I have not succeeded in tracing the miniatures of these subjects which were painted during the years from 1812 to 1844. As Dickinson's work meets with enthusiasm, I hope that by listing them in the *Addenda,* the originals will some day be brought to light.

Anson Dickinson was born in 1780 in Milton, Litchfield County, Connecticut, and died there May 7, 1852. He started life as a silversmith and began the painting of miniatures in 1804, the year he sat to Malbone for his own miniature. Dickinson painted miniatures in Albany, New York City, Canada and in his native State. One of his friends was Washington Irving from whom he received encouragement.

# VII

## JARVIS — WOOD — TROTT — FRASER

NINETEENTH CENTURY miniatures of Jews are further repre-
sented in the distinguished work of John Wesley Jarvis, Joseph
Wood, Benjamin Trott and Charles Fraser.

A beautiful miniature of David I. Cohen signed by John Wesley Jarvis
is in the possession of Mrs. Arnold Burges Johnson of New York, who is
a granddaughter of the sitter.

David I. Cohen was born in Richmond, Virginia, April 30, 1800. He
was the eighth child and seventh son of Israel I. and Judith (Solomon)
Cohen. Israel I. Cohen was born in Oberdorf, Bavaria, in 1751. He was
living in Virginia in 1784. In Baltimore, the Cohen family occupied an
important place in the Jewish community as well as in the general life
of the city.

Eleanor S. Cohen, descended from this family, contributed a large col-
lection of portraits, silhouettes, miniatures and other valuable mementos
of her forebears to the Maryland Historical Society.

David I. Cohen married Harriet Cohen of Swansea, Wales. Their chil-
dren were Mendes, Catherine Myers, Miriam, Margaret, Bertha, Jacob I.,
and Rebecca Jackson.

Mr. Cohen was a member of the banking firm of Jacob I. Cohen, Jr.,
and Brothers, and was also a founder of the Baltimore Stock Exchange.
At the semi-annual election of the Board, held August 12, 1845, he was
elected vice-president. Out of regard for the Cohen family, whose Sab-
bath and Holy Days did not coincide with those of the other members
of the Board, the fine for non-attendance at organization meetings, which
fell on those days, was not imposed on the Cohens.

David I. Cohen died July 4, 1847. He and his wife are buried in the
family cemetery on West Saratoga Street, Baltimore.

The miniature of David I. Cohen is an excellent example of Jarvis's
work. The sitter has a well proportioned face, a high forehead, fringed
by short dark auburn locks and casually brushed sideburns. His eyes are
a lustrous blue. The frame is ornate with flower and leaf motif.

John Wesley Jarvis painted miniatures of considerable merit. He was
born in 1780 in South Shields, England. He came to Philadelphia in 1795.

[ 53 ]

In 1804, when he started to paint miniatures, he opened a studio with Joseph Wood. Malbone gave both of these artists assistance in miniature painting. Henry Inman was apprenticed to Jarvis in 1814, and they made frequent visits together to the South. Jarvis died in New York in 1839.

Joseph Wood painted a miniature of Benjamin I. Cohen, brother of David I. Cohen, which is signed and dated. It is in the Maryland Historical Society in the Cohen Collection with three other miniatures of Benjamin I. Cohen. The *Handlist of Miniatures* of the Maryland Historical Society records the miniature by Wood as well as a miniature of Mr. Cohen by Trott. The other two miniatures of Benjamin I. Cohen are similar and listed as unattributed.

Benjamin I. Cohen was born in Richmond, Virginia, September 17, 1797. On December 15, 1819, he married Kitty Etting, then twenty years of age, the daughter of Solomon Etting. Their children were Israel, Solomon Etting, John Jacob, Benjamin, Rachel Etting, Judith I., Maria Lopez, Kate Frances, Georgiana, Edward and Eliza Emory.

Mr. Cohen was one of the foremost bankers in Baltimore. He, too, was a member of the banking firm of Jacob I. Cohen, Jr., and Brothers and also was president of the Baltimore Stock Exchange.

He was active in creating sentiment for the passage of the "Jew Bill," which extended to persons of the Jewish faith the same civil privileges allowed to other religious sects.

In addition to his captaincy in the Marion Corps, he was at one time a lieutenant in the Columbia Volunteers, which were attached to the Fifth Regiment of Maryland Militia.

Mr. and Mrs. Cohen played an important part in the communal life of Baltimore. A fancy dress ball which they gave at their residence became an incident of the city's social history. Their home, which was the first to make use of gas, was erected at the corner of Charles and Saratoga Streets and their gardens and hothouses extended to Cathedral Street, the present site of the Rennert Hotel. Mr. Cohen was reputed to be a good violinist. He was an officer of the German Society of Maryland, which was probably the oldest benevolent organization in the State. He died September 20, 1845.

The miniature of Benjamin I. Cohen represents him wearing a blue coat with black velvet lapels and a pale buff waistcoat. He has black hair and hazel eyes. The background is bluish.

Joseph Wood, the artist, was born in Clarktown, Orange County, New York, in 1780. He was a farmer's son and self-taught. In 1804, he formed

a partnership with Jarvis in New York. Somewhat later, he moved to Philadelphia and then to Washington, D. C., where he died in 1830.

The miniature of Samuel Etting, owned by the Pennsylvania Academy, was also painted by Wood. It is signed and dated by the artist. This miniature was in an exhibition of American miniatures at the Metropolitan Museum of Art in the Spring of 1927.

Samuel Etting was born in 1796, the son of Solomon Etting of Baltimore. While he was in Captain Nicholson's Company of Baltimore Fencibles he was slightly wounded at Fort McHenry. He died in 1862.

In his miniature, ornately framed, Etting wears a blue-gray coat with velvet collar and a white neckcloth. His eyes are blue, and his medium-brown hair swept off his forehead has a very lifelike appearance in its contour and detail. It is a splendid example of the artist's very capable work.

As a miniature painter the work of Benjamin Trott compares favorably with that of Edward Greene Malbone, Charles Fraser and Robert Field, considered to be our most prominent miniature painters.

A very fine miniature of Solomon Etting by Trott is owned by the Pennsylvania Academy of Fine Arts. Solomon Etting was born in York, Pennsylvania, July 28, 1764. He was the son of Elijah and Shinah (Solomon) Etting. Solomon Etting married Rachel, daughter of Joseph Simon of Lancaster. There he engaged in business with his wealthy father-in-law as a partner under the name of Simon and Etting. In Lancaster, Etting played an important role in Masonic affairs.

After the death of his wife in 1790, he moved to Philadelphia and finally to Baltimore where he married again. The second wife was Rachel Gratz, daughter of Barnard Gratz. Etting was one of the incorporators of the Baltimore Water Company and a member of the Committee of Vigilance and Safety organized August 23, 1814. In 1826 he was a member of the City Council with Benjamin I. Cohen. He and Mr. Cohen were the first Jews to hold office in the State of Maryland.

Etting was also one of the founders of the Baltimore and Ohio Railroad. He had some correspondence with the inventor Robert Fulton, who was also an artist, regarding the construction of steam vessels of war. He passed away in Baltimore in 1847.

The miniature of Solomon Etting represents him with blue eyes and gray hair, brushed back from a large forehead. He wears a gray-black coat with bluish tinge, white neckcloth with bow-tie and white pleated ruffle.

The miniature is set in a plain gold frame with a lock of his graying hair under glass at the back.

Solomon Etting's miniature, painted in 1798, was presented to the Pennsylvania Academy of Fine Arts by Mr. Frank Marx Etting. It was exhibited there in 1887 at a loan collection of historical portraits, and included in the Tenth Annual Exhibition of Miniatures at the Academy in 1911.

Benjamin Trott was born about 1770, probably in Boston. He began to paint miniatures in 1791, working in our eastern cities. His work is characterized by clarity and directness, and often reveals the ivory as part of the color scheme. Trott frequently emphasized the forehead and elongated the neck. In his miniatures of men the hair is loosely brushed in the fashion known as *coup de vent*. Trott was still living in Baltimore in 1841.

The miniature of Benjamin I. Cohen by Trott is in the Eleanor S. Cohen Collection of the Maryland Historical Society. The background is in gray and white. Mr. Cohen's hair is black, his eyes dark brown, and his coat is painted in outline.

There were two miniatures of Mrs. Jacob Myers (Miriam Etting) by Benjamin Trott, both painted in 1804. They were lent by Miss Mordecai to the Pennsylvania Academy in 1911 for the Tenth Annual Exhibition of Miniatures where they were listed as by Trott.

I assume that Miss Eleanor S. Cohen acquired one of these miniatures which is now in the Cohen Collection of the Maryland Historical Society. In Miss Cohen's handwriting on the back of the photograph of this miniature is the inscription, "said to be by Malbone." The other miniature of Mrs. Jacob Myers, I believe, is now owned by the American Jewish Historical Society.

Miriam Etting was born in 1787, the daughter of Solomon Etting and his first wife, who was Rachel Simon. She married Jacob Myers and died in 1808.

A letter from Dr. J. Hall Pleasants quoted in an article by Theodore Bolton in the *Art Quarterly, Autumn, 1944,* says that Trott's work in Baltimore was done in two periods — the first, perhaps about 1815 or thereabouts, when he painted miniatures of the Cohen and Etting families.

Miriam Etting's miniatures were painted in 1804. Supposedly painted by Trott, they may now in view of Dr. Pleasants' statement be considered the work of Malbone.

Miss Etting's miniature in the Maryland Historical Society is a charming oval. The sitter is painted against a delicate blue-gray background wearing

a low-cut dress. Her complexion is fair; her eyes are dark brown, large and far apart. Soft brown curls hover over a wide forehead. She has a markedly pointed chin.

Miniatures painted by the noted Charles Fraser compare favorably in some instances with the work of his friend, Edward Greene Malbone. But on the whole his miniatures lack the sureness of line and delicate coloring identified with Malbone. Fraser did not become an artist until the advanced age of thirty-eight. If his career had been launched at an earlier age, he might have acquired the technical skill essential to the complete mastery of his art, and his work might then have equalled that of Malbone.

Fraser was born August 20, 1782, in Charleston, South Carolina, the youngest of fourteen children. He lost his father when only nine years of age. After his graduation from Charleston College in 1798, Fraser's guardian insisted upon training him for the law. That Fraser regretted this step is very evident from a letter written to Dunlap in which he says, "This unfortunate error by which the destiny of my life was directed, or rather misdirected, will ever be, as it has always been a source of regret to me." He was admitted to the bar in 1807 and after eleven years of practice he abandoned the law and from then on devoted himself to art. Fraser's later miniatures, generally rectangular in shape, are larger than his earlier ones.

Miniatures of a number of Jews were painted by Charles Fraser. They are listed in his Manuscript Account Book and are noted in the *Addenda* of this work. Three of them are illustrated here.

The miniature of Octavus Cohen, which is signed and dated, is owned by the Misses Phillips of Savannah, Georgia. Fraser noted in his Account Book that the charge was forty dollars.

Octavus Cohen was born in 1814. He married Henrietta Yates Levy, daughter of Mr. and Mrs. Jacob Clavius Levy of Charleston and Savannah. He died in 1876.

His miniature was included in an exhibition of Fraser's work at the Carolina Art Association in 1857 and again in 1934. It is very carefully modeled, depicting Mr. Cohen in a narrow-shouldered black coat and wearing a white stock collar and wide black bow-tie. His white shirt-front is studded with a gold button. His face is framed by a shock of dark brown hair and sideburns. He has brown eyes, heavy eyebrows and a fair complexion. In the background, soft gray clouds hover over a blue sky.

The rectangular miniatures of Mr. and Mrs. Mordecai Levy are in the possession of a granddaughter, Mrs. Jacob S. Raisin of Charleston, South Carolina.

Mr. Levy's miniature, thought to be painted after 1830, is listed as unat-tributed in the catalogue, *Exhibition of Miniatures from Charleston and Its Vicinity, Painted Before the Year 1860.* I am inclined to think it was painted by Fraser, and am illustrating it with Mrs. Levy's miniature by that artist.

Mr. Levy was born probably in Camden, South Carolina, January 14, 1808. He conducted a drug store there in partnership with Dr. Abraham De Leon. He was a member of the State Legislature from 1834 to 1838 and a candidate for Congress in 1836. He fought two duels for a close friend, Colonel Rochelle Blair of Camden, South Carolina. Colonel Blair was then a married man, and as Mr. Levy was unmarried at the time, he accepted the challenges for him. Mr. Levy married Jane Hart, daughter of Nathan and Rachel Hart. They were the parents of four daughters, Rachel, Elizabeth Jane, Mary Hannah, and Charlotte Blair; a son died in infancy. Mordecai Levy died February 4, 1850.

The miniature of Mordecai Levy is painted against a gray-brown back-ground. He has light brown, slightly wavy, thick hair. His eyes are blue and complexion florid. He wears the conventional dress suit of the period with high stock collar. His features of utmost delicacy and refinement complete the oval.

Mrs. Mordecai Levy was born in 1816; she died in Camden, South Carolina, October 21, 1865. Her miniature was exhibited in an exhibition of miniatures by Fraser in 1934 at the Carolina Art Association.

It is painted against a pinkish-brown background. Her bright brown hair, parted in the middle, is brushed flat to her ears from which long curls drop to her neck. She has a prominent nose and large brown eyes set far apart, and her forehead narrowed at the sides accentuates the oval face. Exquisitely rendered is her white mull evening bodice, horizontally tucked and off-the-shoulders with sleeves emerging in large puffs. She wears a gold butterfly brooch on her bodice which is finely edged with lace.

\* \* \*

It is seen that this work concerns itself with miniature art in America in relation to Jewish patrons as sitters. The miniature portraits represented here were done not by primitivists or pioneer painters, but by highly skilled artists whose work in keeping with the best traditions of American paint-ing will forever charm succeeding generations.

The Jews portrayed were patriotic citizens of intellectual and cultural attainment and of social and official standing. Viewing the miniatures of these men and women in the light of their humanitarian interests and service, gives one an awareness of a people of proud and ancient heritage, who continued to carry on in this country the faith and culture of Judaism, while at the same time making their contribution to the stream of American history.

# ADDENDA

# ADDENDA

The miniatures listed in the following record are in water color on ivory, unless otherwise stated. They represent the work of native Americans and foreign painters working in America from 1730-1850. A few miniatures painted abroad are included. I should very much appreciate corrections and information about miniatures which are not listed here.

## RECORD OF MINIATURES

### EZRA AMES (1768-1836)

Maurice Levy. Changed to Maurice Lewis.    3 x 2⅜ inches.
   Owner:  Metropolitan Museum of Art, New York.

### PHILIP A. BARNARD (?-?)

Arthur Lumley Levy (1811-1888). Painted about 1840 in England.
   Owner:  In 1944 Miss Florence N. Levy, New York.

Mrs. Arthur Lumley Levy (Louise Barnard) (1807-1887). Painted about 1840 in England.
   Owner:  In 1944 Miss Florence N. Levy, New York.

### HUGH BRIDPORT (born 1794; died after 1837)

Commander Joseph Myers, U.S.N. (1797-1862).    2¾ x 2¼ inches.
   Signed:  "Bridport."
   Reproduced:  *Richmond Portraits In an Exhibition of Makers of Richmond, 1737-1860*. Valentine Museum, 1949.
   Owner:  Mr. Thomas L. Preston, Washington, D. C.

Jonas Altamont Phillips (1806-1862).    2⅝ x 2⅛ inches.
   Signed:  "Bridport."
   Owner:  Pennsylvania Academy of the Fine Arts, Philadelphia.

### A.C. (?-?)

Mrs. David Cardoza Levy (1805-1899).    2⁹⁄₁₆ x 1⅞ inches.
   Signed:  "A.C."
   Owner:  Maryland Historical Society, Baltimore.

### LOUIS ANTOINE COLLAS (born 1775; died after 1829)

Joshua Moses (?-?)    2⅝ x 1⅞ inches.
   Signed:  "Collas, 1804."
   Owner:  American Jewish Historical Society, New York.

# MINIATURES OF EARLY AMERICAN JEWS

## ANSON DICKINSON (1780-1852)

The following miniatures are recorded in the catalogue: *List of Miniatures Painted by Anson Dickinson,* edited by Mary Helen Kidder, Connecticut Historical Society, Hartford, 1937.

| | | | |
|---|---|---|---|
| Mrs. Hart | March 25, 1844. | Mrs. Jacobs | June 26, 1817. |
| Mrs. Hart | | Mrs. Jacobs | |
| Mrs. Hart | April 28, 1825. | Mr. Noah | Painted, Jan. 1812. |
| Mr. Hays | June 20, 1815. | Mr. Noah | |
| Mr. Isaacs | Aug. 15, 1815. | Miss Noah | Painted, May 1822. |
| Mrs. Jacobs | | | |

NOTE: Perhaps not all of these miniatures will be found to be of Jewish people.

## CHARLES FRASER (1782-1857)

Lucretia Cohen (Mrs. ? Mordecai) (?-?). Painted in 1834.
    Owner: Unknown.

Octavus Cohen (1814-1876). Signed on the back: "Painted by C. Fraser/Charleston September, 1836."
    Owner: The Misses Phillips, Savannah, Ga.

Mr. Lazarus (?-?). Painted 1836.
    Owner: Unknown.

Eugenia Levy (Mrs. Philip Phillips) (1819-1901). Painted in 1835.
    Owner: Unknown.

Jacob Clavius Levy (?-1875). Painted in 1825.
    Owned some years ago by Mrs. Henry Taylor, Northport, Long Island, New York.

Mrs. Jacob Clavius Levy (Fanny Yates) (?-?). Painted in 1825.
    Owned some years ago by Mrs. Henry Taylor, Northport, Long Island, New York.

Mrs. Jacob Clavius Levy (Fanny Yates) (?-?). Copy painted in 1828.
    Owner: Unknown.

Mordecai M. Levy (1808-1850).                                   2¾ x 2 3/16 inches.
    Attributed to Fraser.
    Owner: Mrs. Jacob S. Raisin, Charleston, S. C.

Mrs. Mordecai M. Levy (Jane Hart) (1816-1865).
    Owner: Mrs. Jacob S. Raisin, Charleston, S. C.

## HENRY INMAN (1801-1846)

Elias Abrams (1787-1851).                                       3½ x 2¾ inches.
    Attributed to Inman.
    Owner: Mrs. Annabel J. Nathans, New Orleans, La.

Mrs. Elias Abrams (Catherine Cohen) (1811-1864).               3½ x 2¾ inches.
    Attributed to Inman
    Owner: Mrs. Annabel J. Nathans, New Orleans, La.

Simon Nathan (1746-1822).                                       3 1/16 x 2½ inches.
    Owner: American Jewish Historical Society, New York.

ADDENDA

Mrs. Simon Nathan (Grace Seixas) (1752-1831).                          3¹⁄₁₆ x 2½ inches.
   Owner:  American Jewish Historical Society, New York.

## JOHN WESLEY JARVIS (1780-1839)

David I. Cohen (1800-1847).  Signed: "Jarvis."
   Owner:  Mrs. Arnold Burges Johnson, New York.

Harmon Hendricks (1771-1838).                                          3 x 3 inches.
   Signed:  "Jarvis."
   Reproduced:  *Publication of the American Jewish Historical Society,* March, 1952.
   Owner:  Mr. Henry S. Hendricks, New York.

## HENRIETTA ELIZA KIDD (?-?)

Edwin Israel Kursheedt (1840-1906).  Painted in 1842 in Jamaica, British West Indies.
   Owner:  The Misses Kursheedt, New Orleans, La.

## EDWARD GREENE MALBONE (1777-1807)

Rachel Gratz (Mrs. Solomon Moses) (1783-1823).                         2 x 1¼ inches.
   Signed:  "Malbone 1804."
   Reproduced:  *Portraits of Jews,* by H. R. London; *Heirlooms in Miniature,* by
     A. H. Wharton.
   Owner:  Mrs. John H. Hunter, Savannah, Ga.

Rachel Gratz (Mrs. Solomon Moses) (1783-1823).  Copy painted in 1805.
   In 1911 owned by Miss Mordecai, Philadelphia, Pa.

Rachel Gratz (Mrs. Solomon Moses) (1783-1823).  Miniature presented as a gift by
   Malbone to Mrs. J. Ogden Hoffman.
   Owner:  Unknown.

Rebecca Gratz (1781-1869).                                             3⅛ x 2⁵⁄₁₆ inches.
   Painted in 1804.
   Reproduced:  *Portraits of Jews,* by H. R. London; *American Miniatures,* by H. B.
     Wehle; *Heirlooms in Miniature,* by A. H. Wharton.
   Owner:  Mrs. Carrie M. Serra, Westmount, P. Q., Canada.

Rebecca Gratz (1781-1869).  Copy painted in 1805.
   In 1911 owned by Miss Mordecai, Philadelphia, Pa.

Asher Marx (?-?)                                                       2¾ x 2¼ inches.
   Painted in 1803.
   Reproduced:  *Catalogue of an Exhibition of Miniatures Painted in America,*
     Metropolitan Museum of Art, 1927.
   Owner:  Pennsylvania Academy of the Fine Arts, Philadelphia, Pa.

Joseph Marx (1773-1840).                                               2⅞ x 2⅜ inches.
   Painted in 1800.
   Reproduced:  *Catalogue of an Exhibition of Miniatures Painted in America,*
     Metropolitan Museum of Art, 1927.
   Owner:  Pennsylvania Academy of the Fine Arts, Philadelphia.

David Moses (1776-1858).                                3³⁄₁₆ x 2⁹⁄₁₆ inches.
  Reproduced:  *American Miniatures*, by H. B. Wehle.
  Owner:  Miss Miriam Dent, Brunswick, Ga.

Solomon Moses (1774-1857).                              2⅞ x 2⁵⁄₁₆ inches.
  Reproduced:  *American Miniatures*, by H. B. Wehle.
  Owner:  Miss Kathleen Moore, Westmount, P. Q., Canada.

### ANNA CLAYPOOLE PEALE (1791-1878)

Rebecca Gratz (1781-1869).                              2 x 1⅝ inches.
  Owner:  Mrs. Andrew Van Pelt, Radnor, Pa.

### CHARLES WILLSON PEALE (1741-1827)

Colonel David Salisbury Franks (? - about 1794).  Painted in 1778.
  Reproduced:  *Portraits of Jews*, by H. R. London.
  Owner:  Mrs. Clarence I. De Sola, Montreal, P. Q., Canada.

Samuel Myers (1754-1836).                               1 x ¾ inch.
  Attributed to C. W. Peale.
  Reproduced:  *Richmond Portraits In an Exhibition of Makers of Richmond, 1737-
    1860*. The Valentine Museum, 1949.
  Owner:  Mr. William C. Preston, Richmond, Va.

### JAMES PEALE (1749-1831)

Reuben Etting (1762-1848).                              2⁷⁄₁₆ x 1¹⁵⁄₁₆ inches.
  Signed:  "JP 1794."
  Reproduced:  "James Peale's Portrait Miniatures," by F. F. Sherman. *Art in
    America*, Aug. 1931.
  Owner:  Pennsylvania Academy of the Fine Arts, Philadelphia.

Mrs. Reuben Etting (Frances Gratz) (1771-1852).        2½ x 2 inches.
  Signed:  "JP 1794."
  Reproduced:  "James Peale's Portrait Miniatures," by F. F. Sherman. *Art in
    America*, Aug. 1931.
  Owner:  Pennsylvania Academy of the Fine Arts, Philadelphia.

Mrs. Moses Sheftall (Nellie Bush) (?-?).               1¹³⁄₁₆ x 1⁷⁄₁₆ inches.
  Signed:  "J P 1797."
  Reproduced:  "James Peale's Portrait Miniatures," by F. F. Sherman, *Art in
    America*, Aug. 1931. Incorrectly labeled as Mrs. Mordecai Sheftall.
  Reproduced:  *American Miniatures*, by H. B. Wehle. Incorrectly labeled as Mrs.
    Mordecai Sheftall.
  Owner:  Mrs. Edmund H. Abrahams, Savannah, Ga.

### REMBRANDT PEALE (1778-1860)

Jacob I. Cohen (1774-1823).
  Owner:  Mrs. Harriet Cohen Coale, Baltimore, Md.

# ADDENDA

## SARAH M. PEALE (1800-1885)

Mr. Levy (?-?). Painted about 1830.
   Reproduced: "Early American Miniatures," by H. C. *Compleat Collector,* July
   1943.

## PHILIPPE A. PETICOLAS (1760-1843)

Elihu or Elijah Etting (1724-1778).                                         2¾ x 2½ inches.
   Signed: "P. A. Peticolas 1799."
      Note disparity between date of death of Elijah Etting and date of painting.
   Owner: Pennsylvania Academy of the Fine Arts, Philadelphia.

Joseph Solomon (1700-1780).                                                 2⅞ x 2¼ inches.
   Reproduced: *Portraits of Jews,* by H. R. London.
   Owner: Maryland Historical Society, Baltimore.

## CHARLES PEALE POLK (1767-1822)

Barnard Gratz (1738-1801).                                                  1⅞ x 1½ inches.
   Inscription on paper, back of ivory: "Barnard Gratz by Charles Peale Polk."
   Owner: Dr. Jacob R. Marcus, Cincinnati, O.

## JOHN RAMAGE (born before 1763; died 1802)

Jacob De Leon (1764-1828).                                                  2¾ x 1¾ inches.
   Reproduced: *Portraits of Jews,* by H. R. London; *John Ramage,* by F. F. Sherman.
   Owner: Miss Emma L. Samuel, Philadelphia, Pa.

Miss Gomez (?-?).                                                           2 x 1½ inches.
   Attributed to Ramage.
   Owner: Museum of the City of New York.

Solomon Marache (?-?). Resided in Philadelphia in 1760.
   Attributed to Ramage.
   Owner: In 1921, Rev. Rufus Henry Bent, Philadelphia

Major Benjamin Nones (1757-1826).                                          1½ x 1⅛ inches.
   Attributed to Ramage
   Owner: Miss Miriam Goldbaum, New Orleans, La.

Joseph Simson (1686-1787).
   Reproduced: *Lyons Collection No. 27,* Publications of American Jewish Historical
      Society.
   Owner: In 1920, Mrs. Ansel Leo, Yonkers, N. Y.

### A. D. RINCK (Working in New Orleans from 1840 to 1860)

Judah Touro (1775-1854).                                                    3¼ x 2⅜ inches.
   Owner: Louisiana State Museum, New Orleans.

## JOHN SMIBERT (1688-1751)

Rabbi Raphael Haijm Karigal (1729-1777). A likeness of Karigal on ivory, probably
   by Smibert was given to the late Rev. Jacques Judah Lyons by Mrs. Rebecca

Hendricks, daughter of the late Aaron Lopez of Newport, R. I. See *Lyons Collection* No. 27, BII, pages 63-64, Publications of the American Jewish Historical Society, New York.

## LAWRENCE SULLY (1769-1804)

Abraham Alexander, Sr. (1743-1816)                                      2½ x 1⅞ inches.
    Signed: "Sully."
    Reproduced: *New Age Magazine*, February 1907, Masonic publication.
    Owner: Mrs. Thomas J. Tobias, Sr., Charleston, S. C.

## THOMAS SULLY (1783-1872)

Mrs. Hyman Marks (?-?).
    Listed: *Life and Works of Thomas Sully*, by E. Biddle and M. Fielding.
    Owner: Mrs. Grace N. Lederer, Philadelphia, Pa.

## ELKANAH TISDALE (born about 1771; died after 1834)

Major Mordecai Myers (1776-1870). Painted in 1798.
    Reproduced: *Biographical Sketches of the Bailey-Myers-Mason Families*, 1776-
        1905.

## BENJAMIN TROTT (born about 1770; died after 1841)

Benjamin I. Cohen (1797-1845).                                          3⅝ x 2¾ inches.
    Owner: Maryland Historical Society, Baltimore.
Solomon Etting (1764-1847).                                            2¹²⁄₁₆ x 2¹⁄₁₆ inches.
    Painted in 1798.
    Owner: Pennsylvania Academy of the Fine Arts, Philadelphia.
Mrs. Jacob Myers (Miriam Etting) (1787-1808).                          3 x 2½ inches.
    Painted in 1804.
    Reproduced: *Portraits of Jews*, by H. R. London.
    Owner: Maryland Historical Society, Baltimore.
Mrs. Jacob Myers (Miriam Etting) (1787-1808). Painted in 1804.
    In 1911 this miniature was owned by Miss Mordecai, Philadelphia. I believe this
    miniature is now owned by American Jewish Historical Society, New York.

## JOSEPH WOOD (1780-1830)

Benjamin I. Cohen (1797-1845).                                         4 x 3 inches.
    Painted in 1826. Signed: "Painted by / J Wood/ 182-."
    Reproduced: *Portraits of Jews*, by H. R. London.
    Owner: Maryland Historical Society, Baltimore.
Samuel Etting (1796-1862).                                            2⁶⁄₁₆ x 1⅞ inches.
    Signed: "J. Wood pinx 1819."
    Owner: Pennsylvania Academy of the Fine Arts, Philadelphia.

## UNATTRIBUTED MINIATURES

Joseph Andrews (1750-1824).                                           2½ x 2½ inches.
    Owner: Museum of the City of New York.

Mrs. Joseph Andrews (Sally Salomon) (1779-1854).　　　　1¼ x 1⅜ inches.
　　Owner:　Museum of the City of New York.

Isaac Lopez Brandon　　　　　　　　　　　　　　　　　2¾ x 2¼ inches.
　　Owner:　American Jewish Historical Society, New York.

Sarah Brandon (Mrs. Joshua Moses).　　　　　　　　　2¾ x 2¼ inches.
　　Probably painted in London.
　　Owner:　American Jewish Historical Society, New York.

Mrs. Bush (Becky Myers or Mears).
　　In 1922, a photograph of this miniature was owned by Miss Mordecai, Philadelphia.

Benjamin I. Cohen (1797-1845).　　　　　　　　　　　2⁹⁄₁₆ x 2⅛ inches.
　　Owner:　Maryland Historical Society, Baltimore.

Benjamin I. Cohen (1797-1845).　　　　　　　　　　　2⅝ x 2¼ inches.
　　Owner:　Maryland Historical Society, Baltimore.

Mrs. Benjamin I. Cohen (Kitty Etting) (1799-1837).　　3⁹⁄₁₆ x 3⅛ inches.
　　Oil on composition board. Profile.
　　Reproduced:　*Shades of My Forefathers,* by H. R. London.
　　Owner:　Maryland Historical Society, Baltimore.

Mrs. Benjamin I. Cohen (Kitty Etting) (1799-1837).　　3¼ x 2¹⁵⁄₁₆ inches.
　　Oil on composition board. Profile.
　　Owner:　Maryland Historical Society, Baltimore.

Solomon Cohen (?-?). Resided in Georgetown, S. C.
　　Owner:　Mr. Abram Minis, Jr., Savannah, Georgia.

Fanny Da Ponte (1799-1844). Daughter of Lorenzo Da Ponte.
　　Reproduced:　*Memoirs of Lorenzo Da Ponte,* translated by Elizabeth Abbott.
　　Owner:　In 1933, Mr. P. Chauncy Anderson, New York.

Lorenzo Da Ponte (1749-1838). Converted to Catholicism.
　　Reproduced:　*Memoirs of Lorenzo Da Ponte,* translated by Elizabeth Abbott.
　　Owner:　In 1933, Mr. P. Chauncy Anderson, New York.

Mrs. Lorenzo Da Ponte (Ann Celestine Grahl) (1769-1831).
　　Reproduced:　*Memoirs of Lorenzo Da Ponte,* translated by Elizabeth Abbott
　　Owner:　In 1933, Mr. P. Chauncy Anderson, New York.

Isaac De Lyon (?-?). Painted about 1790.
　　Owner:　Mr. Thomas J. Tobias, Charleston, S. C.

Judith De Lyon (Mrs. Moses Cohen) (1748-1816).
　　Owner:　Mr. Thomas J. Tobias, Charleston, S. C.

Jacob De Sola (1800-1867). Probably painted in France.　　2 x 1¾ inches.
　　Owner:　Dr. S. De Sola, New York.

Benjamin Etting (1798-1875). Painted in 1826, from life by an unknown Chinese
　　artist, Canton, China.
　　Owner:　Pennsylvania Academy of the Fine Arts, Philadelphia.

Solomon Etting (1767-1847).                           3 x 2⅜ inches.
    Water color on paper.
    Owner:  Maryland Historical Society, Baltimore.

Solomon Etting (1764-1847).                           2⅞ x 2½ inches.
    Profile.
    Reproduced:  *Portraits of Jews,* by H. R. London.
    Owner:  Maryland Historical Society, Baltimore.

Mrs. Solomon Etting (Rachel Gratz) (1764-1831).        1⅝ x 1⅛ inches.
    Owner:  Maryland Historical Society, Baltimore.

Benjamin Gomez (?-?).                            2½ x 1¾ inches.
    Owner:  Mr. Edgar J. Nathan, New York.

Daniel Hart (?-1810).                       2$\frac{13}{16}$ x 2⅛ inches.
    Painted about 1800-1809.
    Owner:  Mrs. David Hart, Denmark, S. C.

Mrs. Daniel Hart (?-?).
    Owner:  In 1922, Miss Isabel Cohen, New York.

Samuel Hays (?-?). Resided in Philadelphia in 1792. Painted in 1810.
    Exhibited at the Tenth Annual Exhibition of Miniatures, Pennsylvania Academy
        of the Fine Arts, 1911.
    Owner:  In 1911, Miss Mordecai, Philadelphia, Pa.

Uriah Hendricks (1737-1798).                       2⅝ x 2 inches.
    Owner:  Mrs. Laurence Frank, New York.

Joshua Isaacs the Second (1745-1810).             2¾ x 2¼ inches.
    Owner:  Mrs. Benedict Bruml, Long Island City, New York.

Israel Israel (1743-1821).
    Owner:  In 1922, Mrs. Elvira Ellet Kendall, Walpole, Mass.

Myer Jacobs (?-?). Painted about 1815.
    This miniature or photograph of miniature owned in 1922 by Dr. Barnett A. Elzas,
        Charleston, S. C.

Aaron Levy (1742-1815).
    Owner:  In 1946 Dr. A. S. W. Rosenbach, Philadelphia, Pa.

Mrs. Michael Levy (Rachel Phillips) (1769-1839).      4⅝ x 4¼ inches.
    Painted from a large oil portrait, owned by Mr. William C. Oberwalder. This
        portrait may have been painted by Robert Fulton.
    Owner of Miniature:  American Jewish Historical Society, New York.

David Lopez (?-?). Resided in Charleston, S. C. Painted about 1800.
    This miniature or photograph of miniature owned in 1922 by Dr. Barnett A. Elzas,
        Charleston, S. C.

Judah Eleazer Lyons (1799-1849)
    Owner:  American Jewish Historical Society, New York.

Abraham Moise (?-1809).
    Owner:  Mrs. August Kohn, Columbia, S. C.

Isaac C. Moses (?-1834). Profile.
  Reproduced: *Portraits of Jews,* by H. R. London.
  Owner: Mrs. Carrie M. Serra, Westmount, P. Q., Canada.
Moses Mears Myers (1771-1860).
  Owner: Mrs. Brooke Mordecai, Madera, California.
Samuel Myers (1754-1836).                                   2½ x 2¼ inches.
  Reproduced: *Richmond Portraits In an Exhibition of Makers of Richmond,* 1737-
      1860. The Valentine Museum, 1949.
  Owner: Mrs. Edmund M. Preston, Richmond, Va.
Naphtali Phillips (1773-1870).                              2½ x 2 inches.
  Owner: Captain N. Taylor Phillips, New York.
Mrs. Naphtali Phillips (Rachel Hannah Mendes Seixas) (1773-1822). 3½ x 3¼ inches.
  Owner: Captain N. Taylor Phillips, New York.
Mrs. Zalegman Phillips (Arabella Solomon) (1786-1826).
  Owner: Mrs. William Moran, Sumter, S. C.
David Samuel (1804-1881).
  Reproduced: *Records of the Samuel Family,* by J. B. Samuel.
  Owner: Unknown.
Mrs. David Samuel (Hetty Moss) (1808-1867).
  Reproduced: *Records of the Samuel Family,* by J. B. Samuel.
  Owner: Unknown.
Rabbi Gershom Mendes Seixas (1745-1816).                    2 x 1½ inches.
  Reproduced: *Once Upon a Time and To-Day,* by M. Nathan.
  Owner: Mrs. Annie Nathan Meyer, New York.
Mordecai Sheftall (1735-1797). Commissary General of Issues.
  Owner: Mrs. Edmund H. Abrahams, Savannah, Ga.
Mrs. Mordecai Sheftall (Frances Hart).
  Owner: Mrs. Edmund H. Abrahams, Savannah, Ga.
Adolphus Simeon Solomons (1826-1910).                       2¾ x 2 inches.
  Owner: Captain N. Taylor Phillips, New York.
John Solomons (1788-1858).                                  2¾ x 2³⁄₁₆ inches.
  Owner: Captain N. Taylor Phillips, New York.
Abraham Touro (1774-1822).
  Owner: Newport Historical Society, Newport, R. I.
Unidentified Gentleman. Member of the Andrews-Dreyfous family.  2½ x 2 inches.
  Owner: Miss Florence Dreyfous, New York.
Unidentified Lady. Member of the Andrews-Dreyfous family.   2½ x 2 inches.
  Owner: Miss Florence Dreyfous, New York.

# BIBLIOGRAPHY

# BIBLIOGRAPHY

Baroway, Aaron. "The Cohens of Maryland," *Maryland Historical Magazine*. December, 1923; March 1924.

Baroway, Aaron. "Solomon Etting," *Maryland Historical Magazine*. March, 1920.

Bolton, Theodore, *Early American Portrait Painters in Miniature*. New York. Sherman, 1921.

Bolton, Theodore, "Benjamin Trott, An Account of His Life and Work," *The Art Quarterly*, Autumn, 1944. Detroit Institute of Arts.

Bolton, Theodore, and Tolman, Ruel P., "Catalogue of Miniatures by or Attributed to Benjamin Trott," *The Art Quarterly*, Autumn, 1944. Detroit Institute of Arts.

Carolina Art Association, *Exhibition of Miniatures from Charleston and its Vicinity Painted before the year 1860*. Charleston, 1935.

Carolina Art Association, *Exhibition of Miniatures owned in South Carolina and Miniatures of South Carolinians owned elsewhere*. Charleston, 1936.

Cohen, Caroline (Myers), *Records of the Myers, Hays and Mordecai Families from 1707-1913*. Privately printed.

Dunlap, William H., *History of the Rise and Progress of the Arts of Design in the United States*. New York: George P. Scott, 1934.

Fraser, Charles, Manuscript Account Book. Presented to the Carolina Art Association in 1937, by Alwyn Ball.

Fredman, J. George and Falk, Louis A., *Jews in American Wars*. New Jersey: Terminal Printing & Publishing Co., 1942.

*History of the Corporation of Spanish and Portuguese Jews*. "Shearith Israel" of Montreal, Canada.

Metropolitan Museum of Art, *Catalogue of an Exhibition of Miniatures Painted in America, 1720-1850*. New York, 1927.

Morgan, John Hill, *A Sketch of the Life of John Ramage Miniature Painter*. The New York Historical Society, 1930.

National Gallery of Art, *Catalogue of Miniatures and Other Works by Edward Greene Malbone*. Washington, 1929.

Pennsylvania Academy of the Fine Arts, *Catalogue of Tenth Annual Exhibition of Miniatures*. Philadelphia, 1911.

Piers, Harry, *Robert Field: Portrait Painter in Oils, Miniatures, and Water-Colors and Engraver*. New York: Sherman, 1927.

*Publications of the American Jewish Historical Society*. Baltimore: The Lord Baltimore Press.

Rutledge, Anna W., *Hand-List of Miniatures in the Collections of The Maryland Historical Society*. Baltimore, June, 1945.

Sherman, Frederic F., "Charles Willson Peale's Portrait Miniatures," *Art in America,* June 1931.

Sherman, Frederic F., "James Peale's Portrait Miniatures." "Signed and Dated Miniatures by James Peale." "Unsigned Miniatures by James Peale." *Art in America,* August, 1931.

Sherman, Frederic F., *John Ramage.* New York: Sherman, 1929.

Sherman, Frederic F., "Benjamin Trott, an early American Miniaturist," *Art in America,* July, 1941.

Sherman, Frederic F., "John Trumbull's Portrait Miniatures on Wood." "John Trumbull's Miniatures on Wood." *Art in America,* October, 1931.

South Carolina Art Society, *Catalogue of Pictures Exhibited in the Fraser Gallery, Charleston, 1857.* Charleston, S. C.

*The Saint Charles Magazine, 1654-1789,* January, 1935. Camden, New Jersey: Gibbten Co.

Tolman, Ruel P., "Newly Discovered Miniatures by E. G. Malbone," *Antiques Magazine,* November, 1929.

Valentine Museum, 1949. *Richmond Portraits In an Exhibition of Makers of Richmond, 1737-1860.*

Virginia Museum of Fine Arts, *An Exhibition of Virginia Miniatures.* Richmond, 1942.

Wehle, Harry B., *American Miniatures, 1730-1850.* Garden City: Doubleday Page, 1937.

Wharton, Anne H., *Heirlooms in Miniatures.* Philadelphia: Lippincott, 1898.

ILLUSTRATIONS

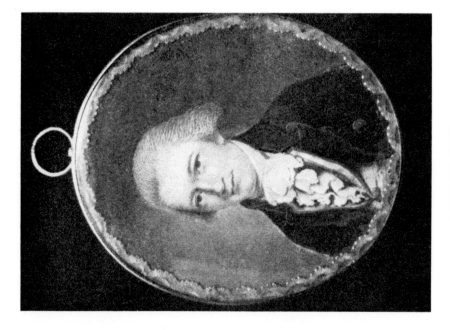

JACOB DE LEON
*By* JOHN RAMAGE
*Owned by Miss Emma L. Samuel, Philadelphia*

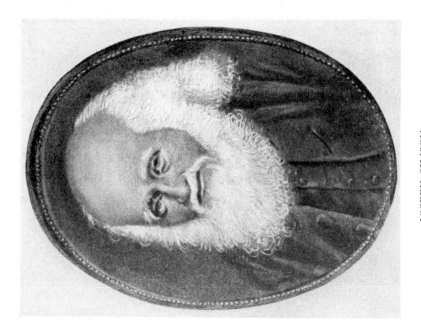

JOSEPH SIMSON
*By* JOHN RAMAGE
*Owned by Mrs. Ansel Leo, Yonkers, N. Y.*

[ 79 ]

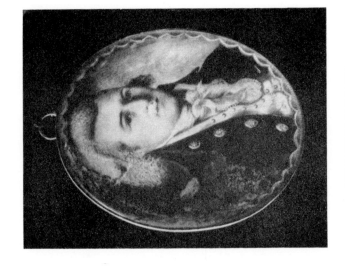

SOLOMON MARACHE
*By* JOHN RAMAGE
*Owned by Rufus H. Bent, Philadelphia, Pa.*

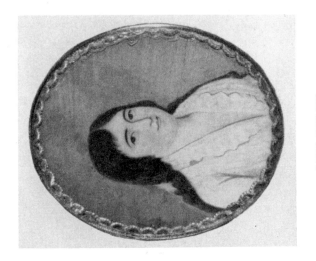

MISS GOMEZ
*By* JOHN RAMAGE
*Owned by Miss Florence Dreyfous, New York*

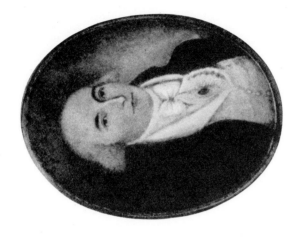

ABRAHAM ALEXANDER, SR.
*By* LAWRENCE SULLY
*Owned by Mrs. Thomas J. Tobias, Sr., Charleston, S. C.*

MAJOR BENJAMIN NONES
*Attributed to* JOHN RAMAGE
*Owned by Miss Miriam Goldbaum, New Orleans, La.*

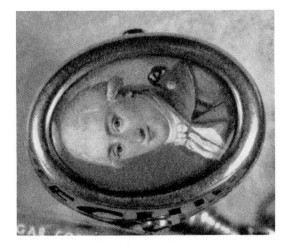

SAMUEL MYERS
*Attributed to* CHARLES WILLSON PEALE
*Owned by Mrs. William C. Preston, Richmond, Va.*

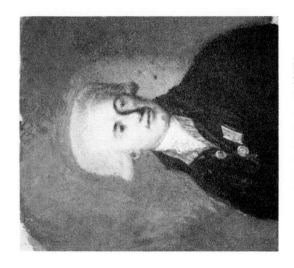

COLONEL DAVID S. FRANKS
*By* CHARLES WILLSON PEALE
*Owned by Mrs. Clarence I. De Sola, Montreal, P. Q.*

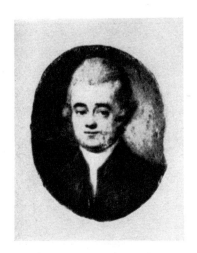

BARNARD GRATZ
*By* CHARLES PEALE POLK
*Owned by Dr. Jacob R. Marcus, Cincinnati, O.*

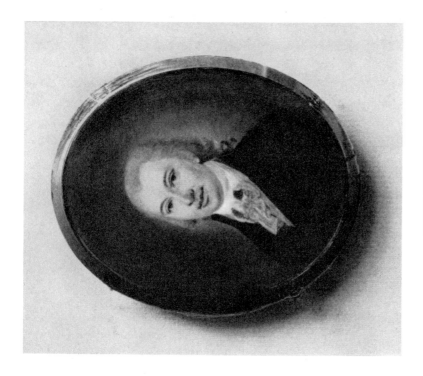

ELIHU ETTING
By Philippe A. Peticolas
Owned by Pennsylvania Academy of the Fine Arts, Philadelphia

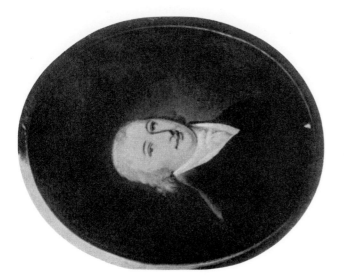

JOSEPH SOLOMON
By Philippe A. Peticolas
Owned by Maryland Historical Society, Baltimore

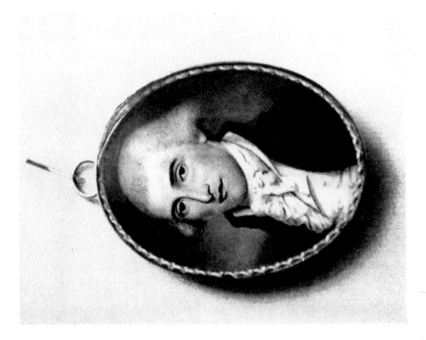

REUBEN ETTING
*By* JAMES PEALE
*Owned by Pennsylvania Academy of the Fine Arts, Philadelphia*

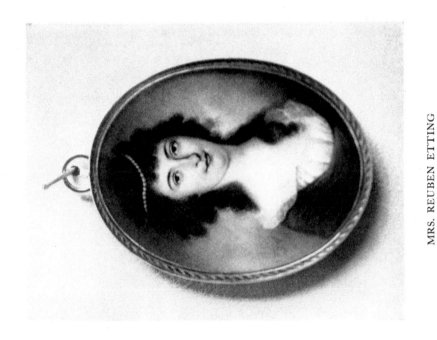

MRS. REUBEN ETTING
*By* JAMES PEALE
*Owned by Pennsylvania Academy of the Fine Arts, Philadelphia*

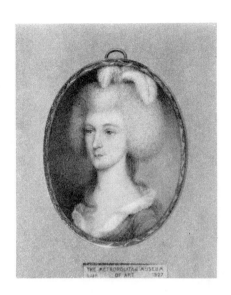

MRS. MOSES SHEFTALL
*By* JAMES PEALE
*Owned by Mrs. Edmund H. Abrahams, Savannah, Ga.*

JOSEPH ANDREWS
UNKNOWN ARTIST
*Owned by Museum of the City of New York*

MRS. JOSEPH ANDREWS
UNKNOWN ARTIST
*Owned by Museum of the City of New York*

[ 95 ]

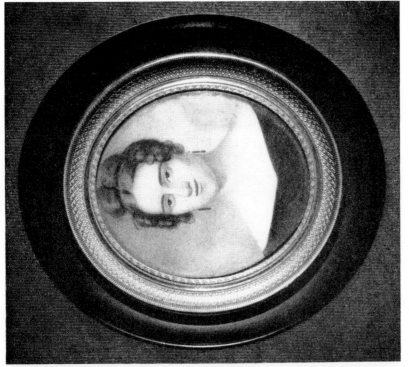

UNIDENTIFIED LADY
UNKNOWN ARTIST
*Owned by Miss Florence Dreyfous, New York*

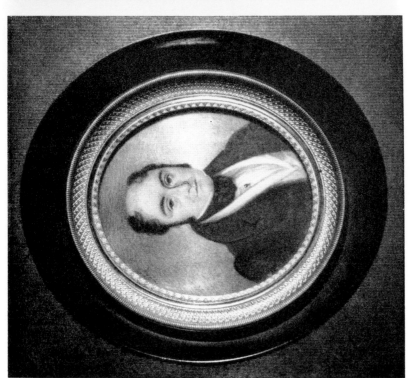

UNIDENTIFIED GENTLEMAN
UNKNOWN ARTIST
*Owned by Miss Florence Dreyfous, New York*

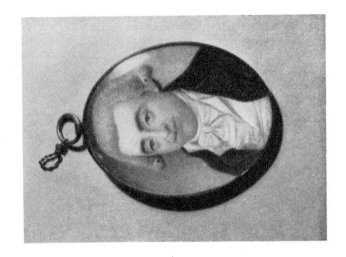

ISAAC DE LYON
UNKNOWN ARTIST
Owned by Mr. Thomas J. Tobias, Charleston, S. C.

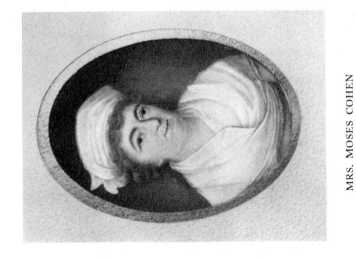

MRS. MOSES COHEN
UNKNOWN ARTIST
Owned by Mr. Thomas J. Tobias, Charleston, S. C.

[ 99 ]

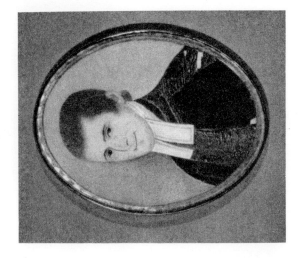

RABBI GERSHOM M. SEIXAS
UNKNOWN ARTIST
*Owned by Mrs. Annie Nathan Meyer, New York*

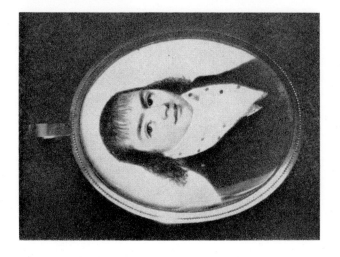

ABRAHAM TOURO
UNKNOWN ARTIST
*Owned by Newport Historical Society, R. I.*

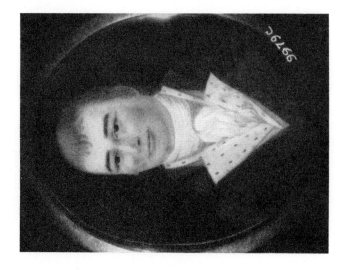

JOSHUA ISAACS, THE SECOND
UNKNOWN ARTIST
*Owned by Mrs. Benedict Bruml, Long Island City, N. Y.*

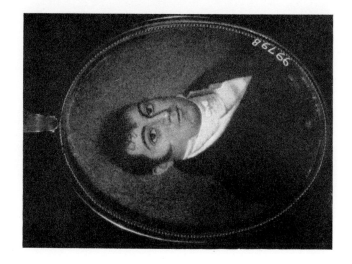

URIAH HENDRICKS
UNKNOWN ARTIST
*Owned by Mrs. Laurence Frank, New York*

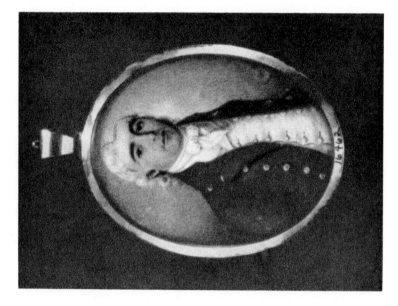

DANIEL HART
UNKNOWN ARTIST
*Owned by Mrs. David Hart, Denmark, S. C.*

ABRAHAM MOISE
UNKNOWN ARTIST
*Owned by Mrs. August Kohn, Columbia, S. C.*

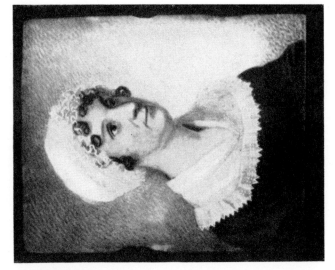

MRS. NAPHTALI PHILLIPS
UNKNOWN ARTIST
*Owned by Captain N. Taylor Phillips, New York*

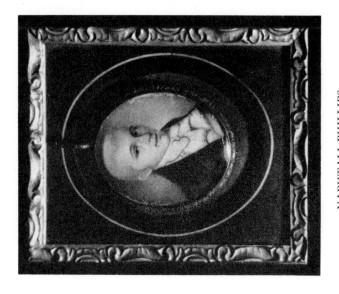

NAPHTALI PHILLIPS
UNKNOWN ARTIST
*Owned by Captain N. Taylor Phillips, New York*

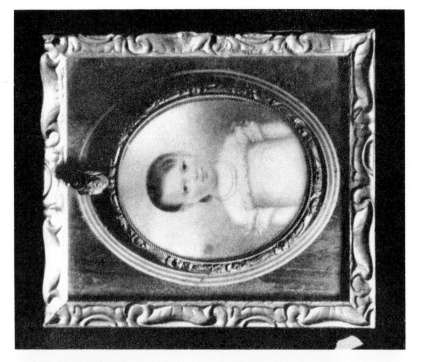

ADOLPHUS SIMEON SOLOMONS
UNKNOWN ARTIST
*Owned by Captain N. Taylor Phillips, New York*

JOHN SOLOMONS
UNKNOWN ARTIST
*Owned by Captain N. Taylor Phillips, New York*

MRS. ZALEGMAN PHILLIPS
UNKNOWN ARTIST
*Owned by Mrs. William Moran, Sumter, S. C.*

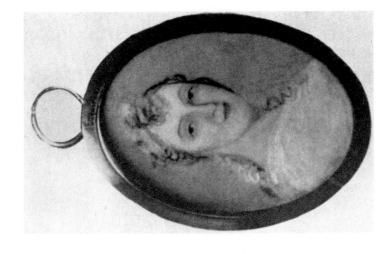

MRS. SOLOMON ETTING
UNKNOWN ARTIST
Owned by Maryland Historical Society, Baltimore

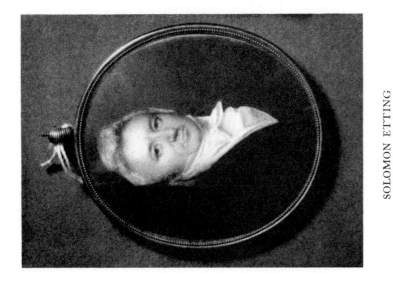

SOLOMON ETTING
UNKNOWN ARTIST
Owned by Maryland Historical Society, Baltimore

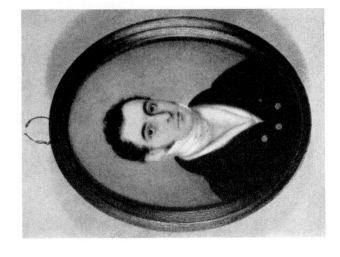

BENJAMIN ETTING
UNKNOWN ARTIST
Owned by Pennsylvania Academy of the
Fine Arts, Philadelphia

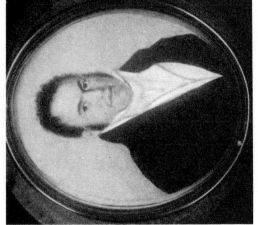

JUDAH ELEAZER LYONS
UNKNOWN ARTIST
Owned by American Jewish Historical
Society, New York

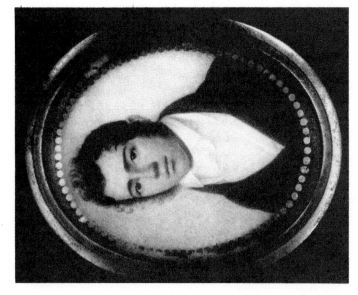

ISAAC LOPEZ BRANDON
UNKNOWN ARTIST
*Owned by American Jewish Historical Society, New York*

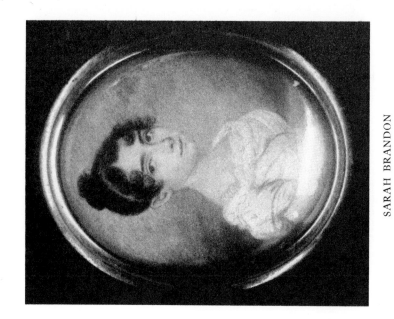

SARAH BRANDON
UNKNOWN ARTIST
*Owned by American Jewish Historical Society, New York*

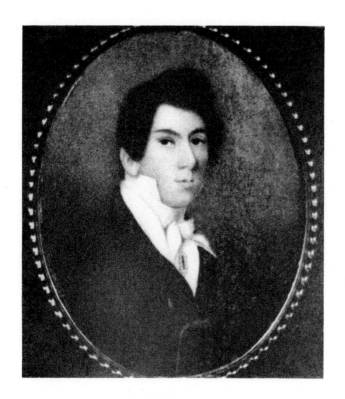

JACOB DE SOLA
UNKNOWN ARTIST
*Owned by Dr. S. De Sola, New York*

SAMUEL MYERS
UNKNOWN ARTIST
*Owned by Mrs. Edmund M. Preston, Richmond, Va.*

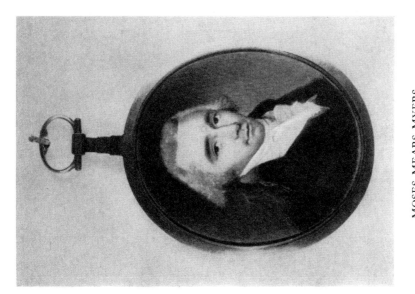

MOSES MEARS MYERS
UNKNOWN ARTIST
*Owned by Mrs. Brooke Mordecai, Madera, Cal.*

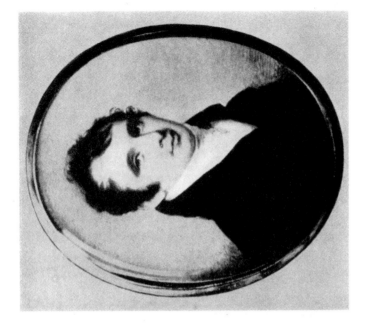

SOLOMON MOSES
*By* EDWARD GREENE MALBONE
*Owned by Miss Kathleen M. Moore, Westmount, P. Q.*

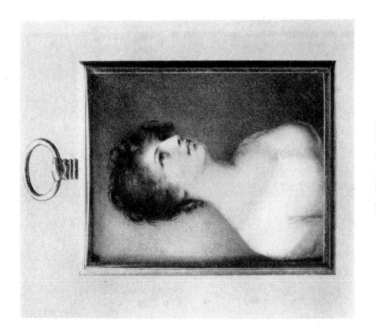

RACHEL GRATZ
*By* EDWARD GREENE MALBONE
*Owned by Mrs. John Heard Hunter, Savannah, Ga.*

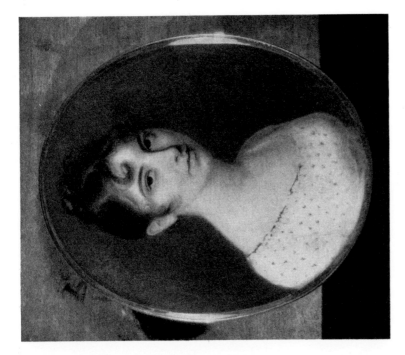

REBECCA GRATZ
By Edward Greene Malbone
Owned by Mrs. Carrie M. Serra, Westmount, P. Q.

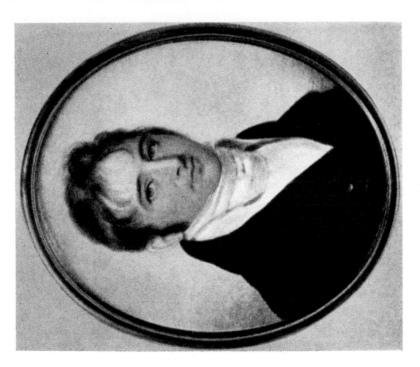

DAVID MOSES
By Edward Greene Malbone
Owned by Miss Miriam Dent, Brunswick, Ga.

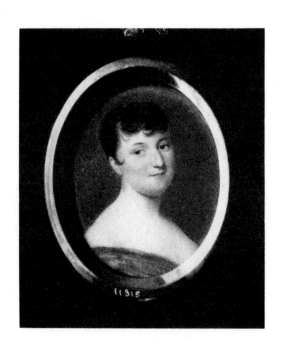

REBECCA GRATZ
*By* ANNA CLAYPOOLE PEALE
*Owned by Mrs. Andrew Van Pelt, Radnor, Pa.*

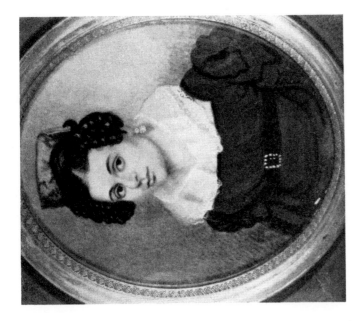

ELIAS ABRAMS
*Attributed to* HENRY INMAN
*Owned by Mrs. Annabel J. Nathans, New Orleans, La.*

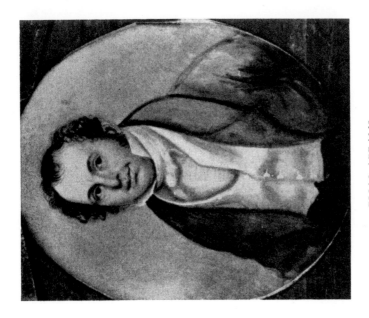

MRS. ELIAS ABRAMS
*Attributed to* HENRY INMAN
*Owned by Mrs. Annabel J. Nathans, New Orleans, La.*

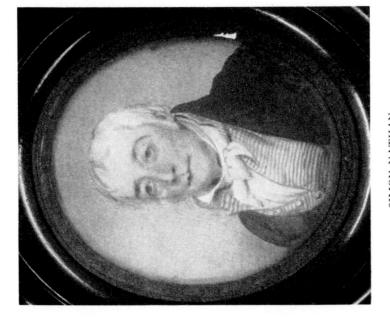

SIMON NATHAN
By Henry Inman
Owned by American Jewish Historical Society, New York

MRS. SIMON NATHAN
By Henry Inman
Owned by American Jewish Historical Society, New York

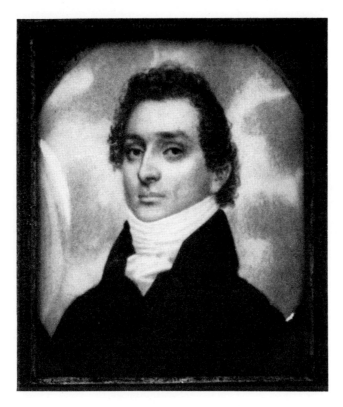

MAURICE LEVY (LEWIS)
*By* EZRA AMES
*Owned by Metropolitan Museum of Art, New York*

J. ALTAMONT PHILLIPS
*By* HUGH BRIDPORT
*Owned by Pennsylvania Academy of the Fine Arts, Philadelphia*

COMMANDER JOSEPH MYERS
*By* HUGH BRIDPORT
*Owned by Mr. Thomas L. Preston, Washington, D. C.*

[ 135 ]

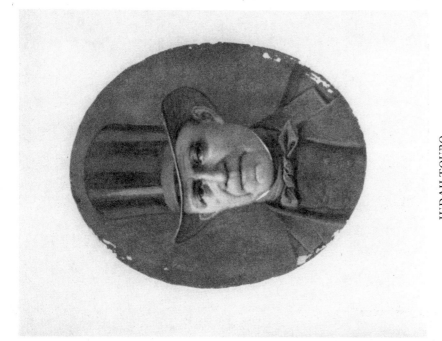

JUDAH TOURO
*By A. D. Rinck*
*Owned by Louisiana State Museum, New Orleans, La.*

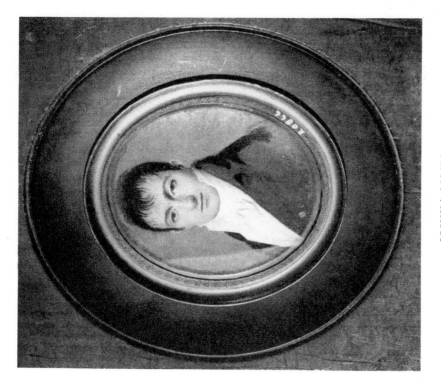

JOSHUA MOSES
*By Louis A. Collas*
*Owned by American Jewish Historical Society, New York*

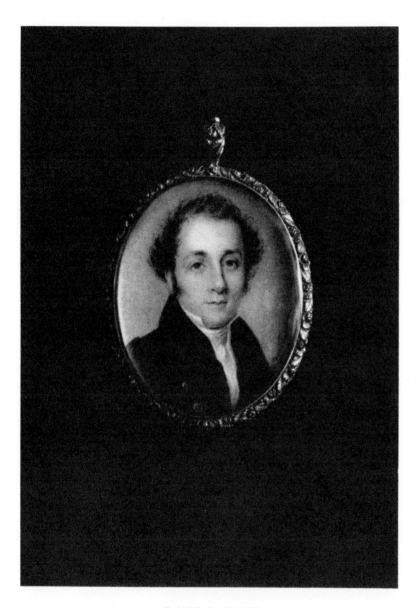

DAVID I. COHEN
*By* JOHN WESLEY JARVIS
*Owned by Mrs. Arnold Burges Johnson, New York*

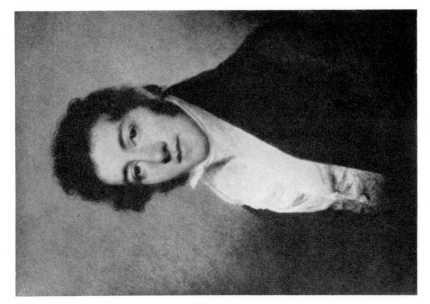

BENJAMIN I. COHEN
By JOSEPH WOOD
Owned by Maryland Historical Society, Baltimore

SAMUEL ETTING
By JOSEPH WOOD
Owned by Pennsylvania Academy of the Fine Arts, Philadelphia

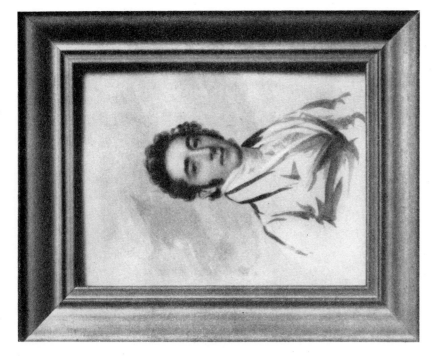

BENJAMIN I. COHEN
*By* BENJAMIN TROTT
*Owned by Maryland Historical Society, Baltimore*

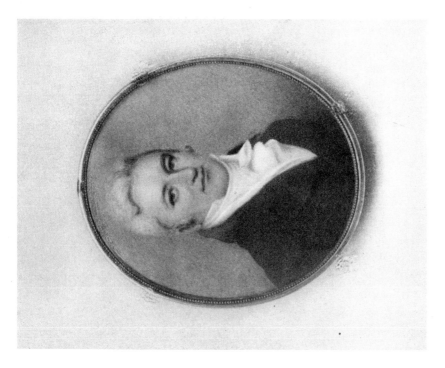

SOLOMON ETTING
*By* BENJAMIN TROTT
*Owned by Pennsylvania Academy of the Fine Arts, Philadelphia*

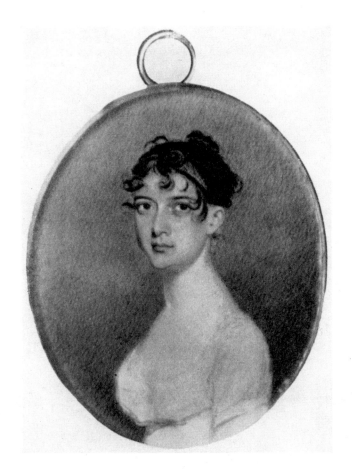

MRS. JACOB MYERS
*By* BENJAMIN TROTT
*Owned by Maryland Historical Society, Baltimore*

OCTAVUS COHEN
*By* CHARLES FRASER
*Owned by the Misses Phillips, Savannah, Ga.*

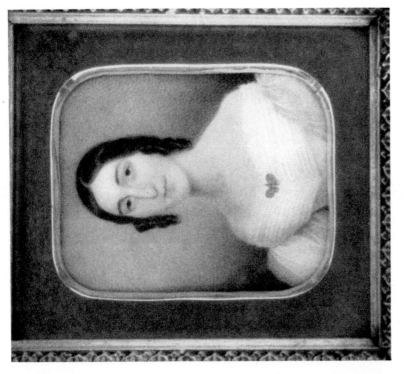

MORDECAI M. LEVY
*Attributed to* CHARLES FRASER
*Owned by Mrs. Jacob S. Raisin, Charleston, S. C.*

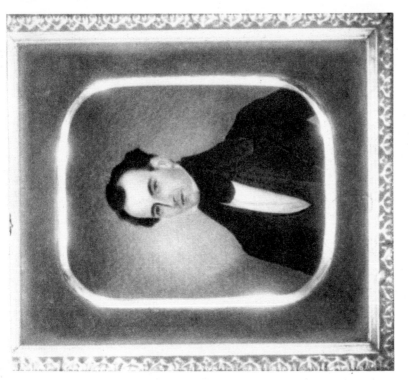

MRS. MORDECAI M. LEVY
*By* CHARLES FRASER
*Owned by Mrs. Jacob S. Raisin, Charleston, S. C.*

# INDEX

Abrahams, Edmund H., 20
Abrahams, Mrs. Edmund H., 20, 66, 71
Abrams, Elias, 45, 64, portrait 129
Abrams, Mrs. Elias (Catherine Cohen)
  45, 46, 64, portrait 129
Alexander, Abraham, Sr., 14, 68,
  portrait 83
Allston, Washington, 37
American Jewish Historical Society, 12,
  33, 34, 46, 50, 56, 63, 64, 65, 69, 70
Ames, Ezra, 47, 48, 63, 133
Ames, Julius R., 48
Anderson, P. Chauncy, 69
Andrews, Joseph, 23, 68, portrait 95
Andrews, Mrs. Joseph (Sally Salomon),
  23, 69, portrait 95
Arthur, Stanley C., 51
Augustin, 4

Barnard, Philip A., 48, 63
Benbridge, Henry, 8
Bent, Rev. Rufus H., 13, 14, 67
Birch, William, 8
Bolton, Theodore, 9
Bone, Henry, 5
Bortman, Mark, 40
Boucher, 4
Brandon, Isaac Lopez, 34, 69, portrait
  117
Brandon, Sarah, 34, 49, 69, portrait 117
Brickner, Mrs. Walter M., 20
Bridport, Hugh, 48, 49, 63, 135
Bruml, Mrs. Benedict, 27, 70
Bush, Mrs. (Becky Myers or Mears), 69

C. A., 63
Catlin, George, 9
Clark, Alvan, 9
Clouet, François, 3
Clouet, Jean, 3
Clovio, Giulio, 3
Coale, Mrs. Harriet Cohen, 66
Cohen, Benjamin I., 54, 56, 68, 69,
  portraits 141, 143
Cohen, Mrs. Benjamin I., 69
Cohen Collection, 32, 54, 56

Cohen, David I., 53, 54, 65, portrait 139
Cohen, Mrs. Edward Caroline, 35, 48
Cohen, Eleanor S., 32, 40, 53, 56
Cohen, Isabel, 70
Cohen, Jacob I., 66
Cohen, Lucretia, 64
Cohen, Mrs. Moses, 24, 69, portrait 99
Cohen, Octavus, 57, 64, portrait 147
Cohen, Rachel Etting, 54
Cohen, Solomon, 69
Collas, Louis A., 49, 50, 63, 137
Cooper, Samuel, 4, 37
Copley, John Singleton, 8, 12, 17
Cosway, Richard, 4, 37
Cummings, T. S., 9

Da Ponte, Fanny, 69
Da Ponte, Lorenzo, 69
Da Ponte, Mrs. Lorenzo, 69
De Leon, Jacob, 12, 13, 67, portrait 79
De Lyon, Isaac, 24, 69, portrait 99
De Lyon, Judith. See Mrs. Moses Cohen
Dent, Miriam, 39, 66
De Sola, Mrs. Clarence I., 15, 66
De Sola, Jacob, 34, 69, portrait 119
De Sola, Dr. S., 34, 69
Dickinson, Anson, 9, 51, 64
Dodge, John Wood, 9
Dreyfous, Esther Andrews, 23, 24
Dreyfous, Florence, 13, 23, 71
Dreyfous, Simeon, 23, 24
Dumont, 4
Duncan, Mrs. See Anna Claypoole Peale
Dunkerley, Joseph, 8
Dunlap, William, 9, 12, 37, 57

Elouis, Henri, 8
Elzas, Dr. Barnett A., 70
Engleheart, George, 4
Etting, Benjamin, 19, 33, 43, 69,
  portrait 115
Etting, Elihu or Elijah, 18, 19, 55, 67,
  portrait 89
Etting, Miriam. See Mrs. Jacob Myers
Etting, Reuben, 18, 19, 66, 69, portrait
  91

Etting, Mrs. Reuben (Frances Gratz),
  19, 20, 40, 66, portrait 91
Etting, Samuel, 55, 68, portrait 141
Etting, Solomon, 18, 19, 32, 33, 54, 55,
  56, 68, 70, portraits 113, 143
Etting, Mrs. Solomon, 17, 33, 35, 55,
  70, portrait 113

Field, Robert, 8, 55
Foster, Benjamin R., 51
Fragonard, 4
Frank, Mrs. Laurence, 27, 70
Franks, Col. David S., 15, 66, portrait 85
Fraser, Charles, 9, 53, 55, 57, 58, 64,
  147, 149
Freeman, George, 8
Frick Art Reference Library, 27, 45, 50
Fromkes, Harry, 2
Fulton, Robert, 8, 55, 70

Goldbaum, Miriam, 14, 67
Gomez, Miss, 13, 67, portrait 81
Gomez, Benjamin, 70
Goodridge, Sarah, 9
Gratz, Barnard, 17, 18, 33, 67, portrait
  87
Gratz, Frances. See Mrs. Reuben Etting
Gratz, Rachel, daughter of Barnard.
  See Mrs. Solomon Etting
Gratz, Rachel, 38, 39, 40, 41, 65,
  portrait 123
Gratz, Rebecca, 20, 38, 40, 41, 45, 65,
  66, portraits 125, 127

Hall, Ann, 9
Hart, Mrs., 64
Hart, Charles Henry, 19
Hart, Daniel, 28, 70, portrait 105
Hart, Mrs. Daniel, 28, 70
Hart, Mrs. David, 28, 70
Hart, Jane. See Mrs. Mordecai Levy
Hays, Mr., 64
Hays, Samuel, 70
Hendricks, Harmon, 65
Hendricks, Henry S., 65
Hendricks, Uriah, 27, 70, portrait 103
Hesselius, John, 8
Hilliard, Nicholas, 4

Hoffman, Mrs. J. Ogden, 39, 41, 65
Hone, Horace, 4
Hone, Nathaniel, 4
Hoskins, John, 4
Hoskins, John, Jr., 4
Humphrey, Ozias, 4
Hunter, Mrs. John Heard, 39, 65

Inman, Henry, 9, 41, 45, 46, 47, 54,
  64, 129, 131
Irving, Washington, 41
Isaacs, Mr., 64
Isaacs, Joshua, the Second, 27, 70,
  portrait 103
Isabey, 4, 37
Israel, Israel, 70

Jacobs, Mrs., 64
Jacobs, Myer, 70
Jarvis, John Wesley, 9, 46, 53, 54, 55,
  65, 139
Johnson, Mrs. Arnold Burges, 53, 65
Joseph, Henry, 39

Karigal, Rabbi Raphael H., 67
Kendall, Mrs. Elvira Ellet, 70
Kidd, Henrietta Eliza, 65
Kohn, Mrs. August, 27, 70
Kursheedt, Misses, 65
Kursheedt, Edwin Israel, 65
Lazarus, Mr., 64
Lederer, Mrs. Grace N., 68
Lemann, Monte M., 51
Leo, Mrs. Ansel, 11, 67
Levy, Mr., 67
Levy, Aaron, 70
Levy, Arthur Lumley, 48, 63
Levy, Mrs. Arthur Lumley
  (Louise Barnard), 48, 63
Levy, Mrs. David Cardoza, 63
Levy, Eugenia, 64
Levy, Florence N., 48, 63
Levy, Jacob Clavius, 57, 64
Levy, Mrs. Jacob Clavius, 57, 64
Levy, Maurice (Lewis), 47, 63, portrait
  133
Levy, Mrs. Michael (Rachel Phillips),
  70

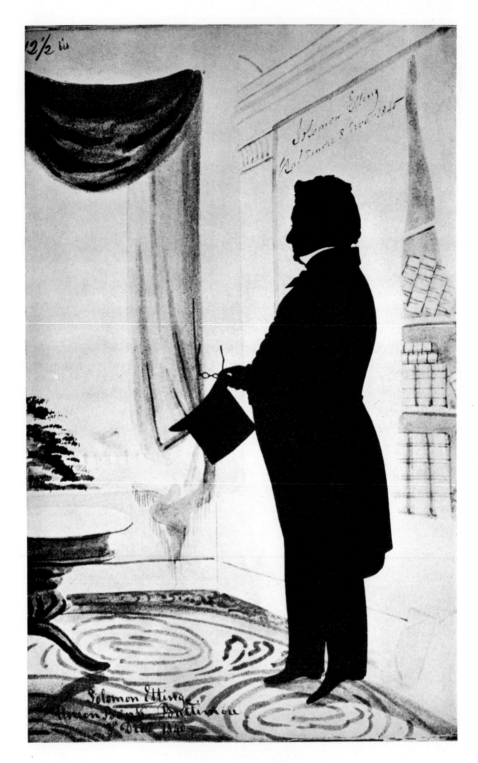

SOLOMON ETTING
*By* AUGUSTIN EDOUART
*Courtesy of the late Mr. Erskine Hewitt, New York City*

# Shades of My Forefathers

BY

HANNAH R. LONDON

WITH A FOREWORD BY

JOHN HAYNES HOLMES

FOR ROBERT

# CONTENTS

[ III ]

# LIST OF ILLUSTRATIONS

[VI]

# FOREWORD

PORTRAITS *of Jews by Gilbert Stuart and other Early American Artists** was an unforgettable book. Miss London did a priceless service in assembling a superb collection of pictures, in showing through these pictures the conspicuous and impressive part played by Jews in the early years of the American republic, and in revealing the altogether extraordinary character and culture of these Jews. Happy the nation which has such men and women among its citizens!

In this second book Miss London repeats her original unique achievement. In addition to portrait paintings, she has now found great numbers of early American silhouettes, and among these, as among the paintings, many Jewish faces and figures. With abounding enthusiasm and untiring energy, she has gathered together some fifty of these silhouettes of Jews and published them in this handsome volume, together with accompanying chapters of comment and description which themselves have great artistic and historical value.

*Shades of My Forefathers* interests me enormously from at least two points of view:

First, there is the endless fascination of the silhouette as a form of portraiture. Its origins in the profile pictures of ancient times, its development into a definite technique in modern times, its wide-spread practice by a variety of artists in the first half of the nineteenth century, comprise a chapter in the history of art which is as absorbing as it is important. Such shadow portraits as those included in this volume reveal accomplishment of rare distinction. There is beauty as well as character depic-

*Published by William Edwin Rudge; New York, 1927.

tion in this work. One almost feels regret at the appearance of photography which brought suddenly to an end a most delicate and difficult form of art.

Secondly, there is the momentous record contained in this book of the place held by the Jews in the social, commercial and cultural life of early America. Here Miss London repeats and extends the impression conveyed by her volume of *Portraits*. Some of the Jews presented in these pages are the same as in the earlier book. But most of the men and women are new, and yet embody the same pre-eminent qualities of personal grace and intellectual and spiritual power. These are remark- able people — men of high standing and repute, women of exceptional beauty and refinement, citizens of indispensable value to a free and enlightened community. Miss London's first collection of pictures was hailed as "a most valuable con- tribution to the history of the Jews in the United States." This second gallery is a fresh contribution of similar value. The two books constitute together an unanswerable challenge to the ignorance and indecencies of anti-Semitism.

I count it a privilege to place on record, here, my sense of indebtedness to Miss London. To speak with her, and to pore over her pages, is to discover that she has found her work itself to be a rich reward. But to this must be added the immeasur- able gratitude of all who would further the cause of truth, goodness and beauty in the world.

JOHN HAYNES HOLMES

# PREFACE

AFTER the publication of my book, *Portraits of Jews by Gilbert Stuart and other Early American Artists,* my attention was directed to a number of silhouettes of American Jews listed in the *Catalogue of American Portraits by August Edouart.*

This *Catalogue* compiled by Mrs. E. Nevill Jackson, the well-known English authority on silhouette history, lists thirty-eight hundred profiles, signed and dated by the artist, who visited us here from 1839 to 1849.

The silhouettes listed were compiled from Mrs. Jackson's own collection of Edouart's American profiles, and most of them, I was informed could be seen at the home of Reverend Glenn Tilley Morse of West Newbury, Massachusetts, most renowned of the silhouette enthusiasts.

It was always delightful to spin over the road to West Newbury, taking the Turnpike, and cutting through at Dummer Academy over the quiet and winding back-roads, enchanted alike by hill-top views and picturesque New England cottages to visit Mr. Morse and chat with him about his hobby.

He treasures by far the most extensive American collection of profile portraits by foreign and native artists; every type and size are represented. Some of these were snipped with scissors; some were hollow-cut; others painted, drawn, engraved, or modeled.

Arresting the attention are striking portraits in original frames of mellowed maple, and group profiles mounted against lithographed or sepia-washed backgrounds. There are miniature silhouettes on rings and in brooches tucked away in

cabinets, and upstairs is the famous Edouart Collection of American profiles hanging on the walls or filed away in folios.

It was no easy task to single out the Edouart silhouettes of Jews. But with Mr. Morse's kind assistance a few were found at each visit. At length it seemed expedient to assemble them for this book with other silhouettes tracked down from various sources.

As my collection grew apace, I would often think of the late Mr. Frank W. Bayley, whom I assisted at the Copley Gallery, Boston. Here I was first enthralled by research in American art. He was interested in my work, as was also the late Lawrence Park, eminent antiquarian. I owe much to their kindness. I also wish to express my thanks to the following from whom I have received inspiration and encouragement in the publication of my work: the late Frederic F. Sherman, Mr. John D. Pond, my publisher; Reverend John Haynes Holmes, Mr. Lee M. Friedman, Mr. Roger W. Straus, Reverend Henry Wilder Foote, Mr. Paul M. Herzog, Mr. Mark M. Horblit, Mr. Frederick F. Greenman, Mr. Mark Bortman, and Judge Jacob J. Kaplan.

The silhouettes in the Massachusetts Historical Society, the Boston Athenæum, the Essex Institute, the Museum of the City of New York, and the American Antiquarian Society, were of great value to me, as background material to the subject. I am indebted to these Societies, as well as to the individuals from whom I have received letters and permission to copy their portraits, and to my husband, Benjamin M. Siegel, for reading the manuscript. Furthermore, I shall welcome corrections and additional information on my subject.

HANNAH R. LONDON

BROOKLINE, MASSACHUSETTS
*June, 1941*

# I
## THE PROFILE IN HISTORICAL
## PORTRAITURE

MANY accomplished profilists practised their art in America, during the colonial period to the advent of photography in 1859. These artists as well as others, have received engaging treatment in the beautifully illustrated and indispensable books on profile portraiture by Mrs. Ethel Stanwood Bolton and Mrs. Alice Van Leer Carrick of New England; by Mr. Desmond Coke and Mrs. E. Nevill Jackson of London.

I made constant reference to the valuable source material in their work, which not only enumerates the biographical history and technique of numerous craftsmen, but also reveals absorbing interest on the art in its entirety.

The delineation of the profile portrait as an art has come down to us since ancient times. Egyptian tombs with their mummy cases and frescoed walls abound in this type of portraiture. It is observed, too, in the classical vase painting of the Greeks and Etruscans; in the manuscript art of Mediæval Persia, and in the professional work of a guild of profilists of sixteenth century Constantinople.

In historical portraiture the shade revealed itself to France during the latter part of the eighteenth century when excavations in central Italy brought to light Etruscan vases ornamented with profile paintings. Patterned on motives of Greek origin, the black shadows depicted scenes in the daily life, the household arts, children happily playing at games, the hunt and warfare.

The French imitated these shades in various forms of artistry, and approached with tremendous enthusiasm the revival of classical art, prevalently expressed during this period.

The vogue for the shadow portrait received further encouragement from Madame de Pompadour, mistress of Louis XV, and from Étienne de Silhouette, financial minister, to whom in 1759 fell the task of relieving a dissolute and extravagant court from its financial difficulties.

Monsieur de Silhouette's methods, however, were scarcely approved. In satirical mood, the Parisians, soon aware of his petty methods of taxation, began to dub everything that connoted the cheap or the small — "silhouette." And the little black shade which could be bought for only a few francs came to be known by that name. The French finance minister, forced to resign, turned out some very good profile pictures when he turned to the art for a hobby.

But the word *Silhouette* was not popularly associated with the profile-picture until 1826, when Augustin Edouart, an émigré Frenchman, who had fled to England, advertised himself as "Silhouettist." Though Edouart gave the accepted name to the craft, other professionals applied the words *Skiagraphy* and *Shadowgraphy* to their art. Some profilists were known as *Scissorgraphists,* and Hubard called himself a "Papyrotomist."

Among the silhouettists of England to develop a remarkable skill, and an individual technique, were Mrs. Pyburg of London Town, who, in 1699, made profile portraits of William of Orange and Queene Mary, and a Mrs. Harrington, known to have practised her art in 1775. We read of Miers and Field of London, who painted profiles on chalk, of the celebrated Charles, of a Mrs. Beetham's exquisite work, and the popular Rosenberg of Bath. Outstanding in the field were also Hubard,

Hankes, and Edouart who cut accurate likenesses with amazing rapidity.

Interesting examples of their silhouettes were collected by the late Mr. Montague Guest and subsequently purchased by Mr. Francis Wellesley. Some of them illustrate his exquisite and notable book, *One Hundred Silhouette Portraits Selected from the Collection of Francis Wellesley.*

The fashion for the silhouette was not only a great success in England, where amateurs and professionals vied with one another to create and excel, but it was carried over into Russia whence Mr. Glenn Tilley Morse says he has seen the very finest examples. In Austria the silhouette was sponsored by the royal family who took to the art for pastime, and in Germany it was extensively used for book illustrating.

Here it was further popularized by John Caspar Lavater, clergyman of Zurich, who wrote *Essays on Physiognomy Calculated to Extend the Knowledge and the Love of Mankind.* This scientific tome is profusely illustrated by silhouette portraits to emphasize his theory that the features and contour of the head reveal an understanding of the human soul.

Many silhouettes were sent to Lavater in the expectation of an interesting character reading, or with the hope of sudden fame in the event that Lavater would favorably use the portrait in his publications.

Even Goethe practised the art, which fascinated him. And its popularity was enhanced by numerous exhibitions, held during the eighteenth century, at Berlin, Brünn, Danzig and Düsseldorf, when royalty, warriors, statesmen, artisans of every profession — the great and small — were featured in the shadow portrait.

The silhouette flourished also during the Georgian period, lending itself to many forms of artistic expression. Generally

the profile was scissored, painted, or drawn, on plaster or paper. Exquisite reductions to miniature size, mounted in rings and pins, and set with jewels were often made for gifts. The profile was also modeled in wax, engraved on copper, or printed in books. It was practised in China painting and etched on glass. Many examples of this latter work, colored, in black, or in clear white, are found in the Victoria and Albert Museum.

In the Theatre, as well, the shadow portrait proclaimed itself. Old Egypt, China, India, and Java made use of the shadow-portrait in their silhouette theatre. Still enacted in Java are their legendary scenes handed down from generation to genera-tion, of which Mr. Hubert Stowitts has captured the spirit in his paintings, recently exhibited at the Boston Museum of Fine Arts.

In Javanese traditional manner little puppets were carved and painted; their shadows were projected on a white screen, while the performers remained hidden and the various parts were spoken. The illusionary effects thus created are revealed in an eleventh century record, culled from Mrs. Anne Holliday Webb's accompanying article on the Stowitts exhibit. "There are some who looking at the figures on the stage, do weep, feel sad, and are bewildered, though they know them to be only cut leather that pretends to speak."

With its historic and artistic background, the profile portrait whether scissored, drawn, or painted, engraved or modeled remains a notable collector's item. Before the advent of photog-raphy in this country, in 1859, this form of portraiture was most customary. It was inexpensive and its novelty captured the fancy of the Americans.

Recently — but long after collecting the material for this book — at the request of Mr. Carl J. Wennerblad, State Direc-

tor of the Massachusetts Historical Records Survey, I launched a *Federal Survey* of profile portraits.

Excluding the four thousand profile portraits in the Glenn Tilley Morse Collection, the *Federal Survey* lists about six thousand American profiles. Included are the portraits illustrated or mentioned in publications and collections. We noted all the silhouettes in the Essex Institute and the Peabody Museum, of Salem; the Todd Album from the Boston Athenæum; the Henry W. L. Dana Collection, with its Class Album of Bowdoin College, 1825; the Bostonian Society; the Wadsworth Athenæum and the Henry Erving Collection in Hartford.

In addition many Historical Societies and Universities throughout the country reported on their profile portraits, as did many individuals who treasure ancestral shades.

The late Mr. Frederic F. Sherman, author of a number of important publications on early American portraiture, sent me a list of the profile portraits in his possession together with collected notes on various profilists. Their names, unfamiliar to me, are Alexander H. Emmons, Galoway, G. Catlin, Silas Dewey, Mary B. Tucker, and Justin Salisbury.

The manuscript, *Workers with Line and Color in New England, 1620-1870,* by Mr. Charles K. Bolton which reposes in the Boston Athenæum, notes other unfamiliar names of profilists. William Stevenson, a silhouettist of Vermont, 1822, is mentioned here as well as a Mr. Elliot, and a James Guild of Vermont, who traveled widely, kept an amusing diary, and was a great wag.

The work of all these artists should be included in the *Survey,* if it is ever resumed. Then, too, there are many silhouettes to be noted in Bache's Scrapbook, owned by Mrs. C. R. Converse, of Elmira, New York, and those in the possession of Mrs. Maurice P. Spillane, of Quincy, and Mr. Mark A.

De Wolfe Howe, of Boston. The late Mrs. Robert Hale Bancroft owned a sizable collection, as did also the late Mr. Erskine Hewitt, of New York. The silhouettes in the American Antiquarian Society, the New York Historical Society, and the Metropolitan Art Museum, should also be listed. Information on these silhouettes would make a notable contribution to the history of profile portraiture in this country.

The modeled portraits in wax are noted in the *Federal Survey of Portraits for New York and New England,* under the direction of Mr. Charles K. Bolton, the former librarian of the Boston Athenæum.

When, for financial reasons, the *Silhouette Survey* was unfortunately terminated in December, 1936, Mr. Bolton wrote:

I have read the outline of your work with appreciation. Mr. Wennerblad and I both had faith in you. I too am sorry to have the work stop at this point — yours and mine. It was work of permanent value. But there is a call for economy in Washington and we were obvious targets.

Many silhouettists are represented in the *Federal Survey.* The hollow-cut variety abounds in the work of William Bache, William Chamberlain, Moses Chapman, William M. S. Doyle, Everet Howard, F. P. Jones, William King, R. Letton, Charles Willson Peale, George (?) Todd, and Henry Williams.

There are profiles in natural tints by Cottu, Michel Felix Cornè, Augustus Day, Thomas Edwards, James Sanford Ellsworth, Fevret de Saint-Mémin, Thomas Gimbrède, William James Hubard, John Wesley Jarvis, Rembrandt Peale, Edwin Plummer, Essex Ridley, Rossiter, and T. Nixon.

Also listed are the profiles painted in India ink by William Bache, Samuel Folwell, Jean François Vallée, John Joye, and others. A. B. Doolittle, C. P. Polk, and Joseph Wood engraved

on gold; they, too, are noted. Of course, many of the silhou-ettists displayed versatility in varying their technique.

Included in the *Survey* are profile drawings by Fevret de Saint-Mémin taken with a physionotrace, as well as his reduced engraved portraits.

Then there are the scissored profiles. They were taken full-length by Augustin Edouart, William Henry Brown, William James Hubard, Philip Lord and Samuel Metford. Cut and pasted they were mounted on plain, lithographed, or water-colored backgrounds. Hubard also expressed himself in the scissored bust profile, as did Master Hankes.

Wafered in the pages of Mrs. Bolton's own copy of her book, *Wax Portraits and Silhouettes,* are valuable notes on some rather obscure silhouettists, which I noted in the *Survey.* Among them, a hollow-cutter, John Thompson; Mr. J. H. Gillespie, of London, who worked in Halifax; E. Metcalf, and Samuel Moore. She also writes of Martin Griffing of Rich-mond, Massachusetts. Crippled for life, at twenty-two, after a fall from a church steeple, which he was painting, he became a profilist. He worked in Berkshire and adjoining counties, in Vermont and New York State. Where are his silhouettes?

If the *Survey* is eventually concluded it will provide much useful information on the subject. The silhouette, like the family Bible, often yields invaluable records. Very often a profile portrait is inscribed with the name of the sitter and artist; also dates, an occupation, and a place of residence, sup-plied by the profilist or furnished by the sitter or some member of his family.

The completed study would also reveal the identity of a number of silhouettists, whose work is neither stamped nor signed, by the method they employed. The bust line frequently distinguishes some profilists; or a characteristic trick of subtly

touching up the silhouette; or the foot or background. A clue, in addition, is often discovered by the frame, as some of the artists made them from their own design. And, too, many striking examples, thought to be only in the large collections will, no doubt, come to light from hidden corners.

Accumulatively they are worth thousands of dollars. For today the silhouette ranges in price from five to one hundred dollars, and unusual portraits of important people command considerably more.

Charming in their original frames, many of which can be seen in the Essex Institute, or even in reproductions, they enhance the background, whenever artistically arranged of almost any decorative scheme.

A renaissance in the art of silhouette is seen now in the work of the Baroness Eveline von Meydell, Mr. David Vernon, and Mr. Ugo Mochi.

## METHODS OF TAKING THE PROFILE
## PORTRAIT

THE various and clever methods which were employed by the artists in taking the profile portrait are in themselves absorbingly interesting.

The scissored and the modeled profile; at times, the painted and the drawn, were taken from life without mechanical intervention. Very often, too, a piece of paper fastened to the wall, caught the sitter's profile which was traced. This was an easy method for children and amateurs.

Then there were many mechanical contrivances used to take the profile portrait. One was known as the "sheet method." For this an especially made screen was constructed, of which there are many quaint prints.

The one illustrated was found in the second volume of the quarto edition of Lavater's *Essays;* another, used by Chapman in New England is reproduced in Mrs. Carrick's *Shades of Our Ancestors.* Numerous advertisements appeared of "sundry wonderful machines," variants of this mechanical method employed both here and in Europe with most effective results.

Generally a sheet of paper was fastened to the frame work of the silhouette machine, which stood upright between the subject and the artist. It was focused to take the full-size bust picture. The subject seated on a chair at the right of the machine was cast in shadow by candle or lamp-light on to the paper. The artist stood at the left half-hidden by the machine and drew the outline. Says Lavater who used such a contrivance, "Coughing, sneezing, or laughing are to be avoided, as such movements put the shadow out of place."

Usually the silhouette was reduced with perfect accuracy to a smaller size by the pantograph, known as the "Monkey." It was blacked, individualized touches were added, the outline was cut and then it was mounted.

A host of hollow-cutters generally employed mechanical means in drawing a likeness. The profile was made on white paper, and then it was incised with a sharp pen-knife or cut into with scissors, and the hollowed outline was generally mounted on a black ground of silk, velvet, or paper.

This type of silhouette was very common here. Some artists left their portraits unadorned, while others created artistic effects with soft pencilings on the hollowed outline to indicate the hair. Often clothes accessories were sketched or painted on the background — frills, collars, or buttons.

The white-heads which remained after the profiles were hollowed out, are sought by collectors as they frame very effectively against a dark ground.

## III

## THE PROFILES OF WILLIAM BACHE TAKEN
## BY MECHANICAL MEANS

I HAVE not found profile portraits of Jews by all the silhou-
ettists, chiefly, I assume, because so many profilists throve in
New England — Salem, Worcester, Boston, and other places
where the Jewish population was still inconsiderable. But I
believe my collection represents the important different types.

The scrapbook of William Bache, in the possession of his
great-granddaughter, Mrs. C. R. Converse of Elmira, New York,
contains a duplicate collection of nearly two thousand bust
profiles.

These silhouettes are not all of the hollow-cut or painted
variety with which we commonly associate Bache's work, and
of which many exquisite examples can be seen in the Essex
Institute and the Peabody Museum of Salem. In fact, almost
all of the profiles in the Bache Scrapbook were merely blacked
after the profile was mechanically taken; then, cut and pasted
into his album.

That Bache used mechanical means to take a profile is
revealed in the advertisement of his patent machine, discovered
in a Connecticut newspaper of 1810 by Mrs. Carrick. He also
used the pantograph to reduce his portraits; most of those in
the album are three to four inches in size, with a sprinkling
of miniature busts about one and one-quarter inches.

In a minute handwriting in which Bache resorts to curious
quirks and frills and which was extremely difficult to read, he
identifies in long columns at the back of the album, the first
seven hundred or more portraits. Using a magnifying glass I
copied the entire list.

Interesting names appear from all walks of life. Many are of the *haute monde*. General Washington and his wife head the list, followed by Chancellor Wythe, Thomas Jefferson, Mr. and Mrs. Randolph and Major Duval. Some names are prefixed by Doctor, Judge, or General. At times Bache jots down the occupation beside the name of the sitter. I noted a painter, a dancing master, a printer, and comedians.

As Bache traveled far and wide, many names of French, Creole, and Spanish origin appear. Unhappily page after page remain without identification — many plain-looking people, as well as the beauties of the day, some smartly bedecked in quaint millinery.

In addition the album or scrapbook, holds a scattering of delightfully painted profiles in India ink. Ruffles and stocks are touched in with Chinese white, and the exquisite treatment of curls and tendrils, evince Bache's pleasing artistry. Then, too, there was a number of hollow-cuts, their edges embellished by the artist's hand touches, and one white-head, all without identification. Some of the silhouettes are stamped "Bache's Patent," — one word over the other, in an oval, with three minute roses and leaves in between.

Bache was born December 22, 1771, at Bromsgrove, a small town in Worcestershire, England. At twenty-two he came to Philadelphia, where he established himself as a cutter of profiles. As an itinerant artist he traveled much. His work was known in New England, the South and the West Indies. In 1811 he married Miss Anna Page and settled in Wellsboro, Pennsylvania, where he bought extensive tracts of land and ran the general store. Unfortunately an accident befell him there in which he lost the use of his right hand, frustrating his career as an artist. But by that time he had no longer to make a living from his art. He was now a successful business man,

and later derived an additional income from his appointment as postmaster of Wellsboro in 1822.

A local history says, "Mr. Bache was a man of strong common sense, well read and with more than ordinary ability. He had a scientific and inquiring turn of mind, was a great lover of Nature, and had a quick and appreciative sense of the ludicrous."

If Bache had identified his entire collection, I am certain many names of Jewish interest would have appeared. A number of profiles are of Semitic appearance, but physiognomy can be as misleading as the name.

However one could be certain of No. 65 in the album, identified as "Jew Pedlar — Dutch." A handsome head with more in it, perhaps, than in his pack. No doubt a descendant of Jews who had fled the Spanish Inquisition. Perhaps someone can identify him for me. His features and bearing bespeak a man of learning. One can picture him traveling about, pack in hand, mulling over idealistic thoughts which had served and would continue to serve his people for generations — their crutch to lean on.

Then there was a Madame Leyva. I venture to say she was a French Jewess whom Bache met in his travels, or one of the Philadelphia Levy's to whose name he had given a fanciful spelling.

I found other names to suggest a Jewish origin. There was a J. Hart in miniature size; he may be Jacob Hart who was buried in the first Jewish cemetery, located in Chatham Square on the Bowery of New York, or John Hart of Baltimore, who identified himself with the Revolutionists. Then I came upon a very plain-looking Miss Pollock, and an L. Pollock, a child's head. There were also a W. Meares, a Harry Elkins, a James Moss, and two silhouettes of Mrs. Henry, one in a delightful looking Quaker bonnet. Do these belong in the Jewish category of portraits?

# IV
## HOLLOW-CUT PROFILES

EMPLOYING mechanical assistance, the versatile Charles Willson Peale, 1741-1826, was perhaps the first here to make the hollow-cut silhouette in mass production. In this type of silhouette, as previously noted, the profile generally taken by machine is incised from white paper and then mounted on a dark ground. Peale was well-known in his Philadelphia "Museum" as silhouettist, miniaturist, portrait-painter, and sculptor. His profiles are often seen stamped "Museum," "Peale Museum," and "Peale." At times the stamp includes a sur-mounted spread eagle.

The hollow-cut profile of Mr. Jacob I. Cohen in soldier's uniform sent to me by his great-great-niece, Mrs. D. Grigsby Long, of University, Virginia, is known, she writes, to have been made by Peale.

It is mounted on black ribbed silk set in an oval frame of ebonized wood with gilt inner rim. A newspaper clipping pasted on the back identifies him. A curly lock sweeps his high forehead, offset by wavy hair. His long nose and chin are well-modeled and the lid of his eye and slightly protruding lips are subtly caught.

Jacob I. Cohen was born January 2, 1744, at Oberdorf, not far from Ansbach, Bavaria. He came to this country in 1773. At first he resided in Lancaster, Pennsylvania, then moved to Charleston, South Carolina, where as a patriot soldier he enlisted in Captain Lushington's Company. He participated in the defense of Charleston, and was a member of the expedition to Beaufort in February, 1779.

It was in Virginia that he formed a successful partnership with Isaiah Isaacs, also a member of Lushington's Company. Their dissolution agreement was found written in Hebrew script. Here Cohen became a prominent citizen, a successful merchant and banker. Frequent references found in the Madison Papers show he rendered important services to the young Republic.

He organized the Beth Shalome Congregation in Richmond shortly after the Revolution. Though many of the organizers were of German origin, the service was that known to the Spanish and Portuguese Jews.

In 1782 he married Elizabeth Whitlock Mordecai, widow of Moses Mordecai. She had been born a Christian in England, but embraced Judaism prior to her marriage to Moses Mordecai by whom she had three sons. The well-known Myers family of Richmond, are among her descendants. When she died in 1804, Cohen moved to Philadelphia. He later married Rachel Jacobs, daughter of Israel Jacobs, and became President of the Mikveh Israel Congregation. He died in Philadelphia October 9, 1823.

Identifying Mrs. Israel I. Cohen, is a mellowed newspaper clipping pasted on the back of the ebonized frame, which encloses her hollow-cut silhouette. She was Judith Solomon of Liverpool, born in 1766. Her profile was also sent by Mrs. Long, a great-granddaughter. It is not known who cut the silhouette, with its long and narrow bust line.

She wears a cap with frill, over a protruding forehead, set high atop her well-poised head, and tied with a neat bow at her neck. Her prominent nose, soft mouth, and firm chin are adroitly featured by the artist.

Mr. Israel I. Cohen met Judith Solomon when traveling in Europe in 1787. They were married in Bristol, England, and

went to Mr. Cohen's home in Virginia. Seven children, six sons and a daughter, were born to them. A famous son was Colonel Mendes I. Cohen who started in 1830 on a six-year cruise around the world.

When Mr. Cohen died in 1807, his widow moved to Baltimore, where her sons became influential members of the community. Mrs. Cohen died April 5, 1837, when she was seventy-four years old. She was buried in the family burying ground in Baltimore.

In the Cohen Collection of the Maryland Historical Society there is an unattributed hollow-cut silhouette of the animated Mrs. Elijah Etting, (Shinah Solomon) crowned with awry headgear. She was born in Lancaster, Pennsylvania, in 1744, the eldest daughter of Joseph and Bilah (née Cohen) Solomon. In November, 1759, she married Elijah Etting, who was engaged in extensive trading with the Indians. Upon his death, at York, Pennsylvania, July 3, 1778, Shinah moved with her family to Baltimore where she died November 30, 1822.

They were the parents of Reuben and Solomon Etting who played distinguished parts in the early history of American Jewry. Shinah Solomon "always in spirits, full of frolic and glee, and possessing the talent of singing agreeably" captivated Captain Alexander Graydon who writes of her and the hospitality of the Elijah Ettings in his *Memoirs* dated 1773:

York, I must say, was somewhat obnoxious to the general charge of unsociableness under which Pennsylvania had always labored; or if I wrong her, I was not the kind of guest that was calculated to profit of her hospitality. Perhaps I approached her under unfavorable auspices, those of a young man debauched by evil communications; or perhaps there was want of congeniality between her manners and mine. Be it as it may, there was but a single house in which I found that sort of reception which invited me to repeat my visit; and that was the house of a Jew. In this I could conceive myself at home, being always received

with ease, with cheerfulness and cordiality. Those who have known York, at this period I am speaking of, can not fail to recollect the sprightly and engaging Mrs. E. (Mrs. Elijah Etting), the life of all the gaiety that could be mustered in the village; always in spirits, full of frolics and glee, and possessing the talent of singing agreeably, she was an indispensable ingredient in the little parties of pleasure which some-times took place and usually consisted in excursions to the Susquehanna, where the company dined, and when successful in angling, upon fish of their own catching.

It was upon one of these occasions, the summer before I met her, that she attracted the notice of Mr. John Dickinson, the celebrated author of the *Letters from a Farmer.* He had been lavish in her praise in the com-pany of a lady of my acquaintance, who told me of it, and then inferred how much I should be pleased with her when I got to York. I paid little attention to the information, having no conception that I should take any interest in the company of a married woman, considerably older than myself, and a mother of several children. The sequel proved how much I was mistaken, and essential to my satisfaction was female society; the access to a house in which I could domesticate myself, and receive attentions, not the less grateful from apparently being blended with somewhat material. The master of the house, though much less brilliant than the mistress of the house, was always good humored and kind; and as they kept a small store, I repaid as well as I could the hospitality of a frequent dish of tea, by purchasing there what articles I wanted.

An album containing some two thousand silhouettes, cut by Todd, around the year 1800, offers some interesting silhouettes of Jews. They are also of the hollow-cut variety.

This collection came into the hands of the Boston Athenæum through Mr. Charles K. Bolton, the well-known librarian and antiquarian, when it was shown him by a Boston bookseller. I think only four hundred dollars was paid for this extraordinary album. Many of the subjects have been indentified as to resi-dence by Mr. Sussex D. David of Philadelphia (S. D. D.), and by Mr. James B. Ludlow (J. B. L.).

Very little is known about the silhouettist, George (?) Todd, whose name Mrs. Carrick located in an 1810 Baltimore directory. His sitters resided all along the Atlantic coast from Massachusetts to Virginia. Many of them, no doubt, stopped at Todd's studio in Baltimore when passing through. Others must have been profiled as he traveled here and there to ply his trade.

In a section preceded by a single page lightly penciled "Baltimore," I found the youthful portrait of Miss Cohen, dainty and smart in starched neckfrill and becoming mobcap. I suppose she was of the illustrious Cohens of Baltimore.

In petal-sprigged cap is Miss Sarah Hays, also known as Sara Ann. I assume she was the daughter of Samuel and Richea Hays. Richea was the second daughter of Michael Gratz, and a sister of Rebecca Gratz. In 1836 Sara Ann married Captain Alfred Mordecai, the first Hebrew to graduate from the Military Academy at West Point. He attained international distinction in military affairs.

A letter from Rebecca Gratz, dated August 27, 1837, to her sister-in-law, Maria Gist Gratz, a gentile, of whom Rebecca was extremely fond, recalls a meeting with her niece, Sarah, at Saratoga Springs. She writes:

Sarah Hays Mordecai is a devoted mother, and rarely has her little Laura out of her arms, it is a sweet little babe — she is going to take it to Richmond, to receive grandfather's blessing — the family are all called together to see perhaps for the last time the venerable old man — his health has been declining ever since you met him here.

The "old man" was Jacob Mordecai, the father of Captain Alfred Mordecai. A son, Alfred Mordecai, Jr., followed in the footsteps of his father, and had a distinguished military career.

In 1893 when she was eighty-eight years old Sara published

*Recollections of My Aunt Rebecca Gratz by One of Her Nieces,* an important source in the intimate life of the most famous member of the Gratz family.

Sara Ann writes "nothing could be lovelier than her every day life, which commenced every morning with prayers and thanks to the Creator for support and for protecting her through the night, and ended with renewed thanks for the blessings bestowed during the day, while the record of every day's life was a lesson to everyone around her, fulfilling every duty with patience, kindness, humility and love."

The Hays family grace the album in various instances. There is a Mrs. Susan Hay, and a Mrs. Hays; George Hayes and Robert Hayes, but I cannot be certain of their Jewish origin.

"S. D. D." identifies the portrait of Mrs. "Capt." Moses as from South Carolina. She was evidently the wife of Captain Myer Moses II, — a handsome matron with beautiful regular features, gracious and noble in her bearing. I was pleased to find this likeness because another portrait of her, which was considered Sully's, had been seriously impaired by fire, and gave no idea of the beauty of her features.

Her handsome husband also was painted by Sully. Born in Charleston, South Carolina, February 10, 1779, Moses became a member of the South Carolina Legislature and a Major in the War of 1812. Painted in uniform the portrait is one of extraordinary beauty. A large thoughtful-looking forehead framed by a wealth of gray waving hair crowns a face Sully must have delighted to paint.

Mrs. Moses, née Esther Phillips, was born in Philadelphia, July 19th, 1778, daughter of Jonas Phillips and Rebecca Mendes Machado. She married Mr. Moses November 2, 1803, and after their residence in South Carolina, they moved in 1825 to New York. Her name appears in the list of women of the

Congregation Shearith Israel, 1828-1839. Myer Moses died in New York, March 20, 1833, survived by his wife and five children. Mrs. Moses died in Sumter, South Carolina, March 10, 1845.

Sally Sollomon in the section marked "Baltimore," aristo-cratic debutante, handsome in ruffled fichu is also in the col-lection, as well as a stunning *beau brummel,* Sam Solomon. His portrait bears the further identification "The Jew," written boldly across the side of the portrait. He appears in ruffled shirt frill, and his hair — though it does not show up in the illustration — is softly penciled on the original mellowed paper, from which the profile is hollowed out.

In an article by Mr. Leon Hühner, *The Jews in the War of 1812,* the name Sam Solomon, 51st Independent Regiment, appears on the "Muster Roll of Citizen Soldiers at North Point and Fort McHenry, September 12 and 13, 1814."

Other names to suggest a Jewish origin are Mrs. "Cap." Abrahams, Mr. Alexanders, Miss Ann Barnett, C. Gideon, Capt. Hayman, Sullon Isaacks, Fanny Jacobs, and R. Jacobs.

Then there is Louisa Meyers, a Mr. Myer with a prominent nose, and a Harriet Myer; a very plain looking Miss Myers appears, a Mrs. Myers of Germanic-Jewish countenance, and Mrs. Mary Myers.

The names Hart, Meyers, and Phillips, with their various spelling forms and large family trees, have always been a night-mare to me — to say nothing of the Franks family, who appeared in *Portraits of Jews.*

From Philadelphia the names, Caroline Phillips and Mrs. Jno. Phillips are perhaps Jewish, as well as Miss Eliza Schwarts, George Solomon, Frank Wise, and a Mr. Zantzinger.

Among these names, I think some interesting identifications will some day be made.

## V
## FEVRET DE SAINT-MÉMIN

A MACHINE for taking profiles was also used by Saint-Mémin who perfected the physionotrace invented by Chrétien, a Frenchman, in 1786. With this instrument, Saint-Mémin could draw a profile portrait of the face and bust with minute accuracy.

Miss Mary Martin, an authority on Saint-Mémin, writes in a monograph, *The Physionotrace in France and America,* that the apparatus was cumbersome, being five feet four inches high, but taking the portrait was not a very tiresome process for the sitter. When the cross-bar and sight were adjusted, an exact life-size profile of the subject could be traced in a few minutes.

The son of a nobleman, Charles Balthazer Julien Fevret de Saint-Mémin was born in 1770 near Dijon, France. At eighteen he was serving as a royalist in the French Revolution, and when his army was disbanded he and his family sought refuge in Switzerland, then came to New York.

The family were now poor; ancestral estates had been confiscated, and as émigrés they took to teaching and gardening to eke out an existence.

But Charles Fevret de Saint-Mémin who could draw and paint lived by his art. With the physionotrace he went to Annapolis, Baltimore, Charleston, New York, Richmond, and Washington. He made close to a thousand life-size profile portraits, a number of silhouette busts, painted profiles in water colors and some charming nature scenes.

His portraits, drawn with black crayon on pink paper,

faithfully produce not only the profile, but the dressing of the hair, the neckwear and the clothing. These bust portraits, about twenty-three by seventeen and one-half inches, were reduced by the pantograph to two inches in diameter and engraved.

The pantograph in the eighteenth century was called the "Stork's Beak" or "Monkey." It is described as consisting "of two triangles so joined by hinges that they resemble a movable square, which is fixed at one point of the base of the drawing, while a point of the larger triangle follows the outline of the life-size silhouette. A pencil attached to the smaller triangle traces the outline smaller, and with perfect accuracy. By repeating these reductions, silhouettes could be made in brooch and locket size." Something like this contrivance is often used by children to reduce the outline drawings found in their picture-books.

Saint-Mémin was very successful in his work. He sold the original life-size drawing, and the reduced twelve engraved prints, to his sitter for thirty-three dollars.

Even at the time it was a good price to fetch, as Copley charged only fifty dollars for a bust portrait and Stuart's price was one hundred dollars. But today Saint-Mémin's charcoal portraits are worth much more than their original cost. When I was assisting the late Mr. Frank W. Bayley, of the Copley Gallery, he asked as much as five hundred dollars for one drawing. Of course, the importance of the subject has much to do with the price of any portrait, especially if it is an excellent example of the artist's work. Saint-Mémin's sitters, who must have paid him about twenty-five thousand dollars, make their gracious appearance in almost all of our eastern Historical Societies.

Two large collections of the engraved portraits were taken

by Saint-Mémin to France. One collection was brought here by J. B. Robertson, an English print seller, and bought by Elias Dexter of New York, who photographed and published it in 1862. This collection numbering seven hundred and sixty-one prints was then bought by Mr. H. L. Carson of Philadelphia, and was sold at auction for forty-eight hundred dollars in 1899.

The second and larger collection was purchased by Mr. Henry Stevens of London, and is now the property of the Corcoran Gallery in Washington. In this collection there are over eight hundred portraits, five silhouettes, and nine views.

Dr. William J. Campbell of Philadelphia, for some time has been collecting the engraved portraits, of which he now has over eight hundred. The Pierpont Morgan Library, the Boston Art Museum, the Metropolitan Museum, and the Bibliothèque Nationale also treasure interesting collections of the engraved portraits.

They are a charming representation of the social, political, and business world of the day. Very handsome are the men, in frilled shirts, unruly locks, or dressed wigs. Among them are the Barclays, the Baches and Beekmans; Washington, Jefferson, and Madison; and the generals, Alexander Macomb and James Clinton. Gracious looking women, too, adorn the collections, their regal heads resplendent in curls and becoming headdress.

A number of portraits are of Jewish interest. Henry Alexander, who was known to have been a Jewish merchant in Baltimore, was drawn in 1803 by Saint-Mémin. His engraved portrait is found in the Saint-Mémin Collection of the Corcoran Gallery.

Abraham Hart of New York had his portrait made in the year 1796. He married Sarah, the daughter of Aaron Storck, who had come from Holland, to these shores, in 1807. Their

son, Abraham, born in Philadelphia, married Rebecca Mears of New York, daughter of Samson Mears and Catherine Cohen Isaacks, descendants of exiles of the Spanish Inquisition. The elder Hart's profile is found in the Dexter Publication.

In the Charles Tyler Saint-Mémin Collection in the Boston Museum of Fine Arts, I found a profile of Judge Moses Levy, engraved by Bouchardy, a successor of Chrétien, of Paris. It is a lovely soft engraving representing Levy with a wealth of curly hair, long Semitic nose and distended nostrils, as in the Peale portrait reproduced in *Portraits of Jews*. As the Saint-Mémin profiles are known to be accurate, the Peale portrait must have been an excellent likeness.

Judge Levy, 1758-1826, was the son of Samson Levy, Sr., and the grandson of Moses Levy who came here in 1695. He was graduated from the University of Pennsylvania, which he entered as a student in 1772, and was admitted to the Bar in 1778.

The late Mrs. Robert Hale Bancroft, of Beverly, a great-granddaughter, said he served in the Battle of Trenton, and that she treasured his commission. He also received an invitation to meet General Lafayette when he returned to this country after the Revolution. Levy distinguished himself as a lawyer and Judge and as a member of the Pennsylvania Legislature. He married June 21, 1791, Mary Pearce of Poplar Neck, Cecil County, Maryland. She was one of the bridesmaids to Peggy Shippen, the second Mrs. Benedict Arnold.

Levy's daughter, Martha, became the wife of Hugh Nelson of Virginia. She was also profiled by Saint-Mémin, and the engraving is in volume six in the Collection of the Pierpont Morgan Library.

A drawing by Saint-Mémin of Samson, Jr., 1761-1831, Judge Levy's brother was owned by Mrs. Bancroft. For some time

this portrait has been on loan with the Boston Museum of Fine Arts. Samson, too, was a lawyer. He was admitted to the Bar in 1787, and was a member of the Pennsylvania Academy of Fine Arts. He was known as a "unique and curious compound of wit, shrewdness, and courage."

Samson Levy's handsome wife, Sarah Coates, and his mother, gentiles, were also done by Saint-Mémin. They are reproduced in the Dexter Publication.

The Levys were all socially prominent in Philadelphia, where they were members of the exclusive Dancing Assembly. They intermarried, became converts to Christianity, and are buried in St. Peter's Church Yard, Philadelphia.

Mrs. Bancroft was very proud of her Jewish ancestry, and delighted to dwell upon it. She brought forth her genealogical records, tracing her descent direct from Moses Levy, and his second wife, Grace Mears, a Jewess, whom he married in 1718. She displayed the Coat of Arms attributed to Moses Levy, which she had worked out in needle-point upon a large screen, and the family portraits of his descendants. Photographic copies from portraits of Moses Levy and members of his family, treasured by Jewish descendants, which I presented to Mrs. Bancroft were a revelation to her.

On various occasions I visited her and gloried in her veritable museum of paintings, miniatures, silhouettes, exquisite pieces of silver, and furniture. Many of her prized possessions she presented to the Gore Place Society, at Waltham, or placed them on loan there. During my latest visit I noticed hanging on the walls the Rembrandt Peale portraits of Judge and Mrs. Moses Levy.

A small room in Mrs. Bancroft's home was hung almost exclusively with rare silhouettes, many brushed in gold. Among them were portraits of Dr. Arthur Pue of Baltimore, a great-

grandfather, and Rebecca Anne Pue, his daughter, who became the wife of Charles Ridgely Carroll. Then there were profiles of Dr. and Mrs. Michael Pue, and of Thomas Poyton Bancroft, Mrs. Bancroft's father-in-law, and his five-year-old son. Judge and Mrs. Samuel Putnam, niece of Timothy Pickering were also there.

But most cherished of Mrs. Bancroft's heirlooms was the family Bible in Hebrew, which belonged to Moses Levy, her great-great-great-grandfather, with entries begun by him, and containing a letter, wafered in, written by his son, Samson Levy, Sr., the father of the brothers — Judge Levy and Samson, Jr.

Very much impressed by the letter I copied it. Samson Levy, Sr., had intermarried; still he clings and desires his children to hold fast to the sacred symbol of their ancestral faith.

My dear Children — or to which soever of your hands this may fall into.

This Book is an Extraordinary Hebrew Bible with annotations or Commentaries on the text —

It was a favourite Book belonging to My Dear Father and Contained the handwriting of him and my Dear Mother for whom I retain the Greatest Affection not withstanding the long time they have been Dead — the former I knew little of but the latter I well remember — in this Book is by them set down or wrote the names and Birth of all their children, & the Death of Some of them by My Self — I therefore recommend this Book to your Most particular Care as an old family Bible with which I hope you will never part but to your latest posterity — as I regard it for My Parents Sake as well as its being an Extraordinary Book of itself — So I hope you will Show the Same regard and affection to my request that I do to My Parents Memmorary —

I am My Dear Child y<sup>r</sup>                    Affectionate Father
                                                          Samson Levy

New Castle June 4, 1779

My Father Lived in the City of New York in w<sup>ch</sup> place both him and my Mother Died the former in the year 1728 — and the Latter in the year 1740 —

My fondness for my Parents made me fond of what they Esteemed. I hope my children will have no less affection for me —
<div align="right">Samson Levy</div>

The engraving by Saint-Mémin of Hyman Marks of Richmond and Philadelphia taken in 1805 may be seen in the Morgan Collection, and in the American Jewish Historical Society. He married Grace Seixas Judah and their daughter, Abigail, married Joseph Newhouse in 1839. A granddaughter is Mrs. Grace N. Lederer of Philadelphia.

The drawing of Solomon Moses, the husband of Rachel Gratz is dated 1798. It was sent to me by his great-granddaughter, Mary Porter Scott of Saint Louis, who writes,

The portrait is one of my great-grandfather, Solomon Moses, done in the style of St. Memin. It is a life-size head on pink paper drawn with either pencil or charcoal with touches of white paint. The artist has signed the portrait Volney 1798.

I have never been able to learn who "Volney" is and if you can tell me anything about him, I will be grateful. Did St. Memin ever use that name? It is a very nice portrait and done by someone with ability.

Doubtless this "Volney" is Valdenuit who often assisted Saint-Mémin, and the answer to Miss Scott's inquiry is found on the engraved portrait of Solomon Moses, reduced from the original drawing, in the Saint-Mémin Collection, Morgan Library, which reads "St. Memin and Valdenuit No. 27 Pine St. N. York."

Dacosta, who has been included in the list of Jewish subjects by Saint-Mémin, was not a Jew, but a Spanish Catholic, thought the late Mr. Samuel Oppenheim. His full name was Jose Roiz Da Costa. Isaac Dacosta, the Jew, died about 1784, before Saint-Mémin came here. However, the portrait might be that of his son, Samuel.

Saint-Mémin's distinguished pictorial record revealing with

<div align="center">[ 33 ]</div>

graceful artistry the appearance of our Americans more than one hundred years ago, thus includes a number of members of the Hebrew race. It is not unreasonable to suppose that other names will turn up from time to time. Successful in the pursuit of his work, Saint-Mémin returned to France in 1810, but revisited this country two years later. In 1814 he journeyed back to France where he was made Curator of the Museum of Dijon, a post he retained until his death in 1852.

# VI

## THE PAINTED TYPE

THE most unusual and in many cases the most beautiful silhouettes with their miniature-like quality belong to the painted type. In this group are a number of profiles which have come to my attention.

Unattributed is the portrait of Aaron Rodrigues Rivera, in the possession of Mrs. Jerome F. Milkman, of New York, who is a descendant of Aaron Lopez, for whom Rivera was named. She writes that the profile is in water color on parchment, the hair and eyes dark brown, and the complexion ruddy. I should think the profile was painted around 1810 when Rivera was a young man.

Aaron was the only son of Abraham Rivera, 1763-1823, and Hannah Lopez, daughter of Aaron Lopez, the merchant prince of Newport, Rhode Island. His grandfather was Jacob Rodrigues Rivera, 1717-1789, well-known in Newport for his spermaceti factories and as an importer. Jacob espoused the Colonial cause, and was forced to flee to Leicester, Massachusetts, but returned to Newport in 1782. He was a public-spirited citizen and observant Jew. His portrait painted by Gilbert Stuart may be seen hanging in the Redwood Library, Newport, a gift from the Rodman family.

The Rivera name had figured prominently for centuries in Seville, Spain. Like the Lopez family, the Riveras lived as Marranos — Jews who outwardly observed Catholicism, but secretly maintained their faith. When Aaron's great-grandfather, Abraham Rodrigues de Rivera came to New York, he and his children had their Catholic names changed in accord-

[ 35 ]

ance with Jewish rites. The great-grandfather, Abraham, died in Newport in 1765.

The painted profile of Simeon Levy, by an unknown artist, was presented to me by Miss Aline E. Solomons, of Washington, D. C., a great-granddaughter of the subject. In addition Miss Solomons and her sister, Julia, cherish a number of portraits in oil and exquisite miniatures of their ancestors who came here from England, before the Revolution. The sisters impressed me with their devotion to orthodox Judaism — traditional in their family — and interest in all phases of communal activity. Jewishness and Americanism are not incompatible, as we find time and again.

Simeon Levy, born in 1748, was the father of a number of children — Jochebed, Bilhah, Benjamin, Hannah, Miriam, and Julia. The latter married John Solomons in 1818, and died in 1862, at the residence of her son, Hon. Adolphus Simeon Solomons, who was an incorporator and active member of the National Association of the Red Cross, in Washington, D. C. Simeon Levy died December 23, 1825, in New York, and was buried in the cemetery on Eleventh Street, of Congregation Shearith Israel.

He was profiled in water color in 1812, when he was sixty-four years old, seated in a chair, holding an open book of reddish hue. His waistcoat, too, is painted red; his coat is black, and the head and hair, which fall to his neck in softly curled strands, are outlined in pencil. Edged with gold, the portrait is attractively framed in wide gilt and under black painted glass.

Captivating is the unattributed profile of Isaac Aaron Isaacs, son of Aaron Isaacs, born in Boston, October, 1825. It was done when he was about two and one-half years old.

Delightful curls and ruffled neck, skirt and pantalets are painted in black and white on rough cream colored paper. The

arms and hands are in natural tints; his shoes are brown and the basket is yellow. The head, however, is hollow-cut mounted over black silk.

The portrait was painted in Boston. This type of silhouette is rare, indeed, as I have seen only one like it, which is owned by Mrs. Maurice Spillane, and that, too, unfortunately remains unattributed.

Isaac Aaron Isaacs married Mary Pyle of Richmond, Virginia, when he was nineteen years of age. By his first wife there were the children, Aaron C., Rebecca, Albert, Henry, and Walter; and by his second wife, Agnes Cohen, there were Clifford and Ernest, who owns the silhouette. Agnes Cohen died at her home in New York, August 23, 1934, aged seventy-seven years. She was a direct lineal descendant of Jewish worthies. Isaacs died March 1, 1897.

His sister-in-law, Miss Gertrude Cohen of New York, who wrote me about the silhouette, writes, "My father's family Seixas originated from Lisbon, Portugal. Both sides served in the Revolutionary War."

I should like to hear from the descendants. Perhaps there are other interesting mementos of this old Jewish family; portraits and miniatures and silhouettes — pictorial evidence of the early Jews who contributed to the industrial and economic wealth of the country, who fought for its defense, and promoted its cultural growth.

The unattributed painted portrait of Mrs. Israel I. Cohen belongs to Mrs. Arnold Burges Johnson of New York, a great-granddaughter. It is certainly very unlike the hollow-cut of the supposedly same person sent to me by Mrs. Johnson's sister, Mrs. D. Grigsby Long. But it is a gracious profile painted in slate-color, enriched with touches of gold; framed in papier-mâché, with acorn and oak-leaf pendant. Writes Mrs. John-

son, "Great-grandmother left to her descendants a rich heritage of indomitable will, courage, and a loyalty to the Jewish faith."

A very finely executed, but unattributed profile is that of Eleazer Lyons. Wearing a black coat and white stock he is pictured against a light-green background. The portrait is in the possession of Mr. John D. Samuel, of Philadelphia, a descendant.

Eleazer Lyons was born in Holland in 1729. His family of Sephardic origin had fled, no doubt, from Spain or Portugal, wrote Mr. Samuel, at the time of the Inquisition. Shortly after Lyons came to this country in 1775, he married Hannah Levy, daughter of Isaac Levy, an Indian trader, of Lancaster, Pennsylvania.

According to tradition in the Lyons family, George Washington breakfasted at the home of the young couple on his march through Lancaster. When he was offered a hot drink, thinking it tea or coffee, he patriotically refused; but on assurance from Hannah Lyons that it was brewed from roasted rye, he drank it down.

Eleazer and his family later moved to Baltimore, then Surinam (Dutch Guiana), and Philadelphia, where he died in 1816. He was buried in the old Spruce Street Jewish Cemetery as was his wife, when she passed away in 1849.

A son, Judah Eleazer, was the father of Reverend Jacques Judah Lyons, Rabbi of the Sephardic Synagogue, Shearith Israel, New York.

Jews who would be cognizant of a past in this country of which they can well be proud, would find it delightful, as well as informing to see the Cohen Collection in the Maryland Historical Society.

It was thrilling, indeed, to visit there and to note the many heirlooms to Jewish Americana contributed, in great measure, by the generosity of Miss Eleanor S. Cohen.

The Maryland Historical Society houses the John Wesley Jarvis portraits of Mr. and Mrs. Solomon Etting; miniatures of Jewish interest by Benjamin Trott and Edward Greene Malbone; precious mementos — jewels, religious ceremonial objects, and interesting shades of my forefathers.

The little known, yet capable artist, Thomas Gimbrède, painted the profile portraits of Solomon Etting, and his second wife, whose maiden name was Rachel Gratz. Lately bequeathed by Miss Cohen to the Maryland Historical Society, they may be seen in the Cohen Room.

Solomon Etting was one of Baltimore's leading citizens, and as he was also profiled by Hubard and Edouart, we shall read more of him later. Mrs. Etting, 1764-1831, was the daughter of Barnard Gratz of Philadelphia, and among her first cousins were the beautiful sisters, Rachel and Rebecca Gratz. In the Cohen Collection is her invitation to attend a Ball in honor of General Lafayette which reads:

BALL TO THE NATION'S GUEST

The honour of Mrs. S. Etting's Company is requested at the ball to be given in welcome of Gen. La Fayette the second night after his arrival.

| | |
|---|---|
| C. Carroll of Carrollton | I. Meredith |
| Col. I. E. Howard | I. G. Davies |
| Gen. S. Smith | R. B. Magruder |
| Gen. Stricker | James Swan |
| Col. Bentalon | D. Hoffman |
| Robert Gilmer | John Thomas |

MANAGERS

In the Gimbrède profile, Mrs. Etting is delicately portrayed in a slate-colored bodice, white kerchief and ribboned white mobcap from which tight curls emerge. Solomon Etting's portrait, equally pleasing, is painted in slate-color, relieved by a white and black tinted fichu. Both portraits signed "T.

Gimbrede," are set within gilt ovals and hang from pendants attached to their black ebonized frames.

Gimbrède, a Frenchman, lived for a while in Baltimore among his compatriots, trying various means of earning a living. William Dunlap says he knew him as a miniature painter, an engraver, and teacher of drawing at the Military Academy of West Point, where he stayed until his death in December 1833.

In the Cohen Room there is still another delicately painted water color signed by Gimbrède of Richea Etting, 1792-1881. Within an ornate gilt oval, the portrait is set under black glass with cornered gold spandrels and framed in heavy gilt. The faintly tinted cheeks are shaded in pale green, and her light brown hair is held by a tortoise-shell comb. In her brown-dotted and low-cut bodice, she presents as enchanting a profile as any I have seen.

Richea was the daughter of Solomon and Rachel (née Gratz) Etting, his second wife. There were three other daughters of this marriage; Kitty who married Benjamin I. Cohen, and Shinah and Ellen who with Richea remained un-married.

The late Miss Josephine Etting, Richea's niece, gave the Gimbrède portrait to Mrs. Francis T. Redwood, who pre-sented it to the Maryland Historical Society, March 22, 1927. Mrs. Redwood writes,

I regret I am unable to furnish you with any information in regard to Miss Richea Etting. The only time I ever saw her was when a very little girl, I was taken by my mother to see "Aunt Richea" and "Aunt Shinah."

One of the old ladies, I can't remember which, was in a high, old four-post bed and wore a ruffled cap. The hall-light, a lamp, took my eye

particularly at that time as it was just like a picture in my copy of Hans Andersen's Tales.

The Etting and Cohen families have always been intimate with both of father's and mother's families. They lived near each other when my father and Mr. Israel Cohen were boys. More than a hundred years ago — for my father was born in 1819.

With a heart for sentiment, I grieve to think our beauteous Richea, who was clever and witty, as well, grew old without marriage and children. She presented to the Maryland Historical Society a portrait of George Washington, which, as a child, she had seen Gilbert Stuart painting. Like Rebecca Gratz, her mother's cousin, she interested herself in religious education for Jewish children, and was a director in 1857 in the Sunday School Association of the Sephardic Congregation in Baltimore.

This Congregation, comprising Jews of Spanish and Portuguese origin, exerted an influential sway upon the Jewish community, but, unfortunately, it did not last very long, as there were not enough *Sephardim* in Baltimore to maintain it. Frequently they were forced to call on the neighboring German Jews for their *Minyan* — at least ten men — the necessary quorum for public worship.

The Cohens, on whom they would call, were not to be counted on for support. They were *Ashkenazim*, Jews of German origin, who preferred their residence on North Charles Street, for worship, with their own ritual. They had their private cemetery, too, at West Saratoga Street, near Carey; while the Etting Cemetery was located at North and Pennsylvania Avenues. I sometimes wonder, if like the Lowells and Cabots, the Cohens and Ettings, alone, could commune with the Almighty!

*Sephardim* and *Ashkenazim* now worship together, and social

discriminations, as well, have been eradicated. A few Sephardic families have adhered more rigidly than others, perhaps, to their ancestral aloofness. But on the whole they are now crossed by their co-religionists or by intermarriage, so that few families remain untouched by various strains.

On the pretext that one ancestor or a remote ancestor of an ancestor was of Spanish origin, there are some who persist, because it seems to lend social prestige, though without substantial claim, to call themselves Sephardic Jews.

But I leave this subject for enlightenment and interpretation to Dr. Walter M. Kraus, of New York, editor of the *Saint Charles Magazine,* who has done much to make evident the roots of American Jewry. He has been aided in his research by examining old wills, family Bibles, and the marriage certificates of Spanish and Portuguese Jews, which include the genealogies of the contracting parties. Dr. Kraus says that he has also found Jewish ancestry in the genealogies of a surprisingly large number of distinguished Christian American and English families, which is not generally known. Among them are Ludlows, Winders, Rockefellers, Morgans, Fahnestocks, Cabots, and Saltonstalls.

A rich field for inquiry upon the almost untouched subject of assimilation of early American Jewry, is suggested in the letter sent to me some time ago from Mr. Bernard Berenson, of Italy — distinguished art critic, of distant kin:

> I am very grateful for your *Portraits of Jews.* It is interesting, informing, and stimulating. How interesting it would be to have a history of the infiltration of the Jewish element into American life! Of course, only if it were done in an unsectarian spirit, without favour and without sentimentality.
>
> You mention a portrait of Lorenzo Da Ponte. Do you happen to have a photo? I am interested in that pathetic figure.

I remember with pleasure your coming to see us, and I should be pleased to see you again.

1 Tatti, Settignano, remains our address.

<div style="text-align:center">

Sincerely yours,

B. Berenson

</div>

In the Cohen Collection of the Maryland Historical Society is a profile of Mrs. Benjamin I. Cohen painted with fine brush strokes in black and white. "It is a composite profile," writes Miss Eleanor S. Cohen of Baltimore; "A son and daughter sat for the portrait after Mrs. Cohen's death in 1837 which is said to be an excellent likeness." She was Kitty Etting, the fourth daughter of Solomon and Rachel Etting, and sister of Richea to whom she bears a strong resemblance. Her husband, Benjamin I. Cohen, 1797-1845, was the son of Israel I. and Judith Cohen. He was a member of the banking firm, Jacob I. Cohen, Jr., & Brothers, and was one of the seven persons, who on February, 1838, formed the first Baltimore Stock Board. He was a botanist and horticulturist and a talented amateur violinist.

The Cohens lived in a handsome residence at the southwest corner of Charles and Saratoga Streets surrounded with gardens and hothouses. Here they played a prominent part in the social life of Baltimore.

A letter published in the *Maryland Historical Magazine,* December 1919, from James M. Nicholson to his mother, the wife of Judge J. H. Nicholson, chattily describes a Fancy Dress Party which he attended at the Cohen residence. He wrote "many distinguished people were there, among whom were Officers of both the Navy and Army. The presence of the Charming Host and Hostess was felt and acknowledged everywhere . . . there was no effort visible for the events went on as if by Magic, and it was not until the small hours in the

Morning the guests shook hands and said Goodnight — to Mr. and Mrs. Cohen, after this most delightful Evening. The house is rich and expensive, and if anything has been added for this occasion, it was all in keeping with the rest. To tell you who was there, no very hard task, for I might in general terms say — everybody was there who is at all in the habit of attending parties." There were Howards, Halls, and Oldfields, Cohens and Graffs and Madame Patterson-Bonaparte.

# VII

## WAX PORTRAITS

THE wax portrait modeled in bas-relief was mounted on a board, framed and protected by glass. I have found only one example of interest to my subject of this very charming expression of the profile-portrait.

A wax profile, in color, of Mrs. Nicholas Schuyler — her maiden name was Shinah Simon — was sent to me by Mr. Henry Joseph of Montreal, a descendant of the Gratz family, whose collection of American Jewish worthies is of extraordinary interest.

Shinah was a daughter of Joseph Simon of Lancaster, Pennsylvania, and sister of Miriam Gratz, Rebecca's mother. Dr. Nicholas Schuyler, her husband, was the cousin of General P. S. Schuyler, a friend of George Washington. As a surgeon in the Revolutionary Army, Dr. Schuyler was stationed in Lancaster, where Shinah resided. She died in 1815, at the age of fifty-three in Troy, New York.

In *Rebecca Gratz* by Rollin G. Osterweis, we read that Shinah was not forgiven for marrying out of the faith until the approaching death of her father, Joseph Simon. About to die he sent for several children and intimate friends, to ask what he could do for them. When Rebecca Gratz was called to his bedside she touchingly said, "Forgive Aunt Shinah, grandfather, please." Sending for his daughter the happy reconciliation took place before he closed his eyes.

I think Shinah's wax portrait was done by John Christian Rauschner, who was working in Philadelphia in 1801, at which time, writes Mr. Henry Joseph, the wax portrait was made.

Rauschner was born in Frankfurt, Germany, in 1760, the

youngest son of Christian Benjamin Rauschner, who was a "Modelleur, Stuccateur and Bossirer" in that city. The son plied the same trade in this country working up and down the coast, and paying his way as barber and hairdresser when the art business was slow.

Shinah's profile is very charming indeed. Within a height of four inches she is beautifully modeled. Her eyes are rather bulged; a bandeau encircles a profuse cluster of dark brown curls and earrings. Pearls entwine her neck over which is a thin white scarf, and she holds a watch and chain.

Mrs. Ethel Stanwood Bolton in her unique book *American Wax Portraits* does not mention this charming wax of Shinah Simon, though she does include two others by John Christian Rauschner of Jewish interest, — Mr. and Mrs. Aaron Storck of Holland, who visited this country in 1810 returning the following year. I should like to know who has acquired them since they were last owned by Mr. Charles Henry Hart.

About them Mr. Hart has written that they are "beautifully and delicately modelled and are artistic in their execution. From the animation and expression they could not have been other than excellent likenesses."

We learn from Mrs. Bolton that the modeling of relief groups and portraits in wax was very popular throughout Europe from the middle of the sixteenth century to the close of the eighteenth century. I noted in her work the remarks of Giorgio Vasari, the Italian chronicler, who says that the colors were ground, sifted and mixed with liquid wax. "Nor," writes he, "shall I conceal that modern artists have discovered the method of working in all sorts of colors, so that in taking portraits from life, in half-relief, they make the flesh tints, the hair, and all so life-like that these figures lack nothing but speech."

Eighteenth century America brought out many examples of the profile modeled in wax which can be seen in the collections of the Essex Institute in Salem, the Boston Museum of Fine Arts, the Bloomfield Moore Collection at Fairmount Park, and in various private collections, notably that of Reverend Glenn Tilley Morse.

The modeling of wax portraits is now happily being revived in the work of Miss Ethel Frances Mundy and Miss Ruth Burke.

# VIII

## WILLIAM JAMES HUBARD

THE scissored type of portraiture, in which the profile is cut free-hand with scissors, from black paper, and pasted on a white ground abounds in my collection.

A silhouette of Solomon Etting by William James Hubard in the Cohen Collection, of the Maryland Historical Society, belongs to this type.

The framed paper-cutter, known as "Master Hubard" was born in Whitechurch in Shropshire, England, in 1809. His grandfather was the German sculptor, Reinhardt, one of whose works, *The Shipwreck*, is in Westminster Abbey.

A gifted youngster, Hubard's free-hand scissor-work in portraiture and landscapes attracted much attention. Like Edouart, he would cut his silhouettes with scissors, merely by a glance at the sitter.

I read about his work in a rare pamphlet entitled, *A Catalogue of the Subjects Contained in the Hubard Gallery; to which is prefixed a Brief Memoir of Master Hubard*. It was printed in New York by D. Fanshaw in 1825, and reposes in the Massachusetts Historical Society.

The youthful prodigy landed in New York in August, 1824, preceding Edouart by fourteen years. Here he established a Gallery at 208 Broadway, open for afternoon and evening work.

The terms of admission were:

50 cents which entitles the visitor to see the Exhibition and obtain a Correct Likeness in Bust cut by Master Hubard, Who, without the least aid from Drawing, Machine, or any kind of outline, but merely by a glance at the Profile, and with a pair of Common Scissors, instantly produces a Striking and Spirited Likeness.

Evidently Hubard did a rushing business in his Gallery, for we read:

Those who wish for Whole Length Figures or their Likenesses Highly Finished in Bronze are advised to call in the Morning; for, as it has become a fashionable Evening Promenade, the Applicants for Likenesses are so numerous that Only the Bust can be taken.

Guided by able management and well advertised in the newspapers, he achieved quite a reputation, for Hubard was not only a good artist, but an *entrepreneur* as well. Where-ever he went he became a great success, cutting a likeness in twenty seconds for fifty cents to two dollars. The completed likeness he would often frame in black glass or black frames.

Heralded in Boston, the *Columbian Centinel* of November 16, 1825, spoke of him as "a boy who possesses the peculiar faculty of delineating every object in Nature or Art, simply with a pair of common scissors."

When the self-called "papyrotomist" came here, he set up a studio. Musical compositions were played by a Panharmoni-cum; the curious were attracted, and they, no doubt, examined his Papyrotomia, or Hubard Gallery of Cuttings. Some were inspired to poetic outbursts in verse dedicated to Hubard on seeing his remarkable collection.

In Boston he was greatly influenced by Gilbert Stuart. When he left for Philadelphia he took up portrait-painting under Thomas Sully, and later painted small full-length portraits in oil. He continued, too, with his silhouette cutting, at which he was so adept, as well as painting profiles in delicate tints, lightly gilded and accented in India ink.

Sympathizing with the South in the Civil War, he invented an explosive for the use of the Confederate Army, and was killed by the bursting of a shell that he was filling on February 25, 1862.

The full-length scissored and bronzed silhouette of Solomon Etting, great-grandfather of Eleanor S. Cohen is a splendid portrait, vibrant with personality. It represents him about ten years younger than the one that was cut by Edouart. Silhouettes with bronze embellishments of this variety, are very rare, as Mrs. Carrick points out, and eagerly sought by collectors.

Solomon Etting was born at York, Pennsylvania, July 28, 1764. He was the son of Elijah Etting who was born in 1724, Frankfort-on-the-Main, Germany. Elijah came to America in 1758 and married Shinah Solomon, daughter of Joseph Solomon, a merchant of Lancaster, Pennsylvania. Her silhouette we have already mentioned.

Solomon Etting married Rachel, daughter of Joseph Simon of Lancaster. His father-in-law, a wealthy trader in the province, was one of the founders of the Pennsylvania Academy of Fine Arts. In Lancaster they entered into partnership under the name of Simon and Etting. Here Solomon played an important role in Masonic affairs. His wife died January 14, 1790, and was buried in the old Jewish cemetery at Lancaster, where her tombstone is still to be found.

Etting then moved to Philadelphia and finally to Baltimore where he married his second wife, Rachel Gratz, the daughter of Barnard Gratz.

During the remaining fifty-five years of his life, Etting devoted himself to many communal activities. He was one of the leading spirits in the movement to influence the Legislature of Maryland to enact the *Jew Bill*.

For this he addressed successive petitions from 1816 to 1826, to make it possible for the Jews to hold public office without first declaring a belief in the Christian religion.

In 1826 when the Bill was passed he was the first Jew to hold public office in the City of Baltimore, where he became

a member of the City Council and later served as president of that body.

The information Etting had furnished about the Jews in America, used by Colonel (later Governor) W. G. D. Worthington in an important speech before the House of Delegates, effected the passage of the Bill.

Colonel Worthington was thus enabled to cite the number of heads of Jewish families in Maryland, their wealth, and their contribution to the service of their country. He added "I know an instance, Mr. Etting of Baltimore had a son of talents and acquirements; he spared no pains on him. The youth wished to study Law. The 'Father,' with pain in his heart and tears in his eyes, told him he could not. Even to be an Attorney in a County Court, he would have first to renounce the religion of his father."

When Etting died in 1847, a Masonic historian wrote "he was a man of sterling integrity, of great wit and drollery and was beloved and respected by a large circle of friends and acquaintances. He was distinguished for his considerable and indiscriminate charities and was in his old age affectionately hailed as 'Father Etting.'"

Hubard's most popular silhouettes are the bust portraits which are upward scooped along the bust line in the manner peculiar to his work. Here is one of the celebrated Rebecca Gratz, taken from the original owned by Mr. Jonathan J. Cullen of Philadelphia, mounted on a card the back of which reads, "Cut with scissors by Master Hubard without Drawing or Machine." It also illustrates the book *Rebecca Gratz* by Rollin G. Osterweis.

Rebecca, a daughter of Michael and Miriam (Simon) Gratz was born in Philadelphia in 1781. As a young lady she interested herself in art and literary circles, and was a member of

a group of which Washington Irving was one of the leading figures. Through his portrayal of her gracious character to Sir Walter Scott, she became the inspiration for *Ivanhoe*. Rebecca devoted her life to rearing the children of her departed sister, Rachel; to philanthropy and educational pursuits. She was deeply religious and her interest in Hebrew Sunday Schools, and in the Jewish Foster Home, Philadelphia, sprang from a passion for her religion which motivated ennobling deeds. She passed away in Philadelphia in 1869.

The many lovely painted portraits by Sully of Rebecca Gratz and her miniature by Malbone, remain, of course, most appealing of the likenesses of this gracious lady of the Salons.

Exquisite to look upon, she must have enthralled the artists who painted her. Her beauty impressed itself upon Miss Catherine Brittin Barlow, of Washington, who, after reading my article "Portraits of Jews by Thomas Sully", in the *Daughters of the American Revolution Magazine,* February, 1926, wrote me the following:

. . . As a native of Philadelphia, I knew of the Gratz family who were flourishing in my early girlhood and one of the finest memories I have is of having seen Miss Rebecca Gratz — sat near her at a meeting and was so deeply impressed by her personality, that I never forgot it, and your article gave me a genuine thrill.

It was the winter of the Centennial Exposition, 1876, when a great Ball was given. The Committee — under the leadership of Mrs. Gillespie — was composed of women representing the 26 Wards of the City of Philadelphia — each ward having a sub committee with its Chairman. As my father was a public spirited man and in the affairs of the city — my sister and I were appointed to the Committee, of the Ward in which we lived. It was at the final meeting of the entire campaign — that we saw Miss Gratz.

Years have rolled on but that scene has been so fixed in my memory that I could paint it if it were possible. Opposite and near me sat a

remarkably beautiful woman, not old, nor young, a little large, and most richly dressed, the exquisite pose of her countenance and repose of her body fascinated me, and I knew very little of what was transpiring around me. She seemed to sit apart a little for she was alone. At that time Jews were not given much friendliness, and I noticed that Mrs. Gillespie gave her a little deference which impressed me as to her importance, and as soon as the meeting adjourned, my inquiry was met with "she is Miss Rebecca Gratz, the sister of Simon Gratz, a family of great means and very philanthropic."

I must add that the copy of Miss Gratz portrait brought her face back to me very vividly, and she bore that same reposeful countenance in later years as in her youth.

# IX

## AUGUSTIN EDOUART

THE work of the Frenchman, Augustin Edouart, is well-known to admirers of the silhouette. He practised his art chiefly in the British Isles and in America, leaving thousands of portraits signed "Augn. Edouart fecit." They were cut from life, generally full-length, the size eight and one-half inches. He inscribed them with the sitter's name, date and place where taken, and sometimes the home address. Very often they were autographed by the sitter. Edouart cut sil-houettes in duplicate from folded black paper, and, of each, methodically retained a duplicate. Occasionally one runs across a profile cut from white paper and mounted on a black ground.

Augustin Amant Constance Fidèle Edouart — what a galaxy of names — was born in Dunkerque, France, in 1789. He served under Napoleon in his youth and was decorated. But he had a distaste for military life and escaped to England where he married Emilie Laurence Vital. A son, the Rev. Augustus Gaspard Edouart, became Vicar of Leominster.

At first, Edouart earned his living teaching French, and by a curious handicraft — making animal portraits and land-scapes from hair. In the year 1825 he began to cut silhouettes quite by chance when he profiled some friends who were visit-ing him.

From his first patron, Dr. Majendie, the Bishop of Bangor, he received much encouragement. He silhouetted the Bishop's family, too, from which he received orders for forty duplicates.

For thirteen years Edouart traveled far and wide through the British Isles, cutting profiles by the thousand. He charged

a few shillings for the profile bust (there were not many); three and six for full-lengths of children and five for adults. His portraits include the nobility, with an especially interesting group of the exiled French monarch, Charles X, at Holyrood Palace in Edinburgh. Also the landed gentry and village folk whose homes he visited or who called at his studio.

In 1839 when Edouart came to the United States he resided at 114 Broadway, New York. As his reputation had preceded him, he became immediately popular, and his studio was thronged. He worked in other important cities, Boston, Brooklyn, Philadelphia, Washington, Baltimore, and New Orleans. During a residence here of ten years, he cut about ten thousand portraits, more life-like than the static photography of a later day.

Individuals from every sphere of life were represented in his albums, among them the American Presidents — John Quincy Adams, Martin Van Buren, William Henry Harrison, John Tyler, Millard Fillmore, and Franklin Pierce. The statesmen, Daniel Webster and Henry Clay were also cut by Edouart, as well as officers in the Army and Navy in resplendent attire.

Some of the most interesting of his profiles were those of family groups with slaves and household pets included, mounted against an interesting interior.

His American sojourn was over in 1849 when he decided to return to England. Sailing from Maryland on the *Oneida,* the vessel was wrecked the nineteenth of December in Vazon Bay off the coast of Guernsey. No lives were lost, and fortunately in the salvaged baggage were fourteen folios with some nine thousand of Edouart's portraits, including a number of the American scene.

In gratitude to the kindness of the Lukis family, with whom

he stayed when taken ashore, Edouart presented the daughter, Frederica, with his valuable albums.

Brokenhearted over the loss of the greater part of his reference collection, he now turned to his native country, settling in Guines, near Calais, where he died in 1861, in his seventy-third year.

The folios came to Mrs. E. Nevill Jackson after she had inserted a notice in the *Connoisseur Magazine,* asking if owners of silhouette collections might allow her to examine them to complete her *History of Silhouettes.* Mrs. Jackson catalogued the Edouart collection, made facsimile photographs, and sold the original American profiles to Mr. Arthur S. Vernay of New York. He classified and exhibited the silhouettes, many of which were later purchased by the Reverend Glenn Tilley Morse.

I read an undated charming appraisal of Edouart's work culled from the *Burlington Magazine.*

How good an artist was Edouart? Was he for instance, a better artist than Raeburn or Lawrence? For my own part we think he was. But in any case he is much more amusing. For he cut out people "as they are" with no nonsense about them. It is evident that many of Edouart's one hundred thousand silhouettes, so vivacious, so witty, so sympathetic, have a genuine artistic value.

Besides those privately owned, Edouart's silhouettes are in the collections of the London National Portrait Gallery, the Victoria and Albert Museum, the Scottish National Gallery, and in the Archivist Museum at Ottawa. In this country many Historical Societies have collected Edouart's work.

A number of profile portraits of American Jews were cut by Augustin Edouart. From the collection of Mrs. E. Nevill Jackson are two portraits of August Belmont. He was born

in Alzey, Rhein-Hessen, Germany, December 2nd, 1816, to Simon Belmont and Fredericka Elsass.

Aaron was the original name, but it was the custom to give Jewish children modernized names with a similarity, at least, in the first letter, and the name was changed to August.

The family originated in Germany with Isaac Simon, of Alzey, who took the name Belmont when Napoleon's royal decree in 1808 made it obligatory for the Jews, as well as Gentiles, to adopt family names. It is often thought the original name was Schonberg or Schonenberg, of which Belmont is the literal translation.

But the late Professor Richard Gottheil says such was not the case. His beautiful volume the *Belmont-Belmonte Family* — which makes genealogical reading a delightful pastime — gives Schonberg or Schonenberg a place-name in the "Amt-Alzei" where Jews had lived for centuries, but where no evidence is found of any connection with the Belmont family.

Isaac Simon, he makes clear, was descended from the Belmonte family of either Amsterdam or Hamburg. There were branches residing, too, in England, in the Dutch colonies of South America, and in Jamaica, Asia Minor, and Southern France.

It is not surprising, we read, that the final "e" was dropped from the family name, as French culture had left its imprint with the Napoleonic invasion.

Isaac Simon Belmont died in 1813 leaving four children, of whom the eldest was Aaron Isaac. Aaron's eldest son was Simon, the father of August Belmont. As a landed proprietor, owning vineyards in Alzey and a town house, August Belmont's father was the outstanding Jew of his "amt" or canton, where for many years he was president of the congregation.

At fourteen August Belmont was sweeping the floors with-

out salary, for the Rothschilds, bankers, at Frankfort-on-Main. When his ability for finance was later discovered, he was invested with responsibility, and within three years transferred to the branch house in Naples where he negotiated important matters with the papal government. He spent his leisure visiting art galleries and developed connoisseurship. Years later he became a foremost collector of his generation. For a number of old Dutch and Spanish masters in 1850 he paid some two hundred thousand dollars.

After a residence in Havana, Cuba, where Belmont again represented the Rothschilds, he went to New York, in 1837, and rented a small office at Wall Street. Here he was American representative of his former employers, and founder of the banking house of August Belmont and Company.

In a duel fought at Elkton, Indiana, August, 1841, with William Hayward of South Carolina, Belmont's leg was permanently injured. *The Twentieth Century Biographical Dictionary of Notable Americans,* says that the innocent cause of the duel was Caroline Slidell Perry, whom he married in 1849. She was the daughter of Commodore Mathew C. Perry, who "opened" Japan to Western Nations and niece of Commodore Oliver H. Perry, commander of the American Fleet at the battle of Lake Erie.

The children were Perry, August, Jr., Oliver H. Perry, Raymond, and a daughter, who married Samuel S. Howland. Writing to John Forsyth of Mobile, Alabama, in 1860, Belmont says, "I prefer to leave to my children, instead of the gilded prospects of New York merchant princes, the more enviable title of American citizen, and as long as God spares my life, I shall not falter in my efforts to procure them that heritage."

Belmont's political services were important to the country

[ 59 ]

of his adoption. In 1848 he was Consul-General in Austria. In 1853 he was appointed by President Pierce Chargé d'Affaires at the Hague, where in the following year he became Minister Resident.

In 1860 he was Chairman of the Democratic National Committee, serving until 1872, when he resigned, but still remained a delegate from New York to every Democratic National Convention and often presiding officer from 1860 to 1884.

He was devoted to the Union and raised and equipped for the Civil War the first German regiment sent from New York City. Lincoln and his advisers were greatly assisted by Belmont during the struggle, when he forcibly impressed the interests of the northern side upon the Rothschilds and influential friends in Europe.

August Belmont died in New York City, November 24, 1890. His services to the nation were his strongest claim to greatness. But he distinguished himself, too, by the charm of his personality, his great wealth which he freely spent, his interest in the turf and his patronage in art circles. To his descendants he left a splendid heritage which they have nobly carried on.

"The Agent of the House of Rothschild," so Edouart inscribed the silhouettes, wears his high-hat with dignity and sports a walking stick in the one portrait. In the other the small featured man, with rumpled hair and bristling moustache, of non-Semitic appearance, stands erect in fashionable attire, hat in hand. The portraits convey more personality than photographs I have seen of him of a later period.

I am invariably asked, if among the early American Jews, there were any professional portrait-painters. Plowing through his Edouart folios, Mr. Morse discovered the profile of Sol-

omon N. Carvalho. Flourishing a palette and brush, he looks like the ubiquitous artist with long hair and tufted chin. It was taken in Washington, March 20, 1841, and autographed by the sitter in graceful gold writing.

Carvalho, born in Charleston, South Carolina, April 27, 1815, attained fame as a painter, an inventor, and writer. Well-known were his portraits of Thomas Hunter and Isaac Leeser. He received a silver medal for his painting, *The Intercession of Moses for Israel*; and his representation of the interior of the Hebrew Synagogue of Charleston, which was founded in 1795, illustrates the book, *The Jews of South Carolina,* by Dr. Barnett A. Elzas.

In 1853 Carvalho accompanied John C. Fremont, as artist and daguerro-typist, on his famous expedition to the West. His published account was called *Last Expedition Across the Rocky Mountains: Including Three Months Residence in Utah and a Perilous Trip Across the Great American Desert to the Pacific.* Vividly described was the journey from Salt Lake City to San Bernardino, and the life of the Mormons and their religion. He was also the author of *The Two Creations,* a treatise on the mosaic cosmogony.

During a residence in Baltimore, Carvalho was a leading member of the Sephardic Congregation, Beth Israel, for which he composed a Hymn at its dedication, September 16, 1857. His wife, Sarah N. Carvalho was interested in the Sunday School modeled from the one created by Rebecca Gratz in Philadelphia. When the Carvalhos moved to New York the Congregation expired.

I should like to hear from Carvalho's descendants, if any, or his collateral relatives. It is interesting to know that he was one of the first Jewish artists on the American scene which now includes many of remarkable talent.

Who was the handsome A. Cohen taken in cut-away in New Orleans, August 6, 1844? Was he as important as his stance bespeaks? Some one will, perhaps, write me about him and other pictorial evidence of the Jewish colony in New Orleans before the Civil War, of which I have very little.

Edouart cuts with befitting dignity the portrait of Dr. Joshua I. Cohen, at Baltimore, December 17, 1840. He was born August 30, 1801, at Richmond, Virginia, the eighth son and ninth child of Israel I. and Judith Cohen. His autographed silhouette is in Mr. Morse's collection.

Graduating as a physician from the University of Maryland in 1823, he became one of the earliest aurists, perhaps, the first in this country. He was also professor of geology and mineralogy in the University of Maryland; a member of the American Philosophical Society, and a founder of the Balti-more Hebrew Hospital. Among his publications was a mono-graph entitled *Post-Mortem Appearances in a Case of Deafness,* and a catalogue of his collection of autographs and currency of colonial times. His large and valuable library of Hebrew books was catalogued some years ago by Dr. Cyrus Adler and pre-sented by Miss Bertha Cohen and her nieces, Mrs. Arnold Burges Johnson, Mrs. David Grigsby Long, and Mrs. Isaac Cole, Jr., to the Library of Dropsie College, Philadelphia.

Dr. Cohen participated in the struggle which resulted in the removal of Jewish disabilities in Maryland, and when the Jews were granted full citizenship in 1826, he was subsequently elected to membership in the City Council.

The silhouettists had a way of following the socialites to further their business interests. At England's delightful spa, Bath, which was visited by the *beau monde,* they would ply their trade, in the shadow of the famous portraitists, among them, Gainsborough and Reynolds.

[ 62 ]

Mrs. Jackson's book, *History of Silhouettes,* pictures many of Edouart's profiles taken here. One is of the kindly-looking General Sir Henry Johnson, G. C. B., in picturesque attire with tied wig and knee breeches. His portrait was taken at Bath, February, 1827. His son, Henry Johnson, Esq., profiled at the same time, looks like a dandy, with top-hat and cane.

The old gentleman who entered the King's service in 1761 served for nearly three-quarters of a century. During the Revolutionary struggle, he was stationed in this country, as an officer in the British Army, married the spirited Jewess, Rebecca Franks of Philadelphia, and removed to Bath, where they made their home. Their descendants are of the Peerage.

How I should like to find a silhouette of Rebecca, whose wit and brilliant sallies won much acclaim! She was the daughter of David Franks, the King's agent for Pennsylvania, and the great-granddaughter of Moses Levy who came to New York in 1695.

In this country the black shade was very popular at Saratoga Springs, where Society flocked for the salubrious baths. Rebecca Gratz pictures the life here of the gay forties in a letter to her sister-in-law, Anna Boswell Gratz, dated September 15, 1848.

My dear Ann:

Sara and Mr. Joseph were with us, but a short time, but we enjoyed every moment that was given — they did not arrive at Saratoga early enough to partake of its gaiety — the Fancy Ball of which Mary has sent you an account was over — though had they been there, they would not have attended it being given on Friday evening — the illuminated garden was very beautiful and seemed to realize those memorable descriptions familiar to readers of fairy tales — the Salon must have appeared equally illusive as it was thronged with representatives of every nation, and every period since men and women learned to trick themselves out in fine dresses — our Mary was tastefully arrayed in the rich dress she

had last winter when she left me to join the group — we were all bene-
fited by our visit to Saratoga — delighted with our journey through New
England and grateful to find ourselves at home again.

A fine and sensitive personality is revealed in the portrait
of Dr. Jacob De La Motta of Charleston, South Carolina,
taken at Saratoga Springs, July 12, 1844, when he was fifty-
five years old. It is in Mr. Morse's collection.

The Doctor's father was Emanuel De La Motta, born in
the Spanish West Indies in 1761. The family emigrated to
Charleston, South Carolina, where Emanuel was brought up
amidst the fine cultural Jewish environment for which this
city was noted. A well-known citizen, he served in the Revo-
lutionary War and in the War of 1812.

Jacob De La Motta was born in Charleston in 1789. He
studied medicine, was a member of the South Carolina Medi-
cal Society in 1810, and a surgeon in the United States Army
during the War of 1812. He became one of Charleston's
leading physicians and took an interest in Jewish communal
affairs. A spiritual discourse he delivered at the consecration
of the Synagogue Mikveh Israel at Savannah, attracted the
attention of Jefferson and Madison, who wrote him an ap-
preciative letter. In 1841 he was appointed by President
Harrison Receiver-General for his district.

Arresting attention among the many items of the Cohen
Collection of the Maryland Historical Society, are the Edouart
portraits of Bernard G. Etting and Solomon Etting, framed in
mellowed maple.

Bernard was born in 1806. He was silhouetted in 1840, in
frock coat, glove in hand — very elegant, indeed, and mounted
against a lithographed background. Collectors find that sil-
houettes with water-color or lithograph mounts are more rare
and expensive than the plain black shade. They are also more

captivating. The looped portières draped over Ionic columns, festooned balustrades, and verdurous gardens — even chairs and tables in ample flowing curves, have a grace which bespeaks the age. The settings recall the Victorian interiors in which I like to picture the early and intriguing plays of Jones and Pinero.

Solomon Etting, great-grandfather of Miss Eleanor S. Cohen of Baltimore, is pictured against a sepia water-color background. Standing before a bookcase, holding glasses and top-hat in hand, he gazes through the large over-draped window to the view beyond.

Practically the same background is employed in another silhouette of Etting in the Erskine Hewitt Collection, both cut in 1840. I prefer the latter characterization with its bold penciled lines indicating the rumpled hair, his coat and buttons, and a firm hand in bold relief.

Edouart was the author of *A Treatise on Silhouette Like-nesses*, in which he claims "the representation of a shade can only be executed by an outline." He deplores the mechanically taken silhouette, and the painted and gilded type in gaudy array. These he termed *bigarrades* of which the Etting profile would be, perhaps, a mild example.

Solomon Etting, as we know, was one of Baltimore's prominent citizens. Edouart evidently enjoyed his friendship for the former's self-portrait in the Cohen Collection, cut in 1840, was a gift to Etting. It carries the remark by Miss Eleanor S. Cohen, "Autographed and silhouette by himself and given by him to my great-grandfather, Solomon Etting."

In contemplative mood, Edouart pictures himself against a delicately lithographed background. Gracefully he displays his nimble fingers, taking a bit of snuff, perhaps. The blunted finger, which came through injury early in his career, shows up in his silhouette.

[ 65 ]

The portrait of Reuben Etting, kindly looking and resigned to the infirmity of old age, was cut in 1843, in his eighty-first year. It is from Mrs. Jackson's collection.

Rebecca Gratz in one of her letters writes of him, "We meet as often together as we can, always on the Sabbath at our eldest sister's house. She never goes abroad, but is so hospitable and cheerful that we assemble in pretty large companies there — three generations together — and Reuben looks like a patriarch, at the head of his tribe."

The son of Elijah and Shinah (Solomon) Etting, Reuben was born at York, Pennsylvania, June 6, 1762. A well-known brother was Solomon Etting. As a young man Reuben clerked in a Baltimore bank. A patriot in the Revolutionary War, he threw down his pen to hasten northward when reverberations of War reached Baltimore.

In 1794 he married Frances Gratz, the eldest sister of Rebecca Gratz. Four years later he was commissioned first captain of the "Baltimore Independent Blues" and in 1801 he was appointed United States Marshal for Maryland by Thomas Jefferson.

His sons and grandchildren distinguished themselves in the service of their country. Elijah Gratz Etting became District Attorney of Cecil County, Maryland. Henry was Commodore in the United States Navy. Benjamin became the father of Lieutenant-Colonel Frank Etting, U. S. Army; and Edward was the father of Captain Charles Etting and Lieutenant Theodore Etting, officers in the Civil War.

When Reuben Etting died, June 3, 1848, he was buried in the private cemetery of the Etting family in Philadelphia, leaving children and his devoted wife who passed away four years later.

The silhouette of James Gratz, taken at Philadelphia, August

18, 1843, was found in the Morse Collection. I think he was "Jac" of whom Rebecca Gratz speaks in her *Letters* with tender affection.

He was born in 1788, and graduated from the University of Pennsylvania when only nineteen years of age. James joined the First Troop of Philadelphia City Cavalry. He was a member of the House of Representatives and of the Senate of Pennsylvania; president of the Union Canal Company; and a director of the Philadelphia Institute for the Deaf and Dumb. He remained unmarried and died September 25, 1856.

When the Gratz family suffered from financial reverses, Rebecca wrote to her sister-in-law Maria Gist Gratz, September 10, 1826:

Jac is most depressed of all he has less power to resist the ills of life in whatever shape they may approach him — and he takes the very worst method to acquire fortitude, for he shuts himself off — communes with his own gloomy thought and becomes — if I were to say nervous it would offend him — but at any rate unhappy.

We must not expect always to have the things we wish for in this world but as you say, to make the best of what we have.

James Gratz is pictured with his cane, perhaps, a necessary crutch, for Rebecca writes in the year of his death, to her brother Benjamin, that "Jac's" lameness continues to give him trouble.

The copy from an original Edouart silhouette, framed in bird's-eye maple, of Mrs. Hyam Harris is in the American Jewish Historical Society. Her maiden name was Catherine Nathan and she was born in Amsterdam, Holland, 1781. She married Hyam Harris, probably, in London in 1798, came to Charleston, South Carolina, in 1800, and to New Orleans later, where she died May 6, 1845.

She is depicted full-length and seated, book in hand, hold-

ing her spectacles. Well-indicated pencilings outline the neat collar, the puffed elbow-sleeves and becoming cap. The lithographed background with mantel, lamp, settee, and table resembles the one employed for Madame Jumel's profile, taken at Saratoga, which illustrates Mrs. Carrick's *Shades of Our Ancestors.* Edouart's stock in trade were the mounts he kept on hand, as well as letters, a book, or a sheet of paper to be placed in the sitter's hand.

The portrait of a son, Alexander Harris, was taken by Edouart, January 21, 1844. It is in the Morse Collection, but I am not including it here, because of its poor condition. Mrs. Harris's daughter, Isabelle, was also silhouetted by Edouart, as we shall see later.

I saw the late Mr. Erskine Hewitt's album of Edouart's silhouettes when on loan at the Museum of the City of New York. This most absorbing collection was purchased by Mr. Hewitt from E. F. Bonaventure, Inc. They had bought it in Paris. The album is now owned by Mr. Norvin H. Green of New York. Page after page follows of entrancing interest. Many of the silhouettes are enhanced by backgrounds, either lithographed or delicately sketched in sepia water color. Among them is a beautiful portrait of Chin Lung of China. Alexander Macomb, General-in-Chief of the United States Army, and General Winfield Scott are represented. They are stunning in their regimentals; as is Commodore Isaac Hull, who appears before a yellow-tinted lithograph accented in black tones with ships in the distance.

The Erskine Hewitt Collection also contains some interesting Jewish portraits. Jacob Hays, 1772-? is pictured here. He was High Constable of New York City from 1802-1840, and his portrait in oil, painted by J. A. Shegogue hangs in the Governor's Room, City Hall, New York.

[ 68 ]

Jacob was the eldest son of David and Esther (née Etting) Hays. His father's family emigrated from Holland in the first quarter of the eighteenth century, and settled in New York City and Westchester County where they farmed. There were six brothers whose sons were patriots during the Revolutionary War. Many descendants are now scattered throughout the United States.

The silhouette bears Edouart's flourishing inscription, "High Constable, Sergeant at Arms and Crier of the Court, New York, of Sessions 25 October, 1839." Pictured against a lithographed background of rural simplicity, Hays struts along a gaunt and intent figure masterfully caught by clever fingers.

Illuminating his personality are quaint remarks in an undated newspaper clipping, pasted beside his silhouette in the album which reads:

. . . What Lestocq was to the Parisian, and Townsend to the London, Old Hays is to the New York, nay, to the American Police. He is the Nestor of the police force in this city, and his fame has extended far and wide. . .

Jacob Hays is a "born genius," and early was the peculiar bent of his mind shown. We have found some difficulty in obtaining the most scanty information of his birth, parentage, education, and doings among the evil doers. What we know our readers shall know; as for the rest, we must be content to let that pass. He was born in Westchester County, in this state, in the year 1772, and we are delighted in being able to state positively and upon good foundation that he had a father and mother. Soon after being breeched he was sent to school, and it was while there that he made the first demonstration of what he was "born to" — of that peculiar talent at detecting thieves, and the recovering of stolen property which has made him famous in his own time, and for all time.

In the garden of his parents was a peach tree, his own exclusive property, upon that tree, at the proper season, came some remarkably fine fruit, which was watched in its progress towards maturity with the anxiety of a parent for its offspring. Each individual peach was known and

daily apostrophized, and as they grew, so did young Hays' affection grow with and for them. He knew them well, and loved them dearly. How subject is poor humanity to disappointment and vexation of spirit! — in one fatal night that tree was stripped, and when our young hero rose the next morning, he was minus his peaches.

For a moment he abandoned himself to grief — the next he set about finding out the thief. He hastened to his school room, and there to a certain boys desk, which he forced upon, and found, as he had shrewdly suspected, the whole of the stolen fruit, which with the thief whom he seized by the collar, he returned in triumph to his anxious parents. . .

Hays' flair for discovering crime when he became a Con-stable is further elaborated upon in the forementioned clipping, which quotes from his biography published in the *Unique* by Charles H. Peabody in 1830. It says:

Indeed, it is supposed by many that he is gifted with supernatural attributes, and can see things that are hid from mortal ken . . . or how, can he discover "undivulged crime" — that when a store has been robbed, he, without stop or hesitation, can march directly to the house where the goods are concealed, and say, "these are they" — or when a gentleman's pocket has been picked, that, from a crowd of unsavory miscreants, he can, with unerring judgment, lay his hands upon one and exclaim "you're wanted!" — or how is it that he is gifted with that strange principle of ubiquity that makes him "here, there, and everywhere" at the same moment?

Jacob Hays was married three times. His second wife was Katherine Conroy and his third wife was Maria Post. One of the wives was pictured by Edouart, but which one? She is freely expressed from billowing hem to the angle of her knitting needles, while the bow beneath the chin and cap adds a piquant touch. This silhouette is from Mrs. Jackson's collection.

S. W. Judah is in the Hewitt Album, in very swanky attire with cane, cut in New York, July 25, 1843. It is autographed.

His wife, the daughter of Hayman Levi of New York, was taken in Saratoga in 1844.

I cannot resist the temptation to couple her with Miss J. P. Noah, though their portraits were not taken at the same time or place. Miss Noah's was cut in New York in 1840.

But how much alike these spirited ladies appear in their plaited chignons, narrow waists, hoop-skirts, and rippling hems! So serene and aware of their awareness! What were they talking of one hundred years ago? A war, a peace, their God and children! Are things far different today?

I assume Miss Noah was related to the brilliant Mordecai Noah, Consul at Tunis. He saw beyond the religious note in Jewish life to the equally dominant one — the nationalistic. He pleaded for a Jewish homeland a century ago, wherein his people might live not by toleration, but by right. Where is his silhouette?

Edouart took two handsome portraits of Henry Lazarus in Louisville, Kentucky, May 13, 1844, which are autographed. They are in the Morse Collection. Henry was born in Phila-delphia, March 15, 1806, the son of Isaac and Esther (Lyons) Lazarus. His uncle Henry and father were in business in Mobile, Alabama, as early as 1827. Here they had business connections with John Moss, a leading ship-owner of Phila-delphia. The Lazarus brothers ended their days in Philadel-phia, from whence they had come and Henry died in Paris, October 21, 1868. He and his wife are buried in a mausoleum in Montmatre Cemetery.

Among the numerous beneficiaries of his will dated Paris, November 18, 1867, were the Jewish Foster Home, the Jewish Portuguese Hebra; his nephew, Henry Samuel; and nieces, Madeline d'Alembert and Eleanor Samuel; a kind friend, Mrs. Octavia Raux, formerly proprietress of the Hotel Prince Regent,

Paris; Benjamin George, his dentist, of the Rue Rivoli; and his adopted son and nephew, Henry M. Isaacson, of whom he says: "I feel in him I leave a son (although by adoption only) in whom I confide, and has always proved worthy of our confidence and affection, and, in compliance with our early counsels, is the only member of his mother's children who has married within his own persuasion, which if possible, forms a closer affinity."

Henry Lazarus evidently was obsessed with fear of being buried alive, because, in his Will he makes the unusual request that at the event of his death, his body be kept in a room as long a time as possible, without covering over nose or mouth, that no ice be put about his body, and that his dear wife must be consulted before closing his remains for inter- ment. He also requested that his funeral be conducted simply, free from pomp or show.

Mary Lazarus, nee Moss, was the wife of Henry Lazarus. From her expression I like to think she was kind, affable, intelligent. Her silhouette, found in one of the rescued folios in Mr. Morse's possession, is somewhat foxed from immersion. It was also taken in Louisville, in 1844.

Hayman Levy's autographed portrait is in the Morse Col- lection. He was Warden of Camden, South Carolina in 1835; later, Intendant; a prominent merchant and cotton factor; di- rector of the bank of Camden, and its Mayor. Chapman Levy and Hayman Levy fought duels with Camden men.

I learned from the late Mr. Bunford Samuel, of Philadelphia, a descendant, that Hayman Levy's wife was Almeria De Leon, a descendant of Jacob De Leon. One of their boys was killed in the Civil War; another was broken by the hardships en- dured during the war and died shortly afterward. Hayman Levy died in 1865.

Many Jewish names figured prominently in the service of the United States Army and Navy, among them Commodore Uriah P. Levy of the Navy. He was the father of the law for the abolition of the barbarous practise of corporal punishment in the Navy.

Cut by Edouart in Saratoga Springs, August 20, 1842, he is a striking figure, against a lithographed background, in epauleted uniform carrying a halberd, as seen in the Erskine Hewitt Collection. The illustrated duplicate profile is from Mrs. Jackson's collection.

He was born in 1792, the son of Michael and Rachel Levy. His mother of colonial descent, was the daughter of Jonas and Rebecca (Mendes Machado) Phillips. During the War of 1812, Levy was Master of the Brig of War *Argus,* which ran the blockade to France with Mr. Crawford, the American minister to that country, on board. When the *Argus* destroyed twenty-one British merchant-men, the Common Council of New York City, honored the Commodore with the freedom of the city.

Levy greatly admired Thomas Jefferson whose statue by David D'Angers, the French Sculptor, he presented to Congress. Levy also purchased Monticello after Jefferson's death.

When Commodore Levy died on March 22, 1862, he left a large share of his estate for the maintenance, at Monticello, of an agricultural school, for the children of deceased warrant-officers of the United States Navy. The legality of the bequest resulted in considerable discussion, and the property reverted to his heirs from whom Monticello has been repurchased, and at last restored as a national shrine.

Also in the Erskine Hewitt Album was the silhouette of John Moss by Edouart, cut November 5, 1842. The original duplicate silhouette was mounted against a most picturesque lithographed background of docked ships, and an expansive

wharf evincing Moss's interests. A copy has recently come into possession of the American Jewish Historical Society.

As Edouart did not resort to caricature, Moss certainly appeared just as he is pictured — a short stocky man, with determined head planted on stooping shoulders — harnessed against the staggering odds of life's vicissitudes. He wears a high hat, frock coat with flapping tails, and carries a cane. It is a very convincing portrait, except for the feet. How could they carry the burden of his worry? But Edouart often did fall down on his feet!

John Moss, son of Joseph Moss, was born in London, England, January 1, 1774. He came to the United States a very poor man in 1793, and married Rebecca Lyons, a Jewess, the daughter of Eleazer and Hannah (Levy) Lyons, of Lancaster, Pennsylvania. They settled in Philadelphia where Moss became a successful merchant, a director in several railroad companies, and a shipping magnate. One of the boats he sailed was the Brig *Tontine,* which was painted in water color by Anton Roux, when it left Marseilles, June, 1825.

Moss was interested in Masonry and in the Jewish community. He was one of the committee here, which marked the first concerted action, since the Fall of Jerusalem on the part of Jews the world over, in behalf of their less fortunate brothers in Damascus.

There the Jews in 1840 were accused of using the blood of a monk for their Passover feast. This horrible and false indictment stirred their communities in Europe and the United States to vindication. Here President Martin Van Buren, through his Secretary of State, John Forsyth, urged the United States Minister at Constantinople to use his influence in behalf of the persecuted Jews.

At this time Rebecca Gratz touchingly wrote to Maria Gist Gratz, August 27, 1840:

What can be done, unless the Governments of Civilized Nations combine to save them — the Jews have no representative powers, and can only act in their individual capacities, the support of the countries of which they are citizens — and the application of their wealth to purchase their brothers lives is all that they can do — and perhaps this is as far as human aid can go. God in his mercy, may touch the hearts of their oppressors, or break the bonds when all visible means fail.

A hundred years have passed. The Jews are still libelled and persecuted in several European countries. But the civilized nations, through the League of Nations, have mandated Palestine to Great Britain as a national homeland for the Jews. By a commercial treaty with England our own Government recognizes and approves the duty of England to facilitate the efforts of the Jews to establish a homeland in Palestine.

Deprived for many centuries of contact with the earth, the Jews have already proved that they are adept with the plow and hammer. No less conspicuous is their achievement in the spiritual and cultural field. The great Hebrew University, many scientific institutions, a prolific literary production, and a Symphony Orchestra testify to the ever throbbing intellectual life of the Jew.

A copy of the silhouette of Mrs. John Moss (Rebecca Lyons), 1777-1864, also reposes in the American Jewish Historical Society, displaying the same lithographed background used with the profile of Mrs. Hyam Harris. White pencilings enhance the value of this graceful example of Edouart's work.

Samuel Lyons Moss, her son, of most refined countenance, his wife Isabelle, their children, and a slave-boy, holding a glass, form an interesting group portrait cut by Edouart, January 15, 1844. It is mounted against a background on which

is silhouetted a race-horse, perhaps Mr. Moss's favorite. A copy of the family group is in the American Jewish Historical Society.

Samuel was born in Philadelphia, June 15, 1811. He became a merchant and cotton broker in New Orleans, where he married Isabelle Harris. She was born in Charleston, South Carolina, April 9, 1819, the daughter of Catherine and Hyam Harris. The children represented are Ernest Goodman, 1839-1901 and Ella Amelia, 1843-1911. Ernest, the eldest son, was about four years old when the silhouette was cut, and the daughter, who became Mrs. Barr Du Val was about five months old at the time. Isabelle, the young and attractive mother in slender waist and voluminous skirt, was nearly twenty-five years old when silhouetted.

Edouart loved to portray children, showing them often with their toys and in delightful animated expression. How quaint and charming they appear — the boy in long curls and wearing full-flounced skirt above short trousers of ankle length.

There were seven children in the Moss family. Isabelle took them to Europe, settling there about 1850. Here they were educated. They lived in Düsseldorf, Dresden, and Paris, and took occasional trips to the United States. Isabelle died in Paris, January 8, 1907. Samuel remained in this country traveling extensively. He died in a popular resort for Southerners, the Stevenson House, St. Catherines, Ontario, Canada, August 10, 1870.

In the Erskine Hewitt Collection is the silhouette cut by Edouart, August 21, 1842, at Saratoga Springs, of Henry M. Phillips, "Counsellor at Law," of Philadelphia. He is a short man, pictured with right arm extended as if eloquently pleading a case.

Henry Phillips was born in 1811. His father, Zalegman

Phillips, was one of the leading criminal lawyers of Philadelphia, having graduated from the University of Pennsylvania in 1795. Henry's mother was Arabella, daughter of Myer and Catherine Bush Solomon of Baltimore.

His grandfather, Jonas Phillips, who came to America in 1756, married Rebecca Mendes Machado to whom twenty-one children were born. Among them and their descendants were many who attained distinction. Jonas was a *shocket* (a religious official who slaughters animals according to Jewish ritual), and also took an active interest in civic affairs.

Henry M. Phillips was evidently a man of many interests, as indicated by his varied activities. He was a congressman and a financier, a Master in Masonry, a member of the old Congregation Mikveh Israel, President of the American Philosophical Society, and the Philadelphia Academy of Music. The fountain which stands before the Museum of Art in Fairmount Park, bears the following inscription: "Erected with funds bequeathed for its construction and maintained by Henry M. Phillips who was appointed a member of the Fairmount Park Commission upon its creation in 1867 and served as its President from 1881 until his death in 1884."

His home at 1325 Walnut Street is said to have contained an artistic collection of marbles, bronzes, ivories, and paintings. The latter were willed to Memorial Hall at Fairmount Park when he died, unmarried, in 1884.

Edouart profiled a number of other Jews whose silhouettes I have not obtained. Benjamin Gratz, the brother of Rebecca, was silhouetted at Lexington, Kentucky, where he lived, May 20, 1844. A. K. Josephs was taken at New Orleans, March 20, 1844; his name appears in the first List of Subscribers to the *Occident*. Edward Israel Kursheedt was cut in New Orleans, March 2, 1844; a portrait of Samuel Moss, brother of John

Moss, whose silhouette is incorrectly listed "James Moss, Jun." is owned by Mr. Glenn Tilley Morse.

The *Vernay and Jackson Catalogues* also list a number of names which suggest a Jewish origin, but I have not been able to identify them. They are A. L. Alexander of Georgia, and Isaac Jacob of New Orleans. The names Hart, Hays, and Henry, and Jacobs appear a number of times. There are thirteen named Mayer and two Mayers; one Meyers, and eight Myers, also a number of Philips and Phillips, and the names Simons, Tobias, Vogel, Weil, Wolf, and Wyse confound me. Probably the future will reveal at least some of them as Jews.

# X

## SOME MISCELLANEOUS SCISSORED
## PROFILES

A STRANGE little full-length scissored profile of Joseph Andrade, may be seen in the American Jewish Historical Society. It is dated May, 1865, and bears the embossed stamp "G. B. Wood, Jr." I think the latter may have been the artist, George B. Wood, who was born in Philadelphia in 1832.

Andrade was born in Bayonne, France, July 17, 1788. His father, the Grand Rabbi at Bordeaux, was much respected for his extraordianry knowledge of Hebrew, and was an intimate friend of Archbishop Dubois de Sanzay of Bordeaux and Monsieur de Cheverus, once Bishop of Boston.

An American merchant, Mr. Lewis Chastant, became acquainted with Joseph Andrade in Bordeaux, and under his patronage, the latter came to the United States in 1816, settling in Philadelphia at 30½ Walnut Street. Mr. Chastant, perceiving Andrade's business acumen, introduced him to Mr. Stephen Girard, for whom he became financial agent and adviser to other capitalists and leading merchants.

A wealthy Philadelphian left him a legacy of fifty thousand dollars, in real estate, which Andrade rejected, disinterestedly allowing it to go to the heirs. Though he lived as a pauper, he contributed liberally to charitable purposes, and when he died without leaving a will, his property reverted to the children of his brother, Auguste, and his sister Made Oxeida.

An interesting newspaper item dated June 20, 1868, affixed to his silhouette reads that:

The deceased was well-known on "Change," and in fact, by everybody who had occasion to do business on Third Street. His quip-like figure

might be seen every day, wending its way along Third and Walnut Streets in the transaction of business. The eccentricity of his dress attracted the attention of all strangers . . .

I know of a scattering of scissored unattributed silhouettes of Jewish interest. Mrs. John Hill Morgan of Brooklyn owns a silhouette of her ancestor, Dr. Henry Meyers, whose family were Christianized. A scissored bust of Daniel L. M. Peixotto, born in Amsterdam in 1800, is in the American Jewish Historical Society. He was a prominent New York physician. A bust portrait of Henry Joseph of Berthier, Canada, is reproduced in the pamphlet, *History of the Corporation of Spanish and Portuguese Jews 'Shearith Israel' of Montreal, Canada.*

The scissored silhouette of Isaac Harby appears in the book *Isaac Harby* by L. C. Moise. The original is owned by Mr. M. E. Harby of Huntington, Long Island. It is unattributed and mounted against a background of scroll-work in black and white.

The genealogy of the Harby family as reconstructed by Isaac Harby of New York, a great-grandson of the subject goes back to fifteenth century England. Nicholas Harby, a Christian, of the County of Cambridge, was the first member of whom there is a record. His son was William, father of Thomas. The latter's son was Clement, whose son Clement, Jr., was knighted at Whitehall in 1669. Some time later he was Consul in Morea where he married a Jewess.

Clement, Jr., and his wife moved to Morocco, where he became secretary to the king and filled the post of Royal Lapidary. Their son, Isaac Harby, as a jeweller, became a very wealthy man. His son, Solomon, was also prosperous, but when the fortunes of the Jews were confiscated with those of the Huguenots, after the Revocation of the Edict of Nantes, Solomon debarked for Jamaica, and in 1781 went to Charleston, South Carolina.

Solomon married Rebecca, daughter of Myer Moses in 1787. Isaac Harby, born in Charleston, South Carolina, November 9, in the following year, was the first child of this union. He became a school teacher and in 1810 married Rachel, daughter of Samuel Mordecai of Savannah. Later he achieved prominence as a journalist, literary critic, and dramatist. But his greatest claim to fame rests as the spiritual leader of the Jewish reform movement of 1824 in Charleston.

In June, 1828, Isaac Harby left the South for New York with his sister and children upon the death of his wife. Here he resumed his literary work and teaching, but within a brief period, he was taken ill and died December 14, 1828, when he was forty years old.

He is buried beneath an upright stone in the tiny triangular cemetery on the south side of Eleventh Street, in the second burying ground of the Shearith Israel Synagogue. There are not more than thirty graves here, as the cemetery was used only from 1805 to 1829. Some of the burial stones stand erect, some lie flat, for between the *Ashkenazim* and the *Sephardim* there were always distinctions, even in death. The former chose upright stones, the latter lie buried under flat stones to indicate that in death all men are level with the earth.

# XI

## WILLIAM HENRY BROWN

LAST of the great scissor-men was William Henry Brown. He was born in 1808 in Charleston, South Carolina, of Quaker ancestry. Beginning his career in 1824 with a likeness of Lafayette, he continued cutting silhouettes until 1859-60, when the camera clicked down on the popularity of the shadow picture. He lived until 1882 devoting his latter years to railroad interests.

His silhouettes in which he cut the whole figure very rapidly are often found against lithographed backgrounds. Many of his distinguished contemporaries among whom are John Quincy Adams, John C. Calhoun, Andrew Jackson, and Chief Justice John Marshall, appear in Brown's own work, *Portrait Gallery of Distinguished Citizens with Biographic Sketches*. The lithographed backgrounds which were done by E. B. and E. C. Kellogg greatly heighten the interest.

The silhouette of Michael Levy belonging to Mr. Henry S. Hendricks, New York, is mounted in a narrow flattish frame of stained wood such as Mrs. Carrick associates with William Henry Brown.

He is all dressed up in top-hat resting close to the ears and tilted backward. In knee-length coat, breeches, and buckled shoes his costume is complete. Brown indicates his eye, and even the lash very subtly, the long nose, the full lower lip and rounded chin. Brown's old men are significant for their personality.

His wife was Rachel, the daughter of Jonas and Rebecca (Mendes Machado) Phillips, and sister of the well-known

[ 83 ]

lawyer, Zalegman Phillips. While in London she is said to have been presented at the British court.

Michael and Rachel were the parents of Rebecca Tobias and two very distinguished sons, Uriah P. Levy, whom we have already mentioned, and Jonas Phillips Levy, commander of the *U. S. S. America,* during the Mexican War. The latter was survived by three sons, Jefferson M., Louis Napoleon, Mitchell, and two daughters.

Michael Levy died when he was one hundred and four years old in 1839, and was buried at Monticello, Virginia.

Mr. Hendricks also has a reproduction of "The First Steam Railway Passenger Train in America" in silhouette by Brown, the original of which is in the Connecticut Historical Society at Hartford, showing old man Jacob Hays, as one of the passengers.

Another silhouette attributed to Brown is that of John Moss in the American Jewish Historical Society presenting him against a lithographed background — Independence Hall. Identical with this silhouette is one which illustrates my book, *Portraits of Jews,* though the backgrounds are different.

*       *       *

No less important than the painted portraits of the early American Jews are these shades of my forefathers. How interesting it would be if all their original portraits could be collected and exhibited, from time to time, in our various art galleries and institutions! These side-lights of history would furnish ample evidence of the Jews who contributed along with other racial groups to build this country. In the teaching of American Jewish history, I believe it would be helpful for students to view such an exhibition, for it would lend charm and interest to the study of their background here.

Jewish children especially could visualize American-Jewish personalities, whose history they might be prompted to interpret in dramatic form. This would lend a refreshing touch to Sunday School work and even to the patriotic celebrations in our Public Schools, where the children descend from various racial strains. Any racial group aware of a full knowledge of its existence calls for a more enlightened citizenship among its members.

To view the original portraits or reproductions of the American-Jewish forefathers contributes educationally in history and in art to Jew and non-Jew. To the Jew, particularly, it lends dignity to the past and inspiration to the future.

[ 85 ]

# BIBLIOGRAPHY

# BIBLIOGRAPHY

BAROWAY, AARON. *Solomon Etting, 1764-1847*, Maryland Historical Magazine, Vol. XV, March, 1920.

BAROWAY, AARON. *The Cohens of Maryland*, Maryland Historical Magazine, Vol. XVIII, December, 1923; Vol. XIX, March, 1924.

BOEHN, MAX VON. *Miniatures and Silhouettes*. Dent, London, 1928.

BOLTON, CHARLES K. *Workers with Line and Color in New England*. In manuscript, at the Boston Athenæum.

BOLTON, ETHEL STANWOOD. *Wax Portraits and Silhouettes*. The Massachusetts Society of the Colonial Dames of America, Boston, 1914.

BOLTON, ETHEL STANWOOD. *American Wax Portraits*. Houghton Mifflin Co., Boston, 1929.

BROWN, WILLIAM HENRY. *Portrait Gallery of Distinguished American Citizens, with Biographical Sketches*. E. B. and E. C. Kellogg, Hartford, 1845. G. A. Baker & Co., New York, 1931.

CARRICK, ALICE VAN LEER. *Shades of our Ancestors*. Little, Brown & Co., Boston, 1928.

CARRICK, ALICE VAN LEER. *Shadows of the Past*, Country Life, August, 1920; *Vogue for the Silhouette*, Country Life, December, 1922; *Novelties in Old American Profiles*, Antiques, October, 1928.

COLQUITT, DELORES BOISFEUILLET. *Distinguished Jews in St. Mémin Miniatures*, Daughters of the American Revolution Magazine, Vol. LIX, February, 1925.

*Dictionary of American Biography*. Scribner's Sons, New York, 1928.

DUNLAP, WILLIAM. *History of the Arts of Design in the United States*. Edited by Bayley and Goodspeed, Boston, 1918.

EARLE, ALICE MORSE. *Two Centuries of Costume in America*. Macmillan Co., New York, 1903.

ELZAS, DR. BARNETT A. *The Jews of South Carolina*. Lippincott Co., Phila., 1905.

FEVRET DE SAINT-MÉMIN, CHARLES B. J. *The St.-Mémin Collection of Portraits*. Photographed by J. Gurney and Son. Elias Dexter, New York, 1862.

GILLINGHAM, HARROLD E. *Notes on Philadelphia Profilists*, Antiques, June, 1930.

GOTTHEIL, R. J. H. *The Belmont-Belmonte Family*. New York, 1917.

HART, CHARLES HENRY. *The Last of the Silhouettists*, The Outlook, October 6, 1900.

HARTOGENSIS, BENJAMIN H., A. B. *The Sephardic Congregation of Baltimore*, Publications of the American Jewish Historical Society, New York, XXIII, 1915.

HUHNER, LEON, A. M., L. L. B. *Jews in the War of 1812*, Publications of the American Jewish Historical Society, New York, XXVI, 1918.

Jackson, E. Nevill. *Ancestors in Silhouette.* John Lane Co., London, 1921.

Jackson, E. Nevill. *The History of Silhouettes,* The Connoisseur, London, 1911.

Jackson, E. Nevill. *Catalogue of 3800 American Silhouette Portraits by August Edouart.* London.

Jewish Encyclopedia.

Lavater, John Caspar. *Essays on Physiognomy; calculated to extend the Knowledge and the Love of Mankind.* Translated from the last Paris Edition by the Rev. C. Moore, L. L. D., F. R. S. London, 1797.

London, Hannah R. *Portraits of Jews by Gilbert Stuart and Other Early American Artists.* W. E. Rudge, New York, 1927.

Lord, Jeanette Mather. *Some Light on Hubard,* Antiques, June 6, 1928.

Mills, Weymer. *Collection of Profile Portraits,* The Connoisseur, December, 1909.

Moise, L. C. *Isaac Harby.* Central Conference of American Rabbis, 1931.

Morais, Henry Samuel. *The Jews of Philadelphia.* The Levytype Co., Philadelphia, 1894.

Morgan, John Hill. *The Work of M. Fevret de Saint-Mémin,* reprinted from the Brooklyn Museum Quarterly, January, 1918, Vol. v, No. 1.

Morrison, Hyman, m. d. *The Early Jewish Physicians in America.* A Pamphlet, read before the Boston Medical History Club, February 24, 1928.

*Occident and American Jewish Advocate.* Vol. i-ix. Philadelphia, 1844.

Osterweis, Rollin G. *Rebecca Gratz.* G. P. Putnam's Sons, New York, 1935.

Philipson, Rabbi David. *The Letters of Rebecca Gratz.* The Jewish Publication Society of America, Philadelphia, 1929.

*Publications of the American Jewish Historical Society.* New York, Vols. i-xxxiv.

Sherman, Frederic Fairchild. *James Sanford Ellsworth; A New England Miniature Painter.* New York. Privately Printed. 1926.

Swan, Mabel M. *Master Hubard, Profilist and Painter,* Antiques, June, 1929.

*The Saint Charles,* Vol. i, No. 1, New York, January, 1935.

*Twentieth Century Biographical Dictionary of Notable Americans.* Biographical Society, Boston, 1904.

Vernay, Arthur S. *A Catalogue of American Silhouettes by Augustin Edouart.* A Notable Collection of Portraits taken between 1839-49. New York, 1913.

Webb, A. Holliday. *Gallery Notes pertaining to the exhibition by J. Stowitts, on the "Arts of the Theatre in Java."* Museum of Fine Arts, Boston. August, 1935.

Wellesley, Francis. *One Hundred Silhouette Portraits selected from the Collection of Francis Wellesley.* Preface by Weymer Mills. University Press, Oxford.

# ILLUSTRATIONS

A Sure and convenient Machine for drawing Silhouettes

"A SURE AND CONVENIENT MACHINE FOR DRAWING SILHOUETTES"
From Lavater's *Essays on Physiognomy*. Quarto Edition, Vol. II
*Courtesy of Widener Library, Harvard University*

FACSIMILE SPECIMEN FROM NAME-LIST OF SILHOUETTES
*In* WILLIAM BACHE'S SCRAPBOOK
*Courtesy of Mrs. C. R. Converse, Elmira, New York*

"JEW PEDLAR—DUTCH"
*By* WILLIAM BACHE
*Courtesy of Mrs. C. R. Converse,*
*Elmira, New York*

[ 95 ]

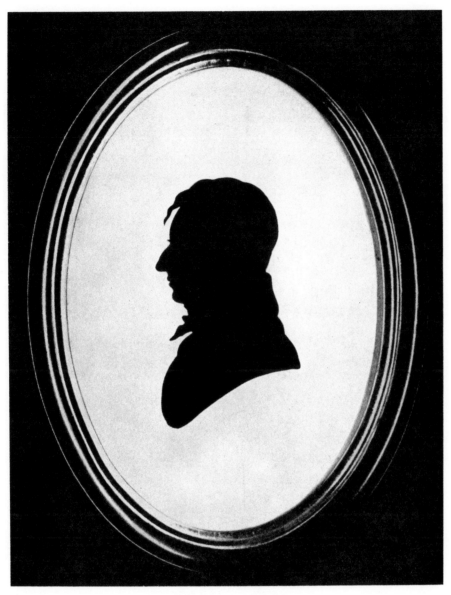

JACOB I. COHEN
*Hollow-cut by* CHARLES WILLSON PEALE
*Courtesy of Mrs. D. Grigsby Long, University, Va.*

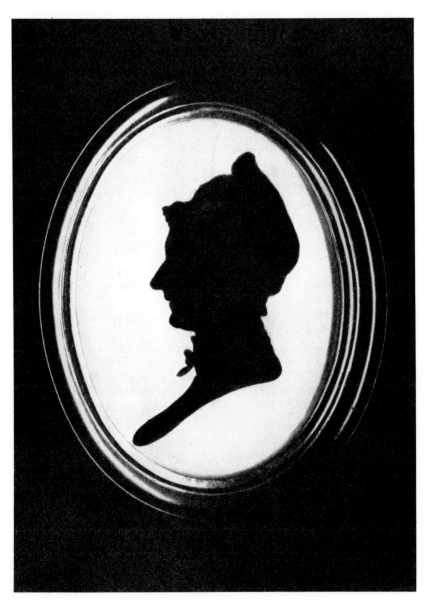

MRS. ISRAEL I. COHEN
(Judith Solomon)
*Hollow-cut by* AN UNKNOWN ARTIST
*Courtesy of Mrs. D. Grigsby Long, University, Va.*

[ 99 ]

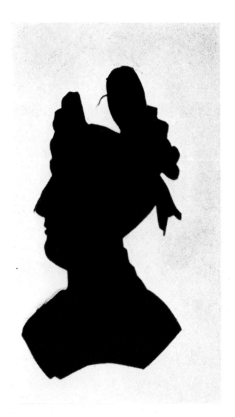

MRS. ELIJAH ETTING
(Shinah Solomon)
*Hollow-cut by* AN UNKNOWN ARTIST
*Courtesy of the Maryland Historical Society*

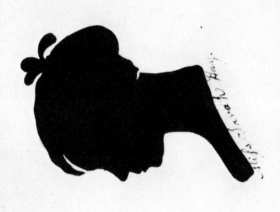

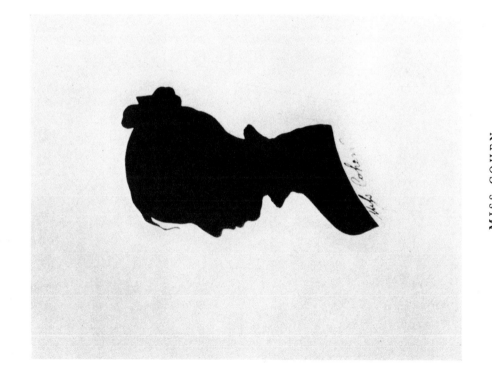

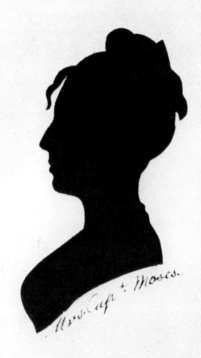

MRS. ''CAPT.'' MOSES
Mrs. Meyer Moses II
(Esther Phillips)
*Hollow-cut by* George (?) Todd
*Courtesy of the Boston Athenæum*

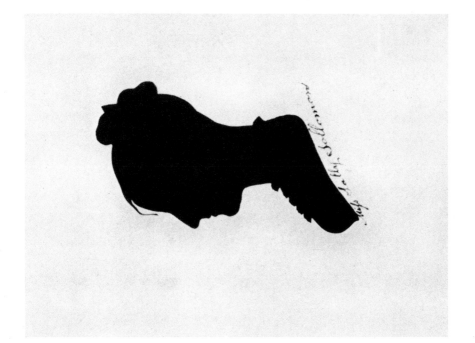

MISS SALLY SOLLOMON
*Hollow-cut by* GEORGE (?) TODD
*Courtesy of the Boston Atheneum*

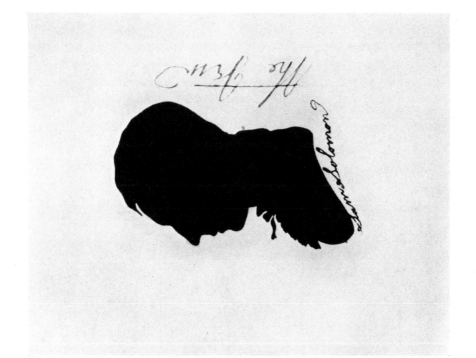

SAM SOLOMON
*Hollow-cut by* GEORGE (?) TODD
*Courtesy of the Boston Atheneum*

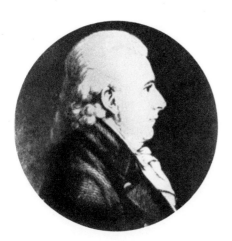 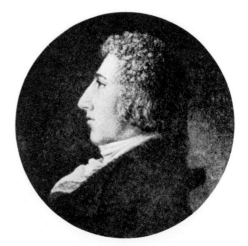

HENRY ALEXANDER
*By* FEVRET DE SAINT-MÉMIN
*Courtesy of the Corcoran Art Gallery*

ABRAHAM HART
*By* FEVRET DE SAINT-MÉMIN
*From the Elias Dexter*
*Saint-Mémin Collection of Portraits*

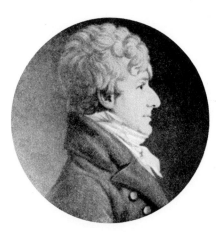 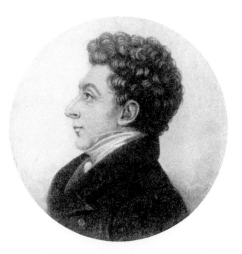

HYMAN MARKS
*By* FEVRET DE SAINT-MÉMIN
*Courtesy of the Pierpont Morgan Library,*
*New York City*

JUDGE MOSES LEVY
*By* FEVRET DE SAINT-MÉMIN
*Engraved by Bouchardy*
*Courtesy of the Boston Museum of Fine Arts*

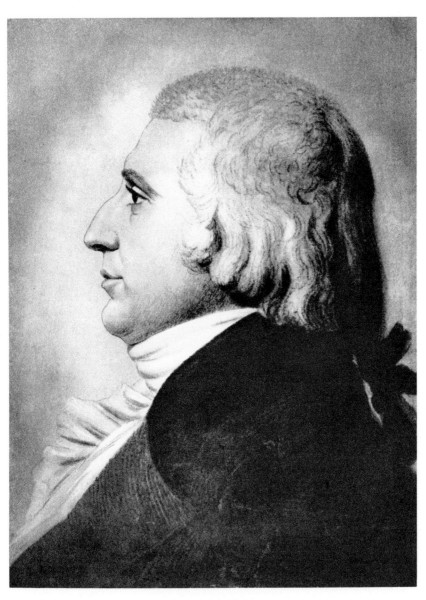

SAMSON LEVY, JR.
*By* FEVRET DE SAINT-MÉMIN
*Courtesy of the late Mrs. Robert Hale Bancroft, Beverly, Mass.*

[ 113 ]

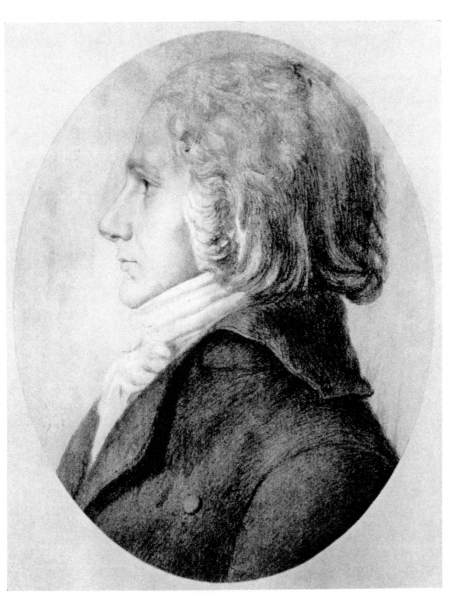

SOLOMON MOSES
*By* FEVRET DE SAINT-MÉMIN
*Courtesy of Miss Mary Porter Scott, St. Louis, Mo.*

AARON RODRIGUES RIVERA
*By* AN UNKNOWN ARTIST
*Courtesy of Mrs. Jerome F. Milkman, New York City*

[ 117 ]

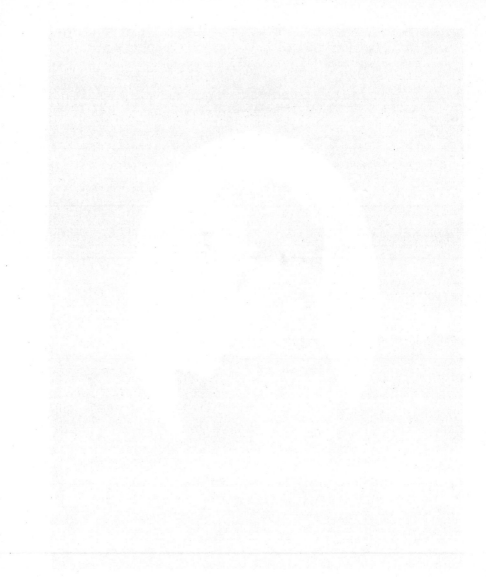

SIMEON LEVY
*By* an Unknown Artist
*Courtesy of Miss Aline E. Solomons, Washington, D. C.*

[ 119 ]

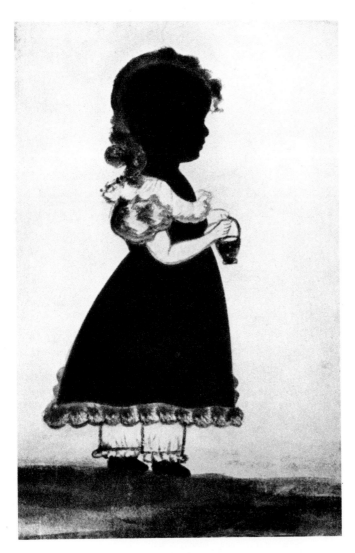

ISAAC AARON ISAACS
*By* AN UNKNOWN ARTIST
*Courtesy of Miss Gertrude Cohen, New York City*

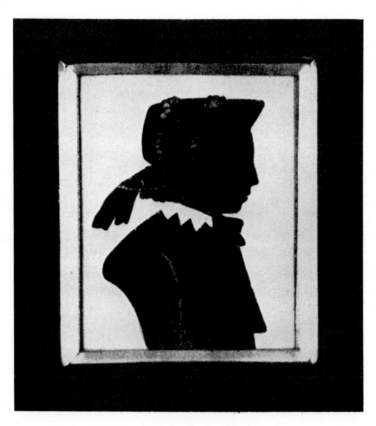

MRS. ISRAEL I. COHEN
(Judith Solomon)
*By* AN UNKNOWN ARTIST
*Courtesy of Mrs. Arnold Burges Johnson, New York City*

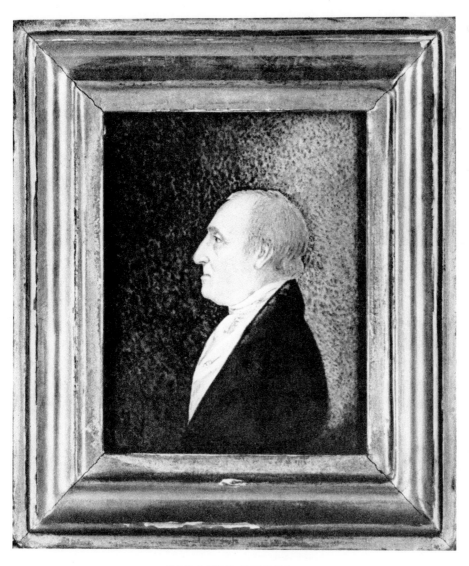

ELEAZER LYONS
*By* AN UNKNOWN ARTIST
*Courtesy of Mr. John D. Samuel, Philadelphia*

[ 125 ]

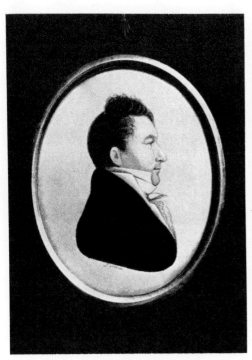

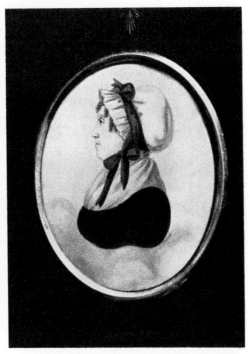

SOLOMON ETTING
*By* THOMAS GIMBRÈDE
*Courtesy of the Maryland Historical Society*

MRS. SOLOMON ETTING
(Rachel Gratz)
*By* THOMAS GIMBRÈDE
*Courtesy of the Maryland Historical Society*

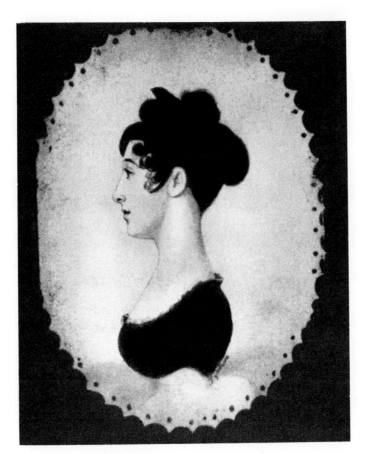

MISS RICHEA G. ETTING
*By* THOMAS GIMBRÈDE
*Courtesy of the Maryland Historical Society*

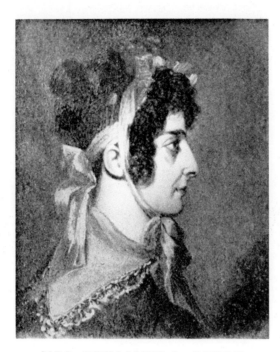

MRS. BENJAMIN I. COHEN
(Kitty Etting)
*By* AN UNKNOWN ARTIST
*Courtesy of the Maryland Historical Society*

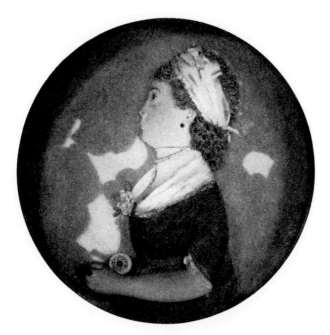

MRS. NICHOLAS SCHUYLER
(Shinah Simon)
A Wax Portrait
*Attributed to* JOHN CHRISTIAN RAUSCHNER
*Courtesy of Mr. Henry Joseph, Montreal*

SOLOMON ETTING
*By* WILLIAM JAMES HUBARD
*Courtesy of the Maryland Historical Society*

REBECCA GRATZ
*By* WILLIAM JAMES HUBARD
*Courtesy of Mr. Rollin G. Osterweis, New Haven, Conn.*

AUGUST BELMONT
*By* AUGUSTIN EDOUART
*Courtesy of Mrs. E. Nevill Jackson,
London, England*

AUGUST BELMONT
*By* AUGUSTIN EDOUART
*Courtesy of Mrs. E. Nevill Jackson,
London, England*

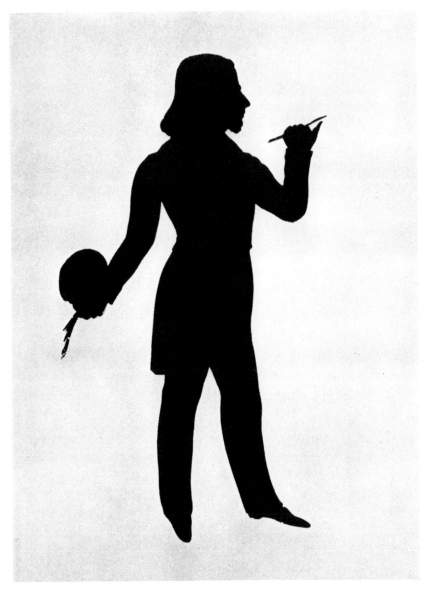

SOLOMON N. CARVALHO
*By* AUGUSTIN EDOUART
*Courtesy of Mr. Glenn Tilley Morse, West Newbury, Mass.*

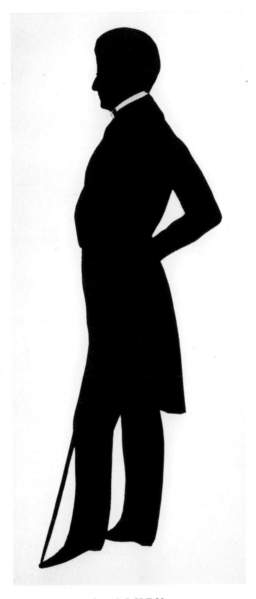

A. COHEN
By AUGUSTIN EDOUART
*Courtesy of Mr. Glenn Tilley Morse,
West Newbury, Mass.*

[ 143 ]

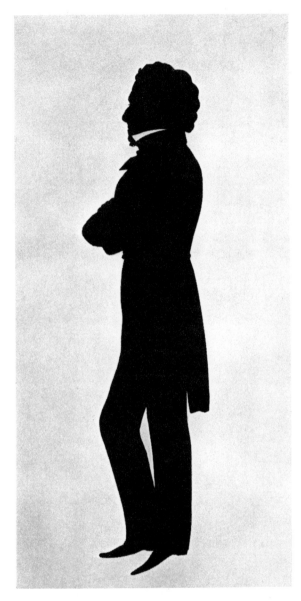

DR. JOSHUA I. COHEN
*By* AUGUSTIN EDOUART
*Courtesy of Mr. Glenn Tilley Morse,*
*West Newbury, Mass.*

[ 145 ]

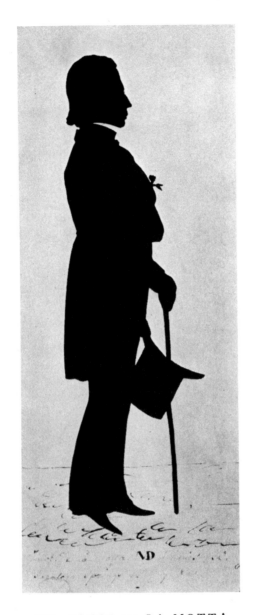

DR. JACOB DE LA MOTTA
*By* AUGUSTIN EDOUART
*Courtesy of the late Mr. Erskine Hewitt,*
*New York City*

[ 147 ]

BERNARD G. ETTING
*By* AUGUSTIN EDOUART
*Courtesy of the Maryland Historical Society*

AUGUSTIN EDOUART
SELF-PORTRAIT
*Courtesy of the Maryland Historical Society*

[ 151 ]

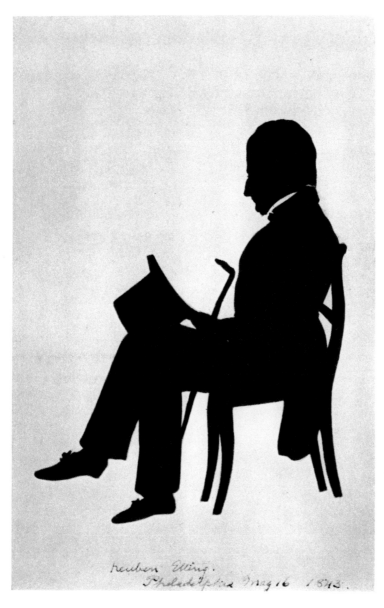

Reuben Etting.
Philadelphia May 16 1843.

REUBEN ETTING
*By* AUGUSTIN EDOUART
*Courtesy of Mrs. E. Nevill Jackson, London, England*

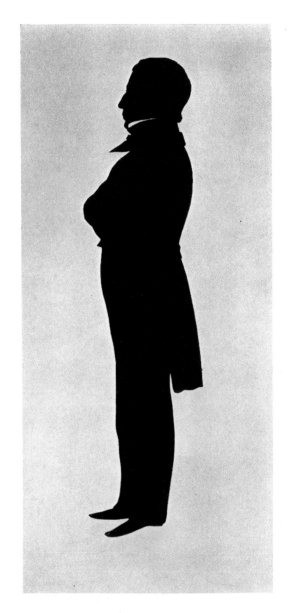

JAMES GRATZ
*By* AUGUSTIN EDOUART
*Courtesy of Mr. Glenn Tilley Morse,*
*West Newbury, Mass.*

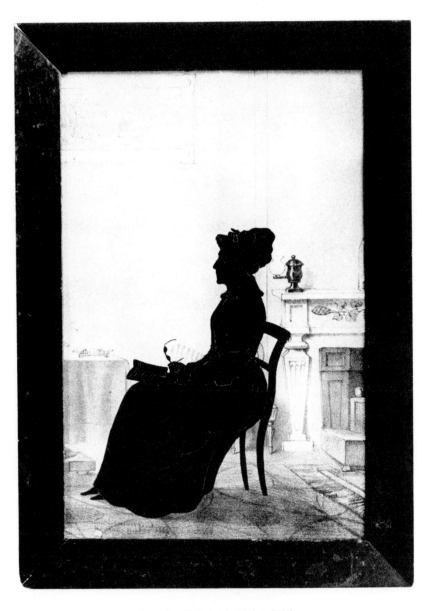

MRS. HYAM HARRIS
(Catherine Nathan)
*By* AUGUSTIN EDOUART
*Courtesy of the American Jewish Historical Society*

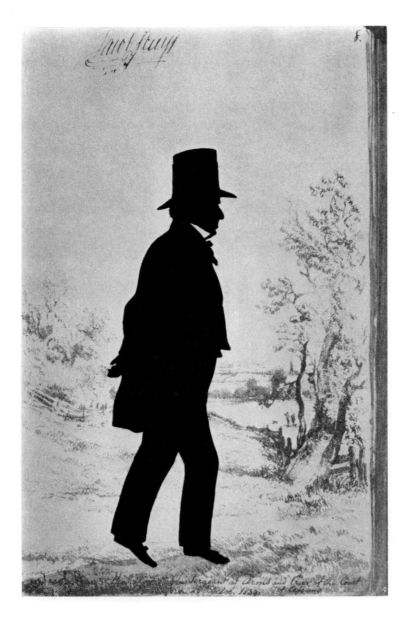

JACOB HAYS
*By* AUGUSTIN EDOUART
*Courtesy of the late Mr. Erskine Hewitt, New York City*

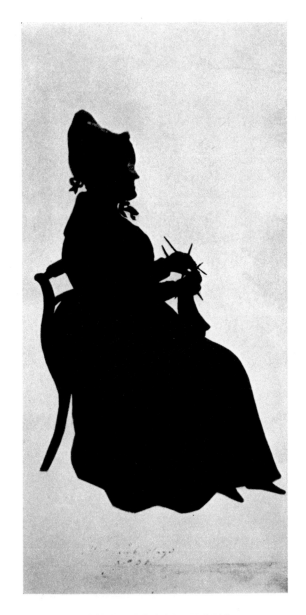

MRS. JACOB HAYS
*By* AUGUSTIN EDOUART
*Courtesy of Mrs. E. Nevill Jackson, London, England*

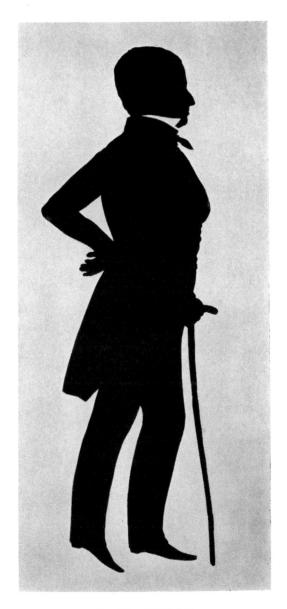

S . W . J U D A H

*By* AUGUSTIN EDOUART

*Courtesy of Mr. Glenn Tilley Morse,*
*West Newbury, Mass.*

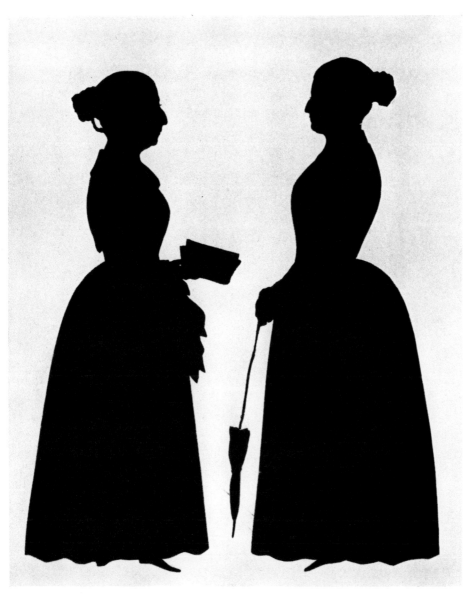

MISS J. P. NOAH                 MRS. S. W. JUDAH

(née Levi)

*By* AUGUSTIN EDOUART

*Courtesy of Mr. Glenn Tilley Morse, West Newbury, Mass.*

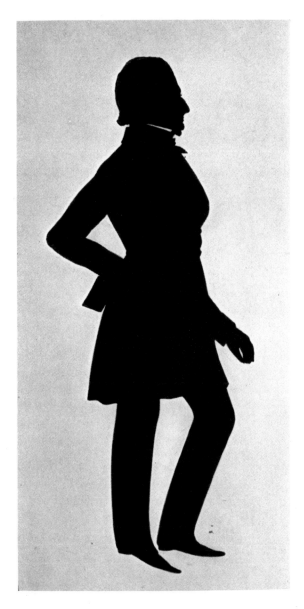

HENRY LAZARUS
*By* Augustin Edouart
*Courtesy of Mr. Glenn Tilley Morse,*
*West Newbury, Mass.*

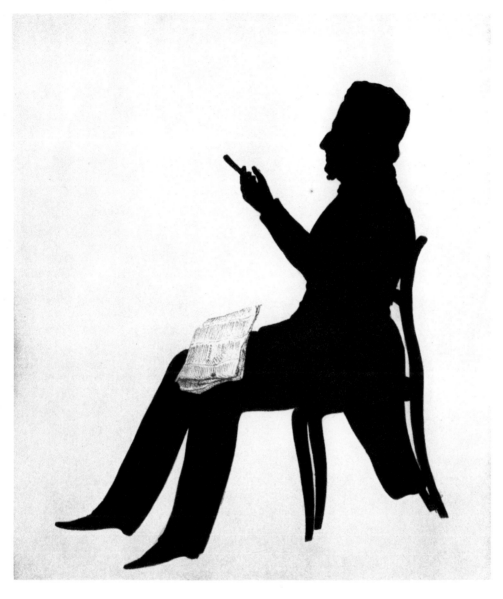

HENRY LAZARUS
*By* AUGUSTIN EDOUART
*Courtesy of Mr. Glenn Tilley Morse, West Newbury, Mass.*

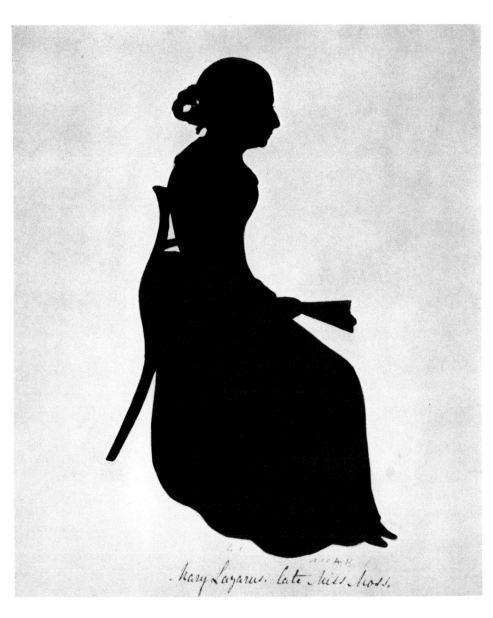

Mary Lazarus. late Miss Moss.

MRS. HENRY LAZARUS
(Mary Moss)
By Augustin Edouart
Courtesy of Mr. Glenn Tilley Morse, West Newbury, Mass.

[ 171 ]

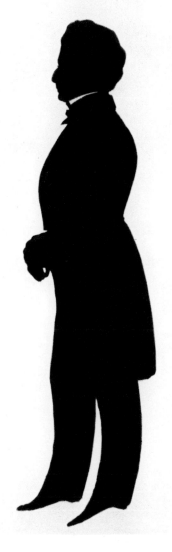

HAYMAN LEVY
Mayor of Camden, S. C.
*By* AUGUSTIN EDOUART

*Courtesy of Mr. Glenn Tilley Morse,*
*West Newbury, Mass.*

[ 173 ]

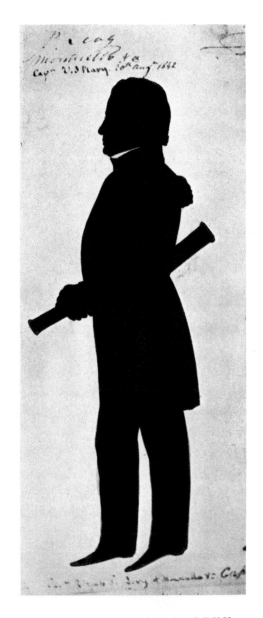

CAPTAIN URIAH P. LEVY
By Augustin Edouart
*Courtesy of Mrs. E. Nevill Jackson,
London, England*

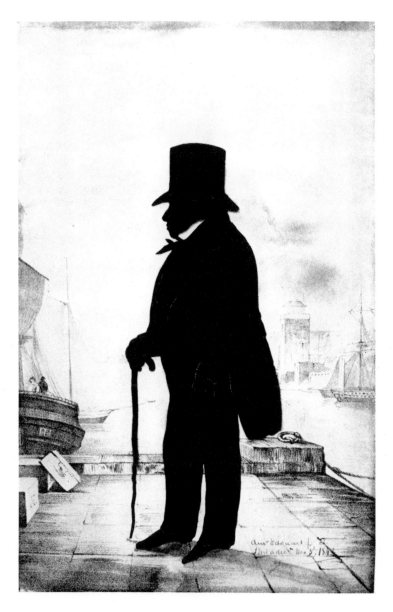

JOHN MOSS
*By* AUGUSTIN EDOUART
*Courtesy of the American Jewish Historical Society*

[ 177 ]

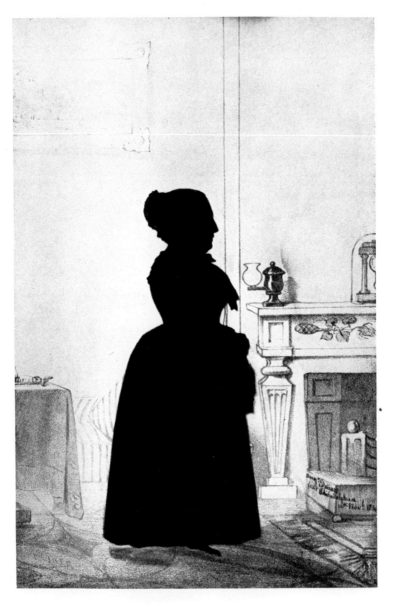

MRS. JOHN MOSS
(Rebecca Lyons)
*By* AUGUSTIN EDOUART
*Courtesy of the American Jewish Historical Society*

[ 179 ]

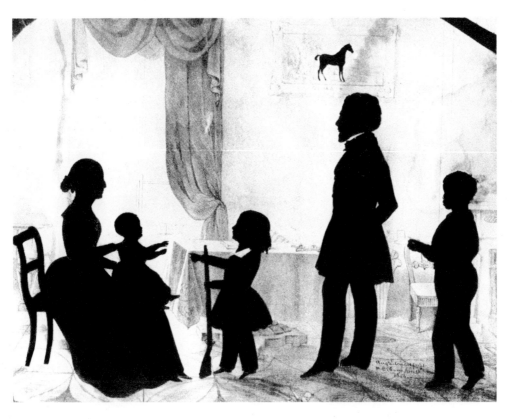

MR. AND MRS. SAMUEL LYONS MOSS (Isabelle Harris) WITH THEIR CHILDREN,
ERNEST GOODMAN AND ELLA AMELIA, AND SLAVE BOY
*By* Augustin Edouart
*Courtesy of the American Jewish Historical Society*

HENRY M. PHILLIPS
*By* AUGUSTIN EDOUART
*Courtesy of the late Mr. Erskine Hewitt, New York City*

[ 183 ]

JOSEPH ANDRADE
*By* G. B. Wood, Jr.
*Courtesy of the American Jewish Historical Society*

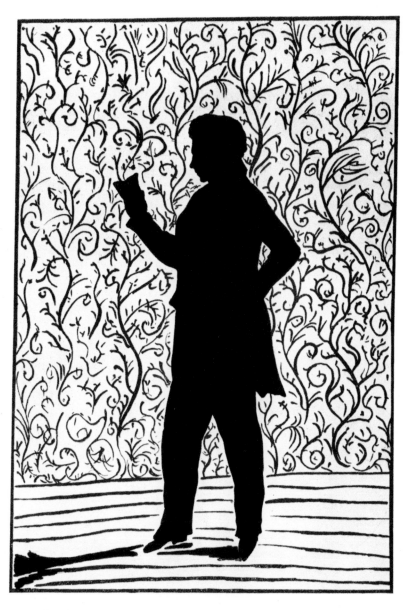

ISAAC HARBY
*By* an Unknown Artist
*Courtesy of Mr. L. C. Moise, Sumter, S. C.*

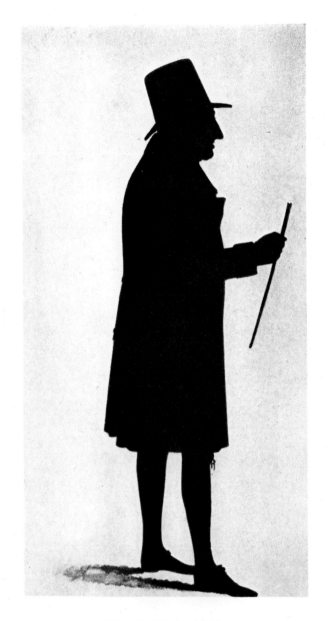

MICHAEL LEVY
*Attributed to* WILLIAM HENRY BROWN
*Courtesy of Mr. Henry S. Hendricks, New York City*

[ 189 ]

JOHN MOSS
*Attributed to* WILLIAM HENRY BROWN
*Courtesy of the American Jewish Historical Society*

# INDEX

INDEX

Cohen, Jacob I., 19, 20, portrait 97
Cohen, Dr. Joshua I., 62 portrait 145
Cohen, Colonel Mendes I., 21
Cohens, of Baltimore, 23, 41, 44
Coke, Desmond, 5
Cole, Mrs. Isaac, Jr., 62
Connecticut Historical Society, 84
Conroy, Katherine (Mrs. Jacob Hays), 70
Converse, Mrs. C. R., 9, 15, 95
Copley, John Singleton, 28
Corcoran Gallery of Art, 29, 109
Cornè, Michel Felix, 10
Cottu, profilist, 10
Crawford, Mr., 73
Cullen, Jonathan J., 52

Dacosta, Isaac, 33
Dacosta, Samuel, 33
Da Costa, Jose, Roiz, 33
Dana, Henry W. L. collection of, 9
D'Angers, David, 73
David, Sussex D., 22, 24
Day, Augustus, 10
De Cheverus, Bishop, 79
De La Motta, Emanuel, 64
De La Motta, Dr. Jacob, 64, portrait 147
De Leon, Almeria (Mrs. Hayman Levy), 72
De Leon, Jacob, 72
De Sanzay, Archbishop Dubois, 79
Dewey, Silas, 9
Dexter, Elias, collection of, 29-31, 109
Doolittle, A. B., 10
Doyle, William M. S., 10
Dropsie College Library, Philadelphia, 62
Dunlap, William, 40
Du Val, Mrs. Barr, 76
Duval, Major, 16

Edouart, Augustin, frontispiece, 4, 6, 7, 11, 39, 49, 51, 55-57, 60, 62-65, 67-71, 73-77, 139 141, 145-149, portrait 151, 153-183
Edouart, Rev. Augustus Gaspard, 55
Edwards, Thomas, 10
Elkins, Harry, 17
Elliot, profilist, 9
Ellsworth, James Sanford, 10
Elsass, Frederica, 58

Elzas, Dr. Barnett A., 61
Emmons, Alexander H., 9
Erving, Henry, collection of, 9
Essex Institute, 4, 9, 12, 15, 47
Etting, Benjamin, 66
Etting, Bernard G., 64, portrait 149
Etting, Captain Charles, 66
Etting, Edward, 66
Etting, Elijah, 21, 51, 66
Etting, Mrs. Elijah (Shinah Solomon), 21, 51, 66, portrait 101
Etting, Elijah Gratz, 66
Etting, Miss Ellen, 40
Etting family, 66
Etting, Lieutenant-Colonel Frank, 66
Etting, Commodore Henry, 66
Etting, Miss Josephine, 40
Etting, Kitty, see Mrs. Benjamin I. Cohen
Etting, Rachel, see Mrs. Solomon Etting
Etting, Reuben, 21, 66, portrait 153
Etting, Miss Richea, 40, 41, 43, portrait 129
Etting, Miss Shinah, 40
Etting, Solomon, 21, 39, 40, 43, 49, 51, 52, 64-66, portraits—frontispiece, 127, 135
Etting, Mrs. Solomon (Rachel Gratz), 39, 40, 43, 51, portrait 127
Etting, Lieutenant Theodore, 66
Ettings, 41

Fahnestocks, 42
Fevret de Saint-Mémin, 10, 11, 27-31, 33, 34, 109-115
Field, of London, 6
Fillmore, Millard, 56
Folwell, Samuel, 10
Forsyth, John, 59, 74
Franks, David, 63
Franks family, 25
Franks, Rebecca, 63
Fremont, John C., 61

Gainsborough, 62
Galoway, profilist, 9
Gideon, C., 25
Gillespie, J. H., 11
Gimbrède, Thomas, 10, 39, 40, 127, 129
Girard, Stephen, 79
Goethe, Wolfgang von, 7

[ 194 ]

# INDEX